DESIGNING WITH THREAD:
From Fibre to Fabric

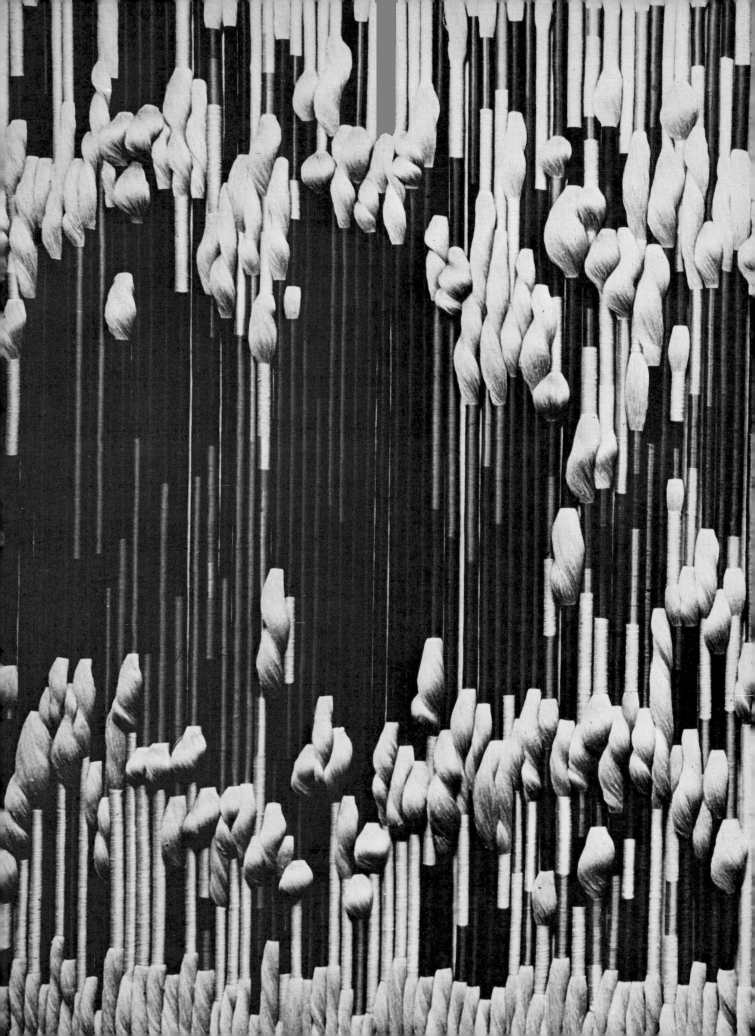

DESIGNING WITH THREAD:
From Fibre to Fabric

Irene Waller

A Studio Book

The Viking Press · New York

Acknowledgements

My thanks go to all my designer friends everywhere who allowed me to use illustrations of their work; to Alan Hill, the photographer, who gave so unstintingly of his time and patience and superb professionalism to capture the essence of fabric; and to Terry Brackenbury, ATI, lecturer at Trent Polytechnic, for his invaluable assistance on the chapters dealing with knitting and lace, and without whose help the book could not have been written as I wished. My thanks also go to the Royal College of Art and the Birmingham Polytechnic Art and Design Centre for allowing students' work to be used as illustrations; to the manufacturers of equipment and supplies who have assisted with information and photographs; and to the many professionals who have helped verify facts. My thanks also to the staff of Studio Vista for their co-operation in shaping the book; to Carole Sizer for typing the manuscript; and to my family and friends for their help, and patience.

Drawings in the text by Irene Waller

Books marked with an asterisk in 'Further Study' lists are especially recommended

Published in 1973 by The Viking Press, Inc
625 Madison Avenue, New York, NY 10022

Published in England under the title *Thread: An Art Form*

SBN 670-26931-x

Library of Congress catalog card number: 72-12059

Printed in England by the Shenval Press, London and Harlow

Designed by Marie-Louise Luxemburg

Contents

Introduction

We are at an exciting moment for the artist, designer and craftsman. The barriers between different media and between different methods of production, and indeed between the people using them, are dissolving. New materials, new techniques and new machines provide new methods of expression and are producing fresh concepts. Something in the quality of life today is causing us to look again at ancient art objects and traditional methods in the light of our contemporary needs. All these factors add up to change and new possibilities, both in exploring the new and re-assessing the already-established.

This seemed to be the moment to create a book which would demonstrate this state of affairs particularly in relation to those who have chosen the interlacing of fibre and yarn as their means of expression. Such a book would underline the richness of the field of the fibre and yarn and indicate the wide variety of ways in which yarns can be used together creatively.

No artist would find it desirable or possible to work in the whole range of textile techniques. Neither, of course, has it been possible, in one book, to touch upon every technique in existence – the ramifications of textile construction are immense. But by the bringing together of some of the methods and techniques which are available to the constructor in fibre and thread, I hope this book may suggest to the individual designer possible new avenues of exploration.

There are so many fine reference books available which deal with the individual disciplines in detail, that the method used here is as follows. Techniques have been placed in relation to each other according to their structural complexities; the characteristics of each technique are described and illustrated by examples of the work of contemporary artists. In the case of hand techniques sufficient technical information is given in diagrams and words to get the craftsman started and, finally, each chapter concludes with information on suppliers of materials and equipment, and suggestions for further reading; the latter, because of its great importance, is placed at the end of each chapter as well as in the bibliography.

(1) *People* C. J. Westacott, Tredegar
(See Chapter 1)

6

1 Design sources, media and methods

(2) *Graveyard* J. E. Burgess, Insight Camera Group, Lichfield

Everything that the artist, designer or craftsman produces should be as near to aesthetic perfection as he can make it, whether he is producing 'one-offs' or designing for mass production. A work of art is a physical realization of an abstract conception. Artists and designers are people who have the capacity to develop an abstract conception and translate it into visual terms. The mental process is fed by reacting to the physical world and to metaphysical concepts. The translation and realization of the idea requires craftsmanship, which involves the careful choice of the correct media and technique; the fullest utilization of their visual and tactile qualities, and impeccable execution based on exhaustive research into, and practice of, the technique.

Craftsmanship is time-consuming. It is often difficult for the artist to give exquisite craftsmanship its due time and attention: we are constantly aware of how much we want to do and how little time there is to do it. But give a thought to craftsmen of earlier times who took ten years or more to become proficient, and then spent a lifetime at one pursuit. The artist today does not always participate in the final execution of a piece of work, particularly in industry. Instead, he guides and supervises craftsmen who are technically competent to produce an object without necessarily having conceived it. This requires a close understanding between artist and craftsman which is rare to find. Nothing can supersede the professionalism of

(3) Felt-pen drawing of rocks

the man who is both artist and craftsman.

Readers who are concerned with the practicalities with which this book deals will be using fibre and thread either to make objects which may be purely fine art or practical, or to make, or cause to be made, yardage for fashion or for the interior. They have one common aim: to create a personal statement which is not only aesthetically satisfying to the mind, the eye and the touch, but also fulfils a functional purpose.

Those who use textile materials solely for fine art have, it is true, been described as 'fully creative designers who use their feeling for materials and structure to work as fine artists, independent of functional limitations and ignoring the concepts of traditional usage to find new and personal means of expression'. But those who design for industry must also retain their right and ability to make a personal and aesthetically satisfying statement: the sophisticated machinery at their disposal gives them both the satisfaction and the tremendous responsibility of knowing that their work will be produced in bulk and reach a wide public at great speed.

Design sources

One can design nothing, however, unless the mind is teeming with ideas. Source material is all around us – in the ash from fire, the pattern of water, rain on the window, grass, bricks, landscapes, buildings, traffic, people – everywhere, in fact (1, 2, 3). The designer must first learn to use his eyes. When we are young every image is new, but often in later years we look with preconceived ideas, certain that we have seen an object before, and often not really *seeing* it at all. Drawing, painting and recording in any medium or manner trains one's powers of observation. Having drawn an object one knows it intimately, and that knowledge will never be lost. With each successive effort one's skill and visual knowledge increase. Nothing can replace either the act of drawing based on observation, or the discipline it requires.

The designer must be receptive, ready to be excited by ideas and by what he sees: what excites him and

him alone is what makes him an individual designer.

A word to students: do not think that unless you do draw or create something completely original it is better not to create at all. During your training this kind of thinking, though understandable, can be inhibiting. You will only progress by seeing and by learning the obvious rules, like learning scales in order to play the piano. This way you will build up a vocabulary and a store of experience. You may well, of course, go on to break the rules afterwards.

There is an abundance of source material in books and magazines, libraries, galleries, museums, gardens and great architecture. It is important to saturate oneself in the work of great modern textile exponents by reading books and magazines and by going to exhibitions – in the industrial field, people like Jack Lenor Larsen, Marianne Straub and the late Margaret Leischner and Dorothy Liebes in the fine art field, Sheila Hicks, Clare Zeisler, Lenore Tawney, Susan Weitzman, Peter Collingwood, and others too numerous to mention here (see illustrations, and Bibliography). Do not think it is cheating to look at the work of other artists and designers – that would be like denying the value of art galleries, museums and books. Good designers are essentially inimitable; do not worry, either, that you will be unduly influenced by them; the final statements of a really creative artist will always be personal.

Design media and methods

Some designers carry their ideas in their heads, with no evidence that anything is going on until the object takes shape, but this is generally the prerogative of more mature artists. Their source material is filtered and perfectly recreated. The beginner or student must observe, record and store: he has before him the task of developing the mental and physical capability to change seen objects or abstract ideas into a visual message.

If you are obsessed by circles or seascapes, then draw them, paint them, cut them out, knit them, knot them, carve them, climb inside them. See what

other people have said about them; what other eras have produced on the subject; what they look like in other materials. But beware of the desire of the observing eye (generally the consumer's) to interpret in the light of something which is already familiar. Be careful that your abstract of a circle and line doesn't look like the emblem of the London Underground, unless you intend it to do so. Exploit unfamiliar aspects of the familiar (1). The designer's only problem should be to find enough hours in the day in which to execute his ideas, and this state stems from saturation in the things which excite him, the willingness to be excited, and from ceaseless observation.

Always carry a small drawing pad and implements: the visual image which intrigues you most may occur quite unexpectedly. There are paint boxes on the market, about $2\frac{1}{2} \times 4$in., which are extremely light and allow one to record colour 'on the spot'. A camera can be used as creatively as the brush or pencil and is also useful as a method of recording matter for later use.

A variety of materials is necessary. Papers in block and sheet: water colour, cartridge, rough, smooth, thick, thin, white, coloured, metallic, tracing, squared, tissue and card of varying thicknesses and colour. Pens, fibre and felt; pencils, hard and soft; rapidographs or their equivalent; crayons; pastels; charcoal and fixative; inks; paints, clear and opaque; dye stuffs, which can also sometimes be used as paint. Do not be mean about it. It can be infuriating not to have the right media at hand, and if everything is carefully stored nothing need be wasted. A large area of pinboard is invaluable, allowing one to change the surrounding stimuli and view work easily.

A method of storing materials tidily (and also for storing the drawings, paintings, photographs, magazine and news cuttings and general reference material which one may wish to preserve) is vital. There are many storage folders and systems on the market and these range from manilla pockets, through lever-arch files and Nyrex folders (the pages of which are pockets of clear plastic), up to portfolios and zipped cases in international sizes. A plan chest will become a 'must' at some time, and the sooner the better, but a cheap way out for a while is to use covered shelves. A visit to a good artists' and designers' supplier will give the answer to all storage problems.

Once the observing and recording stage is past and the design is being developed, choose a medium which is close to the effect that the final design, in textile form, will have. For example, inks and felt pens and dyes have great clarity and resemble silk and some man-made fabrics; crayon or conté may be better for wools and bulked yarns. A final covering of any design with varnish or clear plastic will give it shine, if that is required, as well as protection.

Putting drawn designs into repeat can be facilitated with copying equipment. Twenty copies of the motif, placed, and replaced, will achieve success a great deal sooner than will laboriously traced repeats. A 'light box' (or a sheet of glass over a light) helps with tracing. It may be essential to see a design repeated over a large area to ensure that it doesn't reveal unexpected pathways and holes which can be irritating to live with. A mirror placed lengthways hard against the design will allow you to see something become symmetrical, and two mirrors at right angles on the floor will let you see a wider expanse.

Some people are not at ease with paints and inks, and find it best to work directly with the textile materials involved (4). This method can solve many problems, like colour texture and technique, at an early stage. More often than not, the designer in fibre and yarn feels immediately more at home and sure of himself when working like this. One needs paper, scissors and an adhesive suitable for fabric and fibre (Copydex), as well as yarns, fibres, fabrics, ribbons, plastics, acetates, beads, foil, metal, etc. for the design itself. The procedure is to think directly in terms of yarn, fabric, colour and texture, using these things themselves to make a mock-up of the final design. One needs a store of raw materials on which to draw, but these accumulate quickly if they are stored carefully. Plastic bags, plastic boxes and glass jars are useful containers, as the material will be visible. (4) is an illustration of this method: it was produced quickly and gave the client a clear picture of the final fabric.

Carpets and rugs are designed well by this direct

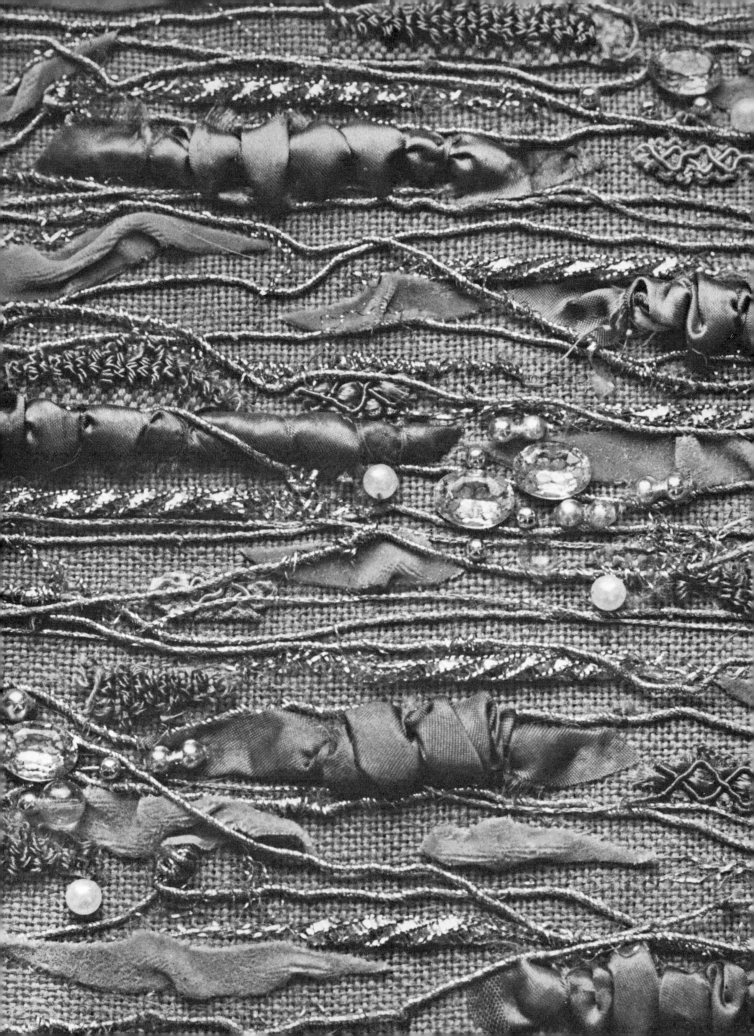

(4) Mock-up for a gold altar frontal fabric. Irene Waller. Composed of yarns, beads, stones and glue. A speedy method of presenting a design to the client. Photo Alan Hill

(5) Mock-up for a rug design, Irene Waller. Wool on card. Photo Alan Hill

(6) Design for a warp, wound around card, Irene Waller. It also has possibilities as a design idea for hanging. Photo Alan Hill

method. Cut up the different wools, in bundles, into $\frac{1}{4}$in. lengths, and store them in saucers, colour by colour. Gum them on the stiff paper onto which the design has been drawn (5). If the design is geometric use squared paper as a helpful base. The carpet trade's 'podge board' – which is a square board of hardboard or perspex drilled with holes which equal the number of tufts to the square inch – is expensive, but invaluable if carpet design is your chosen field. The tufts are pushed through the holes, leaving the necessary length of pile at the front. When the design is complete it is latexed at the back, and when dry, stripped off by pulling through from the back. When designing for stitch-tufted rugs a Venor tufting machine (like a hefty sewing machine, see Suppliers, Chapter 3) or a hand-gun tufter is useful.

Patch designing, much used in the shirting trade, is another example of designing directly with materials. It is used mostly for vertical and horizontal stripes, but is capable of much wider application, with carpets or Jacquards, for example. If you are designing a series of striped fabrics, cloths in the required colours can be bought, woven or knitted, and gummed to paper to make them easier to handle and to prevent fraying. Make sure you do this accurately, so that the sides are straight. Then cut the cloth with very sharp scissors along the threads, into the desired stripe widths. When you have formed the stripes into the required design, gum them firmly onto a sheet of paper or card, taking care to push the stripes very close to each other, so that the joins are invisible. This method lies between designing in threads only and setting up a striped warp on a loom.

The weaver or knitter can, of course, design straight onto the sample warp or knitting machine. Both should be used creatively, like a painter uses canvas – a machine is only there to do what you want. Hand techniques needing no equipment are even less a problem. The weaver can open up new possibilities by putting a white warp on the loom and staining it with various colours as he moves forward; or by putting a wide sample warp on the loom composed across the width of blocks of different colours (keep the colours in harmony with each other or this can be wasteful and defeat its purpose); or by making variations of threadings across the warp; or by combinations of all these methods. And don't despise the back of the fabric: it can yield fruitful results. Always be ready to set in new warp ends to create variation. When sampling on a loom, make a 'viewing card', i.e. a largish piece of card with a 'window' cut to the size of one individual sample. On the cloth, it isolates each design in turn, thus making appraisal possible without the distraction of the adjoining weaves. Warps themselves can be designed by wrapping yarn around the measured card (6). As a temporary measure, when designing either warps or the total fabric, sheets of fine glass-paper or sand-paper hold threads very well, and in this way the design can be placed and re-placed, before being held more permanently on paper with gum.

The knitter can construct instantly with even less preparation than the weaver; as long as he has a versatile knitting machine which he understands completely, he can alter his design instantly.

The weaver, in particular, must take great care not to be so 'taken' with the 'finished' qualities of a woven sample design that he gives insufficient attention to the overall graphic effect. Explore the possibilities of a design by drawing and re-drawing, or placing and re-placing on paper or by the 'patch design' method referred to above. As the design progresses, you might want to leave it for the rest of the day. Pin it up on the wall; the next day, with a fresh eye, you will see whether it is right or wrong. Some designers work on one thing at a time, others on four or five. Using the latter method you can leave one piece of work and turn to another to refresh your mind.

The moment of truth for any design is when it is seen finished at its own practical distance. Either it gives satisfaction to the sight and touch, and says something new, or it does not.

Suppliers

F. G. Kettle, 126 High Holborn, London WC1 (papers)
'Paper Chase', 216 Tottenham Court Road, London
 W1 (papers of every variety)

Reeves & Sons Ltd, 13 Charing Cross Road, London
WC2 *and* 178 Kensington High Street, London w8
(artists' materials)

George Rowney and Co Ltd, Retail Shop, 12 Percy
Street, London w1 (artists' materials)

Winsor and Newton, Ltd, 51 Rathbone Place, London
w1 *and* Wealdstone, Harrow, Middlesex *and*
555 Winsor Drive, Secausus, New Jersey, USA
(everything for the artist, shops everywhere)

Further study

Design sources

Brodatz, Phil *Textures* Dover Publications Inc, New
York 1966

*Feininger, Andreas *Form in Nature and Life* Thames &
Hudson, London 1966

Humbert, Claude *Ornamental Design* Thames &
Hudson, London

Justema, William *The Pleasures of Pattern* Reinhold,
New York 1968

Strache, Wolfe *Forms and Patterns in Nature* Peter Owen,
London 1959

Designers

(Illustrations of their work and, on occasion, informa-
tion about them)

*Albers, Anni *On Weaving* Wesleyan University Press,
Connecticut, USA 1963; Studio Vista, London
1966 (Anni Albers and others)

*Beutlich, Tadek *The Technique of Woven Tapestry*
Batsford, London; Watson-Guptill, New York
1967 (Tadek Beutlich)

*Kaufmann, Ruth *The New American Tapestry* Rein-
hold, New York 1968 (20 artists including:
Trude Guermonprez, Ted Hallman, Glen
Kaufman, Sheila Hicks, Clare Zeisler, Kay
Sekimaki, Lenore Tawney)

*Meilach, Dona *Macramé* Crown, New York;
General Publishing Co, Canada 1971 (Clare
Zeisler and others)

*Nordness, Lee *Objects U.S.A.* Viking Press, New
York; Macmillan, Canada 1971 (over 60 artists

including: Anni Albers, Lili Blumenau, Allen
and Dorothy Fannin, Nell Znamierowski,
Dorothy Liebes, Mary Walker Phillips, Virginia
Harvey, Joan Paque, Jack Larsen, Lenore
Tawney, Trude Guermonprez, Susan Weitzman,
Dominic di Mare, Sheila Hicks, Kay Sekimaki,
Clare Zeisler, Ted Hallman, Glen Kaufman)

Walker-Phillips, Mary *Creative Knitting: A New Art
Form* Van Nostrand Rheinhold, New York 1971
(Mary Walker-Phillips)

Exhibition catalogues

'Josep Grau-Garriga' Catalogue of Exhibition of his
work, February 1971, Museum of Fine Arts,
Houston, Texas, USA

'Collingwood-Coper' Joint Exhibition, February 1969,
Victoria and Albert Museum, London (Peter
Collingwood)

'Modern British Hangings' (44 British artists, including
Peter Collingwood, Tadek Beutlich, Ann Sutton,
Sax Shaw, Theo Moorman), Scottish Arts
Council, Edinburgh 1970

'Craft Horizons' April 1971 (about Jack Larsen),
44 West 53rd Street, New York

'Make' Craft Exhibition (20 Ontario artists,
including Velda Vilson and Marie Aiken),
Ontario Science Centre 1971

Designing

*Albeck, Pat *Printed Textiles* Oxford University Press,
London, New York, Toronto 1969

*Albers, Anni *On Designing* Pellango Press,
Connecticut, USA 1959

*Kirby, Mary *Designing on the Loom* Studio Publica-
tions, London, New York, Toronto 1955

Museums and galleries sometimes have catalogues left
over from exhibitions and keep them for a while, so if
an exhibition in which you are interested is recent it
is worth trying to obtain a catalogue, but they are not
kept indefinitely.

Back numbers of magazines are often obtainable
from the publishers.

2 Techniques and their interrelation

The most important element in creative work is the original conception produced by a lively and fertile mind; the next is to have at hand the necessary technical knowledge and expertise to carry out that idea to the full without undue compromise – whether the designer of furnishing and fashion fabrics is choosing between a woven or knitted construction, or the fine artist is choosing from the wide range of techniques which are available to him since for him none of the restrictions imposed by quantity production apply. It seems undesirable nowadays to think of the various textile constructions as isolated compartments. They all have it in common that they use a simple, continuous, pliable, linear element to form a constructed whole; one should rather use each technique for its own individual quality, aesthetic, practical and economic. Whenever possible keep a very open mind about the method of construction that you use and let the original creative idea speak for itself. Obviously some techniques are capable of more development than others, but in the mind and hands of a creative designer, everything has potential.

Beginning with a sort of tactile doodling, given a piece of string one will instinctively make various shapes and forms with it, partly born out of its own characteristics. If you twist string very tightly, the same way as its natural twist, it will finally curl up on itself, producing little twisted protuberances which

(7) Weaving, macramé, winding, beading and twisting,

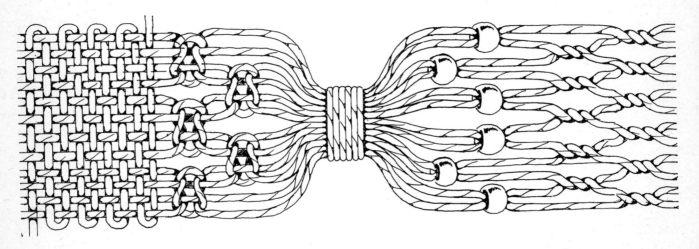

are the basis of some fancy yarn construction (snarl and loop, see [23]) and the basis of some fringe manufacture. Twist it the opposite way to its natural twist and it will be reduced to its component yarns or to fibre. Wind string around the fingers into a little skein, then secure it by wrapping the end firmly around the skein and pulling it through and one has produced three-dimensional form and shape. Make a knot in the string, and then a series of knots, and the result is a beaded effect (32, 33, 34); knot upon knot will form a ball which will immediately have created a pendant object with a certain amount of weight and movement.

With more than one string and a more deliberate approach, if you knot two pieces of string together, and another two together, and so on, in pairs, and then knot the second string of each pair to the first one of the next, and so on, an openwork but stable fabric recognizable as net-like will have been formed. Having made a loop knot, draw yarn through this to form a second loop, and again, and you have a chain which can be the beginning of crochet (68). Make another row of loops into each loop of a crocheted chain and you have the beginnings of knitting.

By now it is obvious that it would be a worthwhile exercise to obtain a piece of soft-board (Celotex) on which to work and some sympathetic string or yarn, and conduct a whole series of unpredetermined experiments with construction. As a beginning take three strings, pass them over and under each other, left over middle, right over new middle, etc. The result is plaiting or braiding (74) which is a technique in its own right, and is also an important component of bobbin or pillow lace. Four, five, or more strings produce complex plaiting which resembles weaving on the diagonal (73). Hang a curtain of strings from something horizontal and static, weight them, or secure them at the bottom, interlace other strings across, over and under, under and over, and one has weaving (74, 81). These simple manipulations from which all the textile complexities can spring, are capable of producing fabrics of widely varying visual effect and characteristics, most of which are translatable into mechanical production.

An evaluation of techniques

To return to simple concepts:

Winding and wrapping, if done tightly, can produce a firm, rod-like result with considerable lustre. Good general samples are cotton reels, Arab head-dresses and whipped rope-ends. It is a technique which must be carried out with great accuracy and is one which Sheila Hicks has used magnificently in her wall coverings composed of great cascades of natural linen yarns, wrapped tightly at intervals with coloured silk (see book jacket).

Knotting can be defined as the interlooping of a thread on itself or with other threads, the operation being concluded with the thread or threads being pulled tight. This results in the formation of a nodule or bead, and most knotting has a characteristic beaded texture. Knotting, apart from its totally functional use for holding things together, can be used for edgings and braids and the like, or for creating fabric. Because knots can be positioned, pulled tight and remain firm, they are used in the production of open fabrics such as nets, which are strong and firm in construction, yet transparent and pliable (31, 35). Equally, knotting can be done at more frequent intervals to produce close fabric, or used purely for its beaded quality (32, 33, 34).

Macramé knotting (12) is a specific form of decorative knotting, which can be used on its own, or with beads as a border or as an entire object. It can be with or without a fringed edge, although it lends itself to the former. Its characteristics are its geometrically decorative and often lattice-like appearance (36). Its limitations are the problems of dealing with the extremely long cords necessary for working. Basically it requires no equipment. Joan Paque and Clare Zeisler are two artists using macramé superbly. See Further Study.

Tatting (41, 42) is another form of hand knotting, which produces firm rings and semi-circles that naturally take the shape of rosettes. When secured together, the resulting structure is open and firm, lies

(8) Hand-spinning, Susan
Weitzman, New York.
Photo Ferdinand Boesh

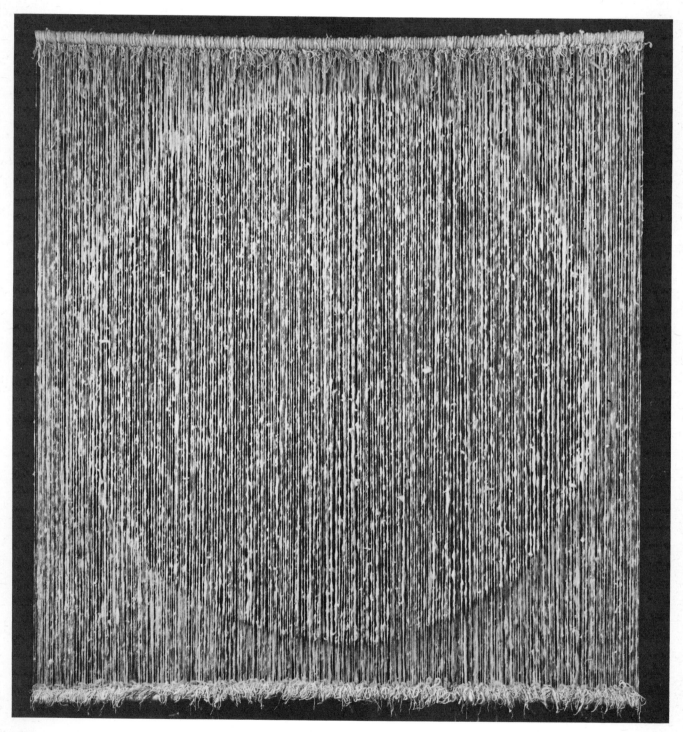

(9) Tapestry *Phase* Susan
Weitzman, New York. Black
and white 4½ft square.
Photo Ferdinand Boesh

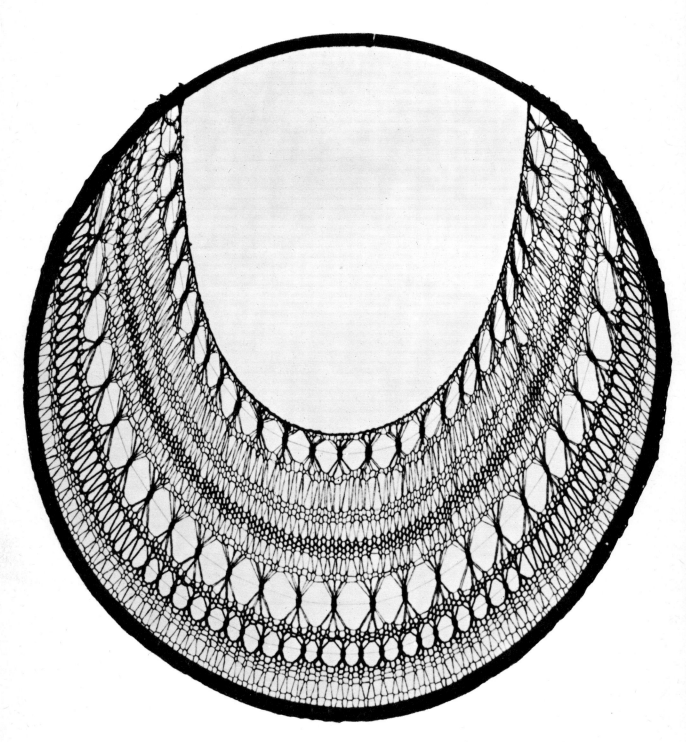

naturally flat, and only stretches when forced. The circle, small and composite, is the dominating visual characteristic. The only vital equipment is a shuttle to take the thread (43).

Plaiting or braiding (11) resembles weaving on the diagonal, as it has the same under-and-over structure of a plain weave, although it is produced in an entirely different manner. It is generally used to produce flat, firm, narrow, decorative braids, with a limited amount of 'give'. It can be composed of multiple elements and needs no equipment (75).

Crochet (68, 69) is composed of one thread looped into itself both horizontally and vertically. Because of this construction it is one of the most stable looped fabrics, much more so than hand knitting, and lies flat. It is decorative in a variety of textures and shapes and needs only a hook as equipment (70).

Hand knitting (10, 48, 49), because of the snaking in and out of the yarn upon itself (mainly in one direction) is very stretchy and pliable, this quality being both its advantage and its disadvantage. It can be texturally decorative, open or close, but is often used for producing areas of comparatively smooth fabric. Because of its construction it easily comes undone until it is firmly fastened off, and is also easily snagged. Plain knitting tends to roll up until it is set. The technique requires two or more knitting 'pins' (47). Mary Walker-Phillips has brought hand knitting into the realm of fine art (see Bibliography).

Machine-knitted fabrics (54, 55) are also stretchy and pliable, can be much finer than hand knitting, and are quite economical to produce. Knitting machines are required, which are proportionally as wide as the desired fabric and either straight or circular.

Warp knitting produces generally stable fabrics. It is an extremely fast and very economical process – the threads are brought individually from a beam, rather as in weaving, and looped together. Some warp-knitted fabrics, made from very fine yarns, are in-distinguishable from wovens without the aid of a textile magnifying glass.

Weave knitting is a warp knitting process which in most cases, though not all, introduces an extra 'weft' element which passes through the knitted cloth, from side to side, making it yet more stable, and can be visually almost indistinguishable from weaves.

Stitch-bonded fabrics (65) is a term used when sheets of fibre or yarn (only) are laid out in web form held together by means of the warp knitting process, i.e. stitched together by vertical wales of knitting. They are extremely cheap to produce; the design variants are in the fibre, the yarn and the stitch.

Woven fabrics (82–125), whatever their weight, possess the straight, firm, stable quality that two sets of threads, interlaced at right angles to each other, will impart. Smallish projects can be produced on frames but yardage requires a loom. Wovens hang and drape well and the possibilities for colour, textural and structural variations are immense. In particular the weft yarn (horizontal), because it passes through an open corridor of warp threads (vertical), can be quite bulky and ornate (95), or even of rigid material. Unlimited graphic ornamentation is possible with the Jacquard mechanism which operates warp threads individually (123).

Pile fabrics (57, 136) have tremendous textural depth and clarity of colour and can have a woven or knitted base cloth. They are, in general, used for purposes of comfort, warmth, luxury and strength (in carpets, the pile protects the base weave). Because of the character of pile, design edges are blurred more or less according to the length of pile. Pile fabric construction is used to simulate fur.

Lace (131, 132). The word 'lace' is associated with delicacy, airiness, and fine graphic ornamentation. Handmade lace (bobbin or pillow, they are the same thing) takes time to produce because lace is almost always made in fine thread. Despite its delicacy the

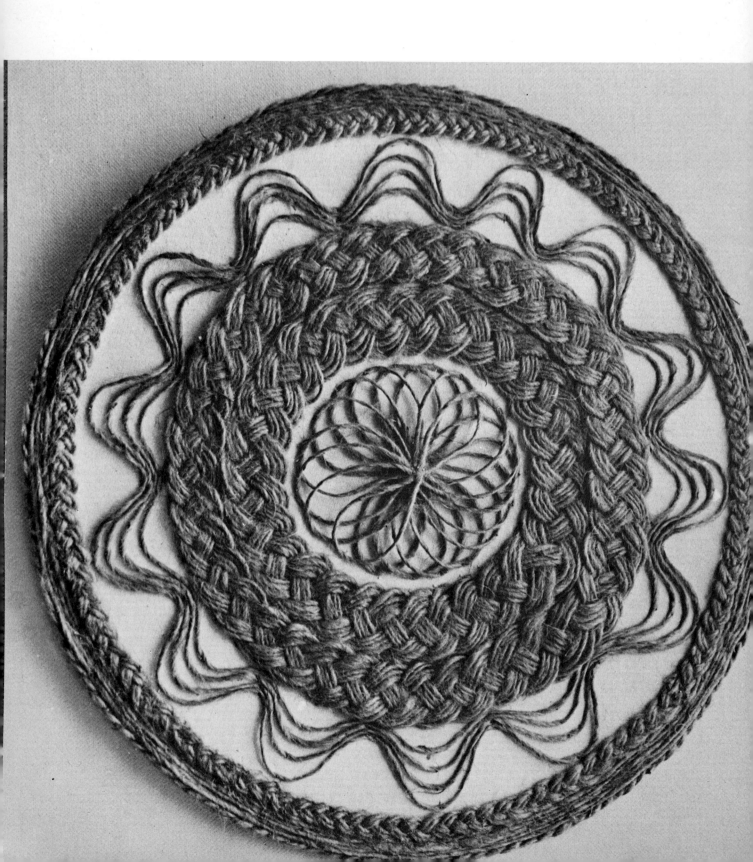

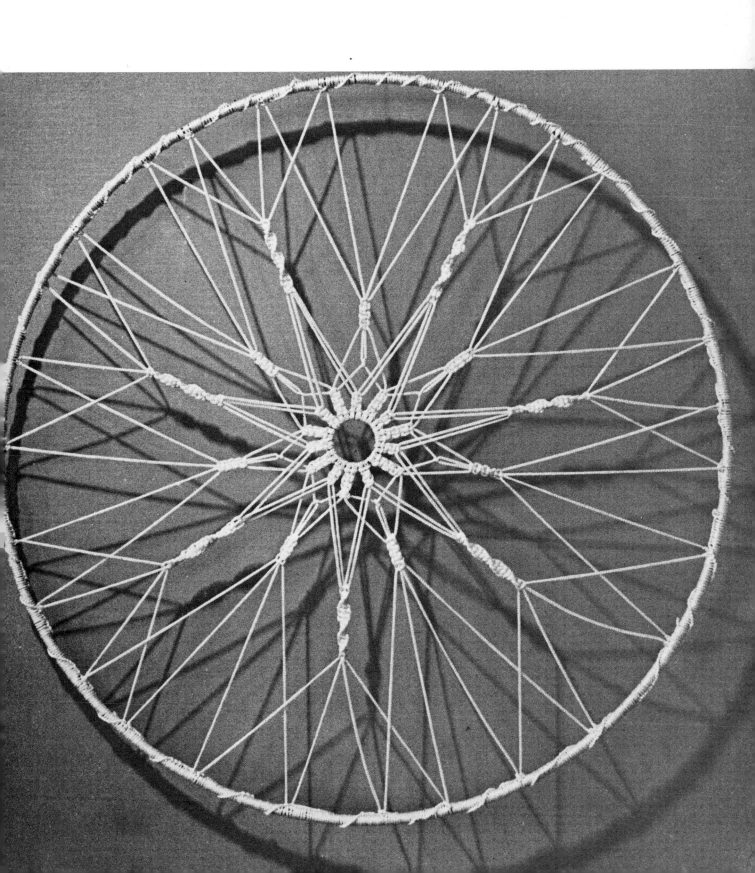

(13) Free tapestry, Irene
Waller. Natural jute and
silver, 2½ft diameter. Photo
Alan Hill

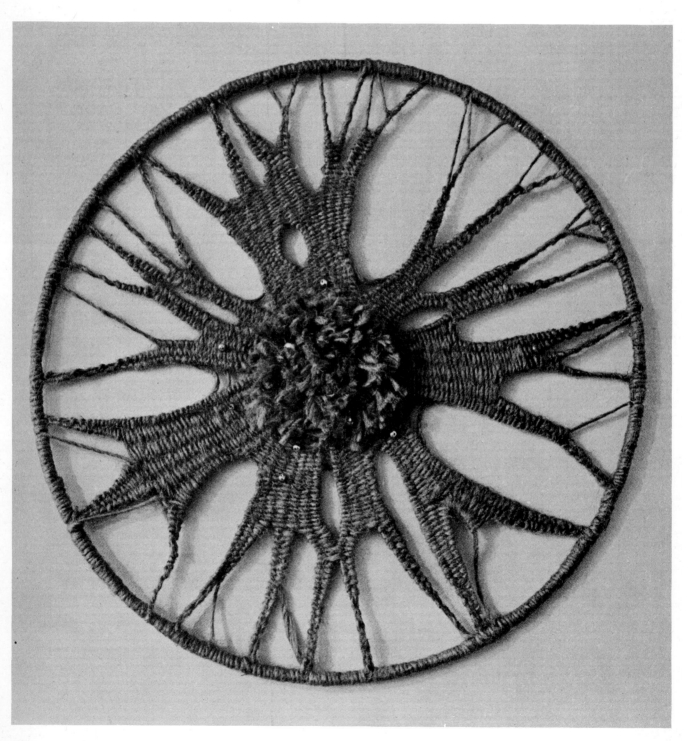

structure is a firm one and is an amalgam of many other techniques, the various decorative areas being produced by plaiting, twisting, looping, knotting and 'weaving'. The hand product is most often narrow strips or small shaped areas. The equipment needed is a pillow, bobbins and pins.

Machine-made lace, created on wide, slightly loom-like machines, is produced on the 'twisting' principle. Sheets of threads, mainly vertical, twist around each other, producing the base fabric. Areas of ornamentation are produced by extra yarns of greater or lesser density moving over the surface of the cloth held in place by the twisting base threads. The freedom of design is great and the fabric stable, though transparent (131, 133, 134).

Laminated or bonded fabrics (138) can be simulated simply by gluing two pieces of dissimilar fabric together with an adhesive suitable for fabric (Copydex). The result is not just a fusion of the two, but a new fabric with new properties. Laminating can add strength and stability to a light or loose weave or knit, or add bulk and padding. The fabrics created are invariably exceedingly stable; they drape and tailor well.

Chemstitching (139) is essentially quilting simulated by the laminating process. The lamination takes place only where an ordinary quilted fabric would be stitched. Fabrics are always very stable, padded, and three-dimensional in appearance. The design possibilities are considerable: the design can move freely over the surface of the cloth and the play of light and shadow can be exploited.

The foregoing are general statements about some of the characteristics of various methods of constructing with thread. In the interests of experiment one can sometimes quite deliberately deny them by weaving with elastic yarns or knitting with wire.

The greatest creative fulfilment and professional expertise can be achieved by wide awareness of a variety of techniques, sometimes fusing them, always remaining open to new methods of doing things. Machines and chemistry are constantly offering us new media and solutions. In some of Clare Zeisler's work (Chicago) one sees the most original and yet most natural combinations, such as warp painting, double and plain weaves, stuffed pockets and crochet, or warp painting, double and plain weave, braiding, knotting and netting. (See Ruth Kauffman's *The New American Tapestry*.) In (8–13) the circle is treated in six ways.

Further study

American Fabrics Magazine, The Editors *American Fabrics' Encyclopaedia of Textiles* Prentice-Hall, New York, USA

*Emery, Irene *The Primary Structure of Fabrics* The Textile Museum, Washington, DC, USA 1966

Groves, Sylvia *The History of Needlework Tools* Country Life Books, Hamlyn Publishing Group, Middlesex, UK 1966

*Hartung, Rolf *Creative Textile Craft* Batsford, London; Reinhold, New York 1964

Here, books dealing with the specific techniques have been omitted, and are placed at the end of the relevant chapter.

3 The workroom and equipment

far right
(15) Some textile tools and accessories

This chapter suggests the type of workroom suitable for either a professional design studio, well-equipped to produce a wide diversity of fabrics and with plenty of space and money available, or an educational establishment, again with space and funds. On page 33 there are suggestions for sets of equipment to fill less complex needs.

Basic requirements for the workroom are good light, both natural and artificial, adequate heating and ventilation for both designer and equipment, and sound workmanlike tools, well maintained and stored. The floor, whatever its finish, should be smooth, to prevent fibre and yarn sticking and to facilitate cleaning. It should always be kept free of clutter. The windows should be as big as possible, but need some form of blinds in order to protect fabrics from undue sunlight and heat when the room is not in use, and so that slides can be shown. Unused wall space should be covered with soft pinboard, so that designs, fabrics, ideas in embryo, design references and written information can be easily displayed and referred to. Pinboarding furnished with spring clips can also be used for holding tools. It is a good idea to paint part of the pinboarding white, part dark and part mid-tone, as the background for a design can affect it greatly. An area of boarding covered with sandpaper or glass-paper is very practical for the instant holding of yarns and fabrics and the instant planning of warps.

(14) Yarn storage

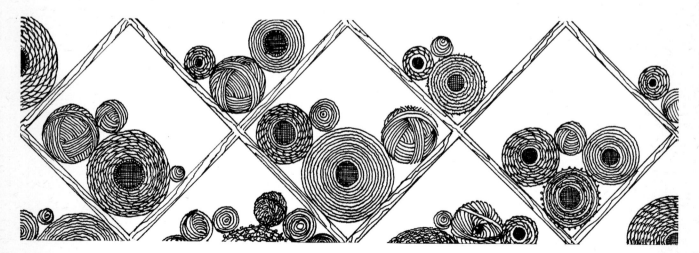

1 Warping mill
2 Shuttle stick
3 Roller shuttle
4 Shuttle quill
5 Quill winder
6 Beating fork (brass) for rugs and tapestry
7 Carders
8 Spindle
9 Reed hook
10 Heddle hook
11 Heddle
12 Warping posts with warp
13 Rigid heddle with clamp
14 Spool rack
15 Shaft holder (2 required)
16 Knitting pins
17 Pliers
18 Weaver's scissors
19 Skein holder
20 Tatting shuttle
21 Crochet hook
22 Netting needle
23 8-needle knitting 'machine' for Rouleau
24 Floor rice (skein holder)
25 Finishing roller
26 Ball winder for knitting machines
27 Shears
28 Stitch transfer tools (knitting)
29 Weights
30 Paddle (for getting singles cross in multiple warp)
31 Heck block, ditto, but attached to warping mill
32 Reed
33 Raddle
34 Warping board with warp
35 Knitting machine table
36 Scrutinising table (glass top, light under)
37 Pegging table (grille in top to accept lags, drawers under to receive pegs, cupboard)

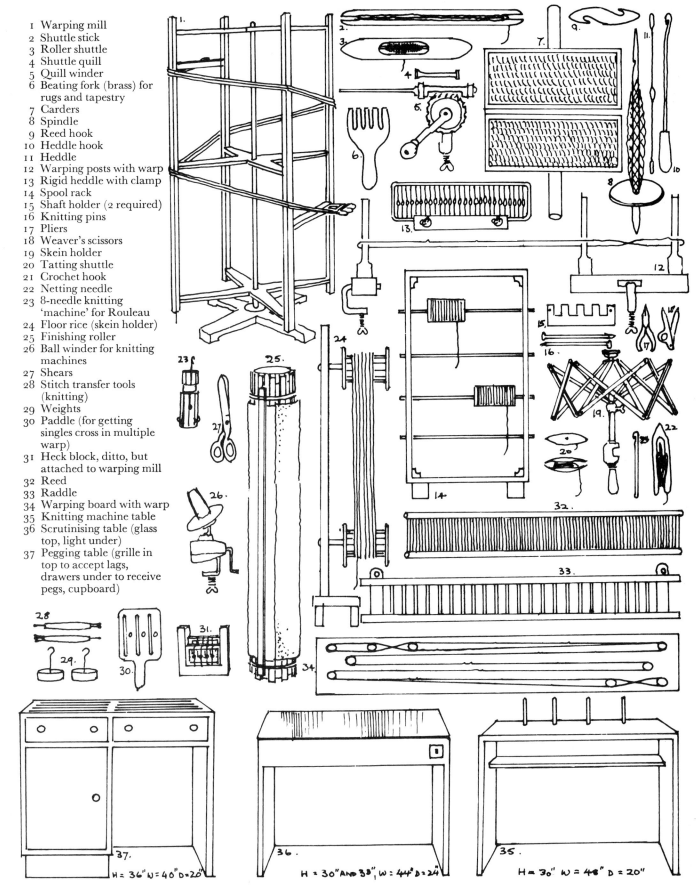

H = 36" W = 40" D = 20"

H = 30" AND 33", W = 44" D = 24"

H = 30" W = 48" D = 20"

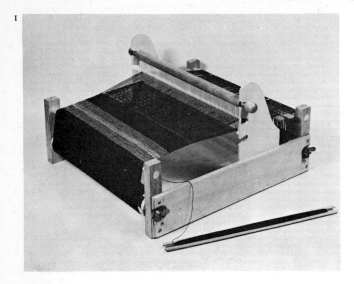

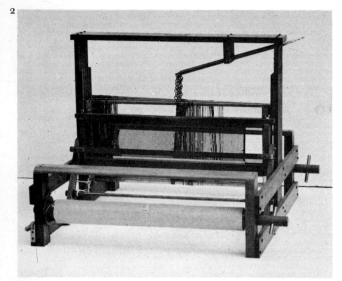

A 12in. deep (back to front) curtain board with three or four tracks, one in front of the other, the whole thing hard against the ceiling and running the length of one wall, is good for hanging fabrics, and wall hangings and for designing three-dimensional work. You can get curtain pins which are a combination of curtain hook and safety-pin from furnishing stores. If the ceiling is high a pair of folding steps are needed.

There should be good overhead lights, with local lights on the desk, drawing board and at every specific work point. Clip-on lamps are invaluable for threading and other detailed jobs. These can be moved around and plugged into special hanging sockets. Hanging sockets are the best way of handling all other tools needing power as they keep the floor free of trailing electric cord. Equipment should not have to be moved and there should be plenty of room to walk around it.

The layout of the workroom

If there is plenty of space it is a good idea to have equipment and processes laid out in order of use as far as possible.

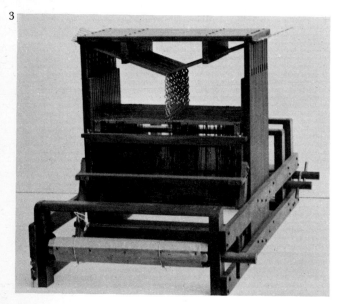

1 Desk, with light and pinboard. Card-index boxes to deal with suppliers, customers and work. Diary, Nyrex folders (141 [6]) containing reference photographs of work; headed notepaper, compliment slips, cards, etc. Filing drawers for correspondence, design samples mounted on cards (141 [7]) and suppliers' samples. An address book is necessary in spite of the fact that most of the information will be in the card index file, as this can be carried around.

2 Bookcase (glass fronted, to keep dust away) for reference books, magazines, notebooks and sketchbooks.

3 Drawing table (72 × 36in.) with plan chest underneath, drawing board and board rest, pinboard and light. The plan chest can be positioned on the right or left, depending on whether the designer is right- or

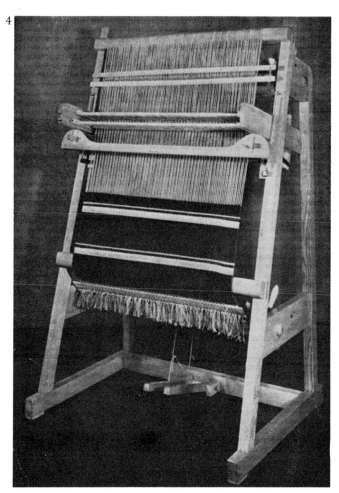

4

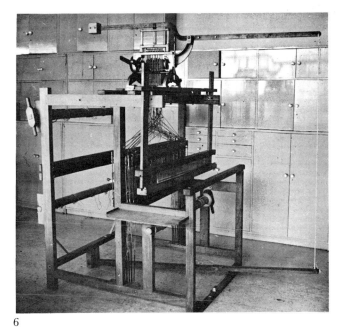

6

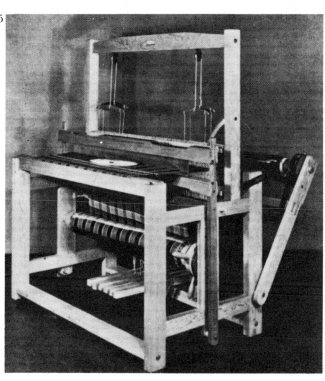

5

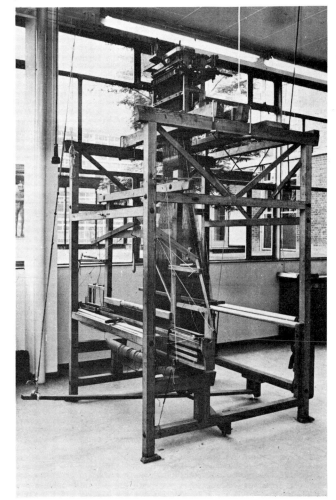

7

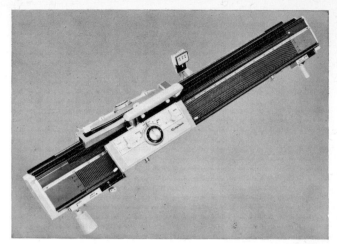

left-handed, and holds designing materials, papers, extra mounting cards, designs, etc. Alternatively, drawing stand and plan chest can be separate but this is sometimes inconvenient and more expensive.

4 Sturdy table for mounting finished work, with formica or plateglass top and guillotine. Drawer underneath for card and sample design cards, cutting knives and shears, metal-edged rulers and T-squares, sticky tape, adhesives, and plenty of wiping cloths.

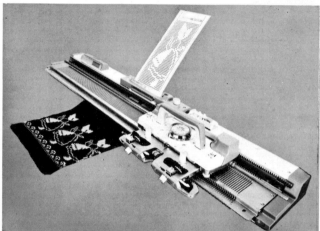

5 A comfortable chair for the client (if you are a practising designer) and a big table on which to discuss work.

6 Yarn storage (see also Chapter 4). It is an advantage to be able to store considerable quantities of yarn and other materials, not only because it ensures that a wide choice of material is always available but also because of the economic advantage of bulk offers and sales of oddments. However, the problem is not only that of space, but also of preservation, as yarn dries out in normal room temperatures and fades in sunlight. A large cupboard or pantry-sized room with no heating or natural light is excellent if fitted from floor to ceiling with adjustable shallow shelving. Movable, upright partitions on the shelving are necessary because the quantity of a given yarn in stock will vary from week to week; these can be made with metal or wood angle (like bookends, which slip under and are held down by the weight of the books). Yarns should be carefully labelled. Clear plastic flaps hanging down from the shelf above give added protection. Yarns in constant use should be re-ordered when they are seen to be running low. Fleece and fibre can also be stored in this sort of room in sacks.

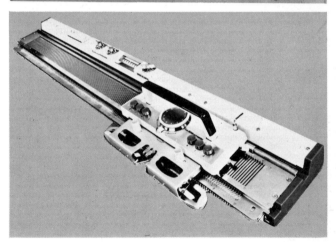

It is a stimulus to have a single sample cone of all the yarns which are available and in stock in glass-fronted, diamond-partitioned cupboards in the working area (14). In the same cupboards could be kept cellophane, plastics, metals, glass, fibres and so on. Stored in this way, yarns and materials are usually more pleasing and stimulating, perhaps grouped together in colours rather than types. Marvellous

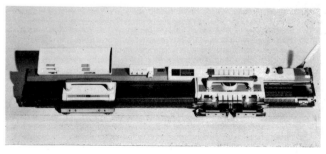

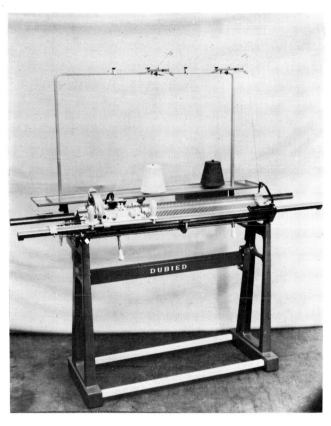

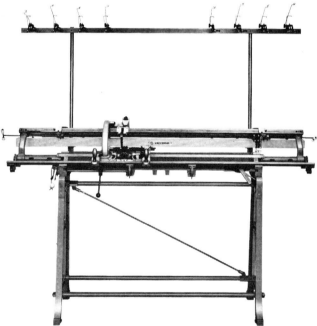

4 Jones 588 knitting machine
5 Dubied NHF2 hand flat-
knitting machine
6 Universal Transrapid hand
flat-knitting machine

receptacles for storing difficult things like beads, paper clips, sewing materials, small tools, inks, and paints, are the partitioned, clear plastic boxes intended for the handyman. These boxes can be stacked in sky-scrapers and everything available can be seen at a glance (24 [3]).

7 Yarn production area (Chapter 4). Spinning wheel (21) for spinning and folding (plying), spindles, carders, skein winder, table. Baskets are good for holding fleece and fibre, and better still but out-rageously expensive, are very large plexiglass or perspex lid-less boxes.

8 Dyeing area (Chapter 4). Preferably in a separate room as dyeing is a wet, smelly and steamy process. There should be a composition floor, a drain and effective ventilation – either a big window, an ex-tractor fan, or hood and canopies over the vats, with an extractor system. Gas rings or electric plates can be placed on a surface which is easy to clean. Stain-less steel is the proper material for equipment and surfaces in both the dyeing and finishing area. It requires little cleaning, and all previous dye stains (which could be disastrous to a new dyeing) are easily removed. Mixing vessels and glass rods, dye buckets of varying sizes, large dye vats with U-rods for skeins, a double sink, a wringer or spin dryer. A bench with a good light for colour-matching, balances, dye recipe books and cards for dye mixing and matching. Cup-boards with locks for dyes and chemicals. A clothes-airer or drying cupboard. A glass-fronted (to protect from steam) bookcase for books and recipes. Plenty of cleaning cloths and scouring powder.

9 Knitting area with knitting machines (17) and knitting tables (15 [35]). Possibly one domestic single needle-bed, one domestic double needle-bed, one domestic single needle-bed with figuring attachment, one domestic single needle-bed with automatic transfer of stitches, one semi-industrial double needle-bed heavy gauge and one semi-industrial double needle-bed fine gauges (17).

10 Warping and winding area (Chapter 13). A warping mill (with heckblock and somewhere to fix the warp instruction card) for long warps; a warping board, either positioned flat or screwed to a wall, for medium warps; warping posts for small warps if other equipment is in use. Spool rack, skein winders, cone holder and a piece of winding equipment which will wind from skein to spool and spool to skein (this is also used in conjunction with dyeing). Hand or electric quill winders; ball winder for knitting yarns. These pieces of equipment are illustrated in diagram 15.

11 Worktable or tables. These should be sturdy, with washable and unscratchable surfaces, standing about 36in. high, with high stools for sitting. One drawer underneath to hold tools. The tables should take weaving frames and table looms, knitting machines, if necessary, pads for knotting, warping posts and sewing machine, and should give space for raddling, etc. There should be sufficient table space for any designer to have two or three projects in hand at the same time. This prevents too much putting away with the consequent loss of time and interruption of the train of thought. This method of working can also minimize mental fatigue: one can refresh oneself by moving from one design to another.

12 Loom rack, of adjustable shelving, to the depth of the deepest hand loom, fitted with a dust curtain. The rack could store other items, depending upon the extent of the equipment.

13 Weaving area (Chapter 13). A collection of weaving cards, wooden frames of all sizes, or wood sections which can be screwed up to frames of the desired size (74). One rigid heddle loom with one ordinary heddle and one gauze heddle. One four-shaft table loom and one eight-shaft table loom with two beams. One four-shaft 42-in. foot loom; one upright rug loom for rugs, tapestries and hangings. One 15-in. (sample) and one 42-in. (cloth), sixteen-shaft loom with two beams and a dobby attachment (16). Remember that if you wish to do fairly complex

work but can have only one loom, a 42-in. sixteen-shaft dobby will do everything. In the USA, the dobby mechanism does not appear to be widely used; in that case, for 'dobby mechanism' read 'jack loom', preferably a Macomber.

14 One or more movable trolleys to have at the side of a loom or desk, to hold tools and yarns.

15 Finishing area (Chapter 20). Scrutinizing and mending table, which comprises a sloping sheet of opaque glass, wider than the cloth, with a light beneath (15 [36]). The tools required in conjunction with this are weavers' scissors and blunt needles. Table for stretching finished hangings and panels on their frames and for stretching cloth on to finishing rollers (15 [25]), and for pinning out knitting, crochet, garment pieces, etc. Deep double sinks for washing and shrinking, wringer and spin dryer (this is the same equipment as already incorporated in the dyeing area). Ironing board, with steam iron or, better still but expensive, a flat steam press with head so that fabrics can either be pressed flat and smooth or given a raised finish (see Suppliers). The latter is a most satisfactory way of finishing cloth and if you can establish good relations with your local laundry they may let you use their equipment or, alternatively, let you supervise the finishing of your cloth by their operatives. Finishing rollers (15 [25]) and a drying cupboard. In time, cloth will dry naturally without the help of a drying cupboard.

16 A cloth-folding and packing table is only used in very big and busy establishments; otherwise, the various other tables are used.

17 Sundries and optionals. Dust covers made from sheeting or clear plastic to protect work. Waste bins, extra cupboards, photographic equipment. Duplicating equipment for taking copies of correspondence and for repeating design elements quickly. A tufting machine, which is like a strong sewing machine with an enormous needle or needles to take rug wools, for carpet design and for creating hangings. (Suppliers.)

Equipment chart (refer to 15, 16 and 17)

	Warping	Weaving equipment	Machine knitting equipment	Finishing of cloth yardage
Beginner – money and space available variable – as yet relatively unknowledgeable.	Warping Board screwed to wall.	Two-way rigid heddle table loom (Dryad, Leclerc). Two-way upright tapestry and rug loom (Dryad, Leclerc). Four-shaft 24in table loom (Dryad, Leclerc, Purrington). Four-shaft 42in foot loom (Dryad, Leclerc, Herald, Macomber). If a jack loom is chosen, more shafts can be added later.	Domestic single needle-bed machine with automatic transfer of stitches (Jones). Knitting table if you have the space (15[35]).	One finishing roller or have your cloth finished at a textile mill or wash it and then have it pressed or raised on a steam-press.
Student – little money and space – varied work – future expansion.	Set of warping posts which can be packed away; or make your warps at college.	Preferably second-hand 15in twelve or sixteen shaft floor sample loom, jack or dobby with two beams. (Macomber; or Callaghan plus Harris or Stansfield) or Second-hand 15in twelve or sixteen shaft table sample loom with two beams. (Harris or Purrington, the latter folds.) Remember you still have to find room and weaving is slower on a table loom	Second-hand domestic double needle-bed machine (packs away) or second-hand domestic single needle-bed machine with automatic transfer of stitches (packs away). (Jones, Brother, Passap, Knitmaster)	Finish your cloth at college.
Craftsmen in general – already knowledgeable – money and space available – variable.	Warping mill with heck block.	Twelve or sixteen-shaft 42in jack or dobby loom with two beams (Macomber; or Callaghan plus Harris or Stansfield). Twelve or sixteen-shaft 15in jack or dobby loom with two beams (Macomber; or Callaghan plus Harris or Stansfield) for sampling. Upright tapestry and rug loom (Dryad, Leclerc). Other looms, or duplication of the first would depend on space.	Semi-industrial double needle-bed, free-standing machine (Dubied).	Finishing roller or rollers; or professional cloth finishers; or obtain the use of a steam press.

18　Small tools (15) – tatting shuttles, crochet hooks, knitting needles, netting shuttles, all in various sizes. Weaver's kit, comprising reed hook, threading hook, shuttle quills, weaving needles, screw-driver, pointed pliers, blunt pliers, weaving scissors, ordinary scissors, tape measure, pins and needles.

Buying equipment

Before ordering a piece of equipment always try to see an example working and discuss it with the person who is using it. The manufacturers will generally install and give instructions on complex new equipment. Consider whether second-hand equipment is the answer for you and, if it is, read and advertise in the textile and craft journals and the newspapers. Don't collect equipment for the sake of it or you'll curse the dust and clutter. Decide upon your aims, consider what you need and go for it, rejecting everything that does not answer your requirements exactly.
A good thing to remember, if you have a small amount of money and space, is that simple equipment will only ever do simple things, while more advanced equipment will cope with anything, including the simple.

The beginner should not randomly acquire pieces of weaving and knitting equipment. Instead, it is desirable to have a session on first-class equipment either with a weaver or at the local guild or at an art school. The student will have equipment available at college; any he buys will have to serve for the future as well as the present. It would be sound policy to buy the best and most versatile, but second-hand, equipment.

Further study

Albeck, Pat *Printed Textiles* Oxford University Press, London, New York, Toronto 1969
Chetwynd, Hilary *Simple Weaving* Studio Vista, London; Watson-Guptill, New York 1969
Goslett, Dorothy *Professional Practice for Designers* Batsford, London 1961

Suppliers' catalogues
Books having information in them about making looms are:
Regensteiner, E. *The Art of Weaving* Studio Vista, London 1971
Tidball, H. *Build or Buy a Loom* Craft & Hobby Book Service, Pacific Grove, California, USA
Wilson, Jean *Weaving is for Anyone* Studio Vista, London; Reinhold, New York 1967

Suppliers

Office and drawing equipment
Abbott Bros, Abbess Works, Southall, Middlesex, UK
G. A. Harvey & Co Ltd, Woolwich Road, London SE7
Kaplan Furniture Ltd, 41 Paul Street, London EC2
Ryman Conran Ltd, 4 Langham Place, London W1

Looms and accessories
Dryad Ltd, Northgates, Leicester, UK *and* The Craft-tool Co, 1 Industrial Road, Wood Ridge, New Jersey, USA (table and foot looms and all accessories)
Harris Looms Ltd, North Grove Road, Hawkhurst, Kent, UK *and* Cooper Square Art Center, 37 East 8th Street, New York, USA (table looms, foot looms and looms for dobbies)
Herald Looms, Bailey Manufacturing Co, 118 Lee Street, Lodi, Ohio, USA (compact jack looms)
Macomber Looms, 166 Essex Street, Saugus, Massachusetts, USA (these looms are, without doubt, superb jack looms)
Nilus Leclerc Inc, L'Isletville, Quebec, Canada *and* 2 Montcalm Avenue, Plattsburg, New York, USA (a wide range of excellent looms)
Purrington Looms, Quivet Drive, East Dennis, Massachusetts, USA (folding looms, very useful if there is little space, or if one travels a lot!)
Messrs Stansfield, Almondbury, Yorkshire, UK (looms to take dobbies and Jacquards)

Loomcord
F. Uttley, Prospect Mill, Huddersfield, UK

Dobby mechanisms
Callaghan Renard Ltd, 5 East Street, Chichester,
 Sussex, UK (either foot-pedal operated or foot-
 switch semi-automatic)

Jacquard mechanisms
Wadsworth and Devoge Ltd, Manor Road, Droylsden,
 Manchester, UK

Dyeing equipment
Andrew Engineering and Development Co Ltd,
 Bulwell, Nottingham, UK
Platt International Ltd, Dewsbury Road, Leeds, UK
Samuel Pegg & Son Ltd, Barkby Road, Leicester, UK

Domestic knitting machines
Jones Sewing Machine Co, 964 High Road, Finchley,
 London N12, UK and Brother International
 Corporation, 680 Fifth Avenue, New York, USA
Knitmaster Ltd, 32 Elcho Street, Battersea, London
 SW11, UK and Sears Roebuck, USA

Industrial knitting machines
Universal Knitting Machines, Oswald Donner Ltd,
 13 Jarrom Street, Leicester, UK and Universal
 Knitting Machine Corporation of America,
 2849 Fullton Street, Brooklyn, New York, USA
Dubied Machinery Co Ltd, Northampton Street,
 Leicester, UK and 21–31 46th Avenue, Long Island
 City 1, New York, USA

Small tools for weaving, knitting, crochet, netting,
lace, spinning, etc.
Dryad Ltd, Northgates, Leicester, UK

Venor tufting machines
David Almond Ltd, Waterfoot, Rossendale,
 Lancashire, UK

Pressing machinery
Ibis Engineers Ltd, Ibis Works, Kendall, West-
morland, UK

Spinning wheels and spinning accessories
Ashford Handicrafts Ltd, PO Box 12, Rakaia, New
 Zealand (spinning wheel kit)
Nilus Leclerc Ltd, L'Isletville, Quebec, Canada
Peter Teal, Spinning Wheel Maker, Mill House
 Studios, Parracombe Mill, North Devon, UK
Dryad Ltd, Northgates, Leicester, UK

Cloth finishing
T. M. Hunter Ltd, Brora, Scotland

4 Raw materials, yarn production and dyeing

(19) Fibre characteristics and identification charts

Raw materials

The original natural raw materials available to the textile constructor were either of animal, mineral or vegetable origin, all of them fibrous, with staple (average length of fibre) of varying lengths (20), and all with very individual characteristics. Silk is the exception being a continuous filament. They include: cotton, linen, jute, hemp, ramie, coir, sisal (vegetable), wool, silk, mohair, camel hair, rabbit hair, cashmere, vicuna, alpaca (animal), and asbestos (mineral). In order to ascertain the suitability of a particular natural raw material for a particular purpose it is helpful to categorize their characteristics and some simplified results can be seen from the chart on the opposite page.

When man needed to create textile raw materials of his own, it is interesting to note that at first he tried to emulate nature in technique and result (artificial silk or rayon). Even the highly sophisticated contemporary technology finds that it must constantly re-examine the qualities of natural materials in order to make the synthetic acceptable. In general, man-mades are processed from the liquid of raw materials such as wood-pulp, or oil and coal by-products plus chemical additives. The liquid is extruded under pressure as a fine jet or film, and converted into fila-

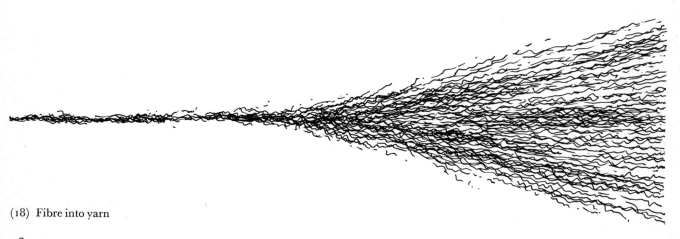

(18) Fibre into yarn

Burning tests

Hold the sample near a flame. If it does not melt it is one of the non-thermoplastic group (natural and rayon fibres).
If it does melt it is one of the thermo-plastic group (synthetic and acetate fibres).

To test the non-thermoplastics: burn the sample and immediately blow out the flame.			To test the thermoplastics: observe how the sample burns before extinguishing it.		
Smell – burnt paper. Ash – negligible	Smell – burnt hair. Ash – inflated, bulbous, soft	Smell – bad fish Ash – forms a blackened skeleton	Burns with difficulty, on extinction smells like celery	Burns readily with luminous flame, without soot	Burns with luminous sooty flame; bead on extinction
Rayon Spun Rayon Cotton Linen	Silk Spun Silk Wool	Resin-finished Rayon or Cotton	Nylon	Acetate Tricel	Terylene Acrilan Courtelle

Some natural fibres

Fibre	Colour	Staple	Characteristics
Cotton	White to off-white to fawn	Up to 2in.	Smooth. Fairly lustrous. Very moisture-absorbent. Dyes well. Launders well. Cool.
Wool	Cream-white to brown-black	Up to 10in.	Strong, resilient. Scaly fibre surface. Grease helps spinning. Crimp traps warm air.
Silk	White (cultivated) Coffee (wild)	Continuous filament	Extremely lustrous. Light, soft, airy. Dyes well. Fine. Elastic.
Linen	White when processes completed	Up to 20in.	Very lustrous. Strong. Dyes well. Launders beautifully.
Jute	Yellow-brown	Up to 36in.	Not over-strong. Cannot be bleached. Spun coarsely for sacking, etc.
Sisal	Ivory white	Up to 48in.	Very coarse and strong. Used for rope.
Mohair	Creamy white	4–6in.	Strong, lustrous, resilient. Not as much crimp as wool.

Some man-made fibres

Type	Brands	Characteristics
Acetate (filament and staple)	Dicel Lansil Lancola Celafibre Fibroceta	Soft handle. Silk-like. Useful as a blend. Takes special dyes for piece-dyeing.
Triacetate (filament and staple)	Tricel Tricelon	Silk-like. 'Easy care'. Heat set. Shape retention. Often blended.
Acrylic (staple)	Acrilan Courtelle Orlon Sayelle	Warm handle. Wool-like.
Modacrylic (staple)	Teklan	Flame-proof (used to simulate hair).
Elastofibres (filament)	Lycra Spanzelle	Used doubled with other fibres for swimwear, corsetry, etc.
Nylon (filament)	Bri-Nylon Enkalon Tendrelle Blue C Bri-Nova Shareen	Incredibly strong. Quick-drying. Shape retention. Excellent heat-setting property
Nylon (staple)	Bri-Nylon	Generally used as a blend with other fibres to increase abrasion resistance.
Polyester (filament and staple)	Terylene Crimplene Diolen Terlenka Trevira Lirelle	Very strong. Often bulked.
Viscose (filament)	Delustra Tenasco Ribbonfil	Medium strength.
Rayon (staple)	Fibro Darelle Evlan Sarille	Medium strength. Often blended. Crimped and deep-dyed for piece-dyeing.
Rayon (staple high wet modulus)	Vincel	Resembles cotton and often used as replacement.
Olefin Polyethylene Monofilament	Courlene	Strong (deckchairs, matting).
Polypropylene Monofilament (staple, tape fibrilated)	Spunstron Cournova Fibrite	Strong. Ropes. Sacking. Carpet backs. Industrial uses.

Charts compiled from information supplied by British Man-Made Fibres Federation.

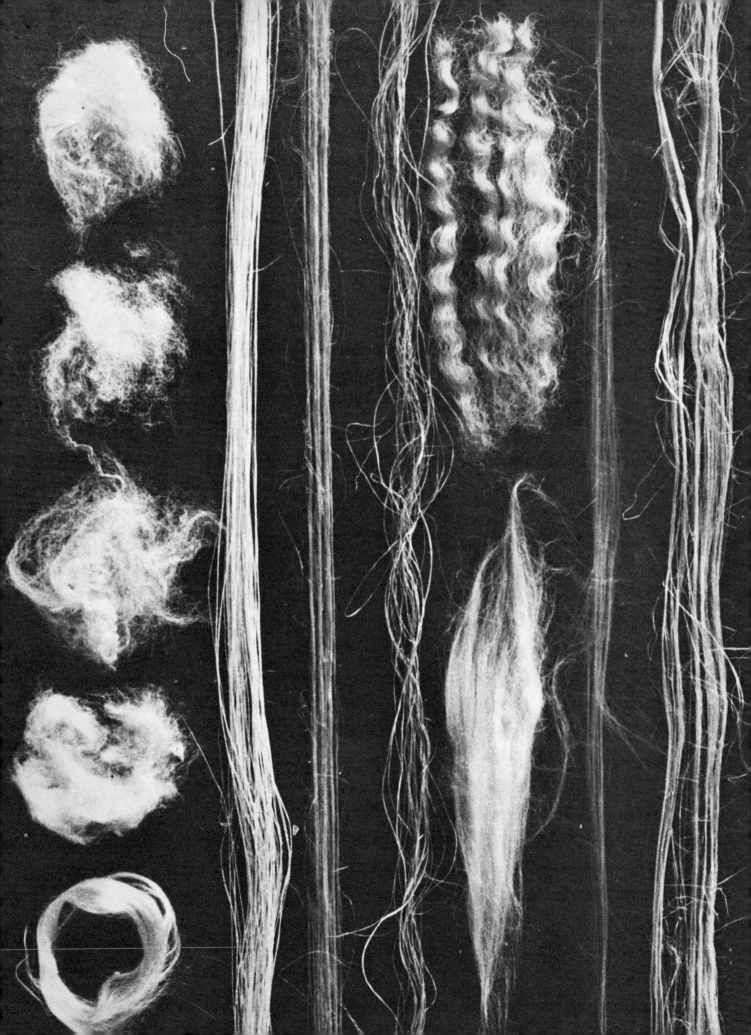

ments. It is then either left in filament form, in which case many filaments are twisted together to make a viable yarn, or chopped into a simulated staple, crimped, possibly de-lustred, dyed (although this can be done in the liquid stage), spun like a natural fibre, and generally made attractive, practical and commercially viable.

Man-made materials fall into various groups: viscose type, which are regenerated mainly from wood pulp (e.g. Fibro, Evlan); acetates and triacetates, which are semi-synthetics (Dicel, Tricel); and true synthetics polyamides (nylon, Enkalon), polyesters (Terylene, Trevira), acrylics and modacrylics (Courtelle, Orlon, Acrilan), and polyolefins (polypropylene and polyethylene). Again, some very simplified results can be seen from the chart on page 37. The charts deal briefly with some categories and basic properties of raw materials. Proper understanding can only be attained by study, handling, comparisons, identification tests (19), and then manual translation into yarn and finally into cloth. Often the ideal solution to a textile problem is to blend natural and man-made fibres together, thus enjoying the properties of both.

Kay Sekimaki, with her fine black monofilament double and treble and quadruple weaves, opened out and drawn up into shapes, exploits as beautifully as anyone ever has, the fine linear delicacy of man-made filaments (120).

Yarn production

Fibre requires preparation for spinning. Spinning is the drawing out of the fibres to a required density, which will determine the bulk or fineness of the yarn, and the imparting of twist for strength. Preparation includes (if we take wool as an example), the following processes:

Sorting The fleece is unrolled and opened out, taking on again the shape of the animal it came from, but in a slightly larger version. It is then sorted into different grades: e.g. wool near the tail and legs will be in poorer condition and of a different texture to the wool on the back. Different grades of wool are used for different end products (21 [3]).

Teasing The fibre is then taken into the fingers, bit by bit, and opened out, to allow all dirt and rubbish to fall away. Teasing is a process needing time and care and is best done over a white surface to make sure that the fibre is clean and to see the dirt particles dropping away. All the foreign matter must be removed or it will be incorporated in the resulting yarn, with undesirable results.

Carding This process lays the teased fibres side by side. A pair of carders is needed, each one being a piece of wood, about $5 \times 8 \times \frac{3}{8}$ in., with a handle set in the middle of the longer side. On to the flat surface is nailed a piece of leather cut to the same size, into which has been set a surface of wire hooks. A small amount of teased fibre is placed on to one carder, and the handle is grasped in the left hand but held 'inwards' so that the carder itself is lying back along the arm (21 [4]). With arm and carder outstretched, the second carder, held normally and firmly, and with the index finger pressing on the back of it, is dragged lightly across the first carder in the direction of the handles. The action is repeated until the fibre is carded. This is a light process and when the fibre is removed from the carders (21 [5]) and given a slight roll (this is called a rolag [6]) the result should be a light, airy, clean, chrysalis-shape of fibre, ready for spinning. In machine carding, which is roughly the same process achieved by vastly different means, it is at this stage that the difference between woollen and worsted yarns is achieved. For woollens all the fibres remain; for worsteds the short fibres are removed entirely, leaving only the long fibres, with a consequent increase in smoothness and lustre.

Spinning The earliest and simplest spinning implement was the spindle, (21[1]). A spindle is a tapered stick about 10in. or 12in. long with a weight near its base and a notch at the top. (It can be simulated with a stick and a potato.) It is most important that it is

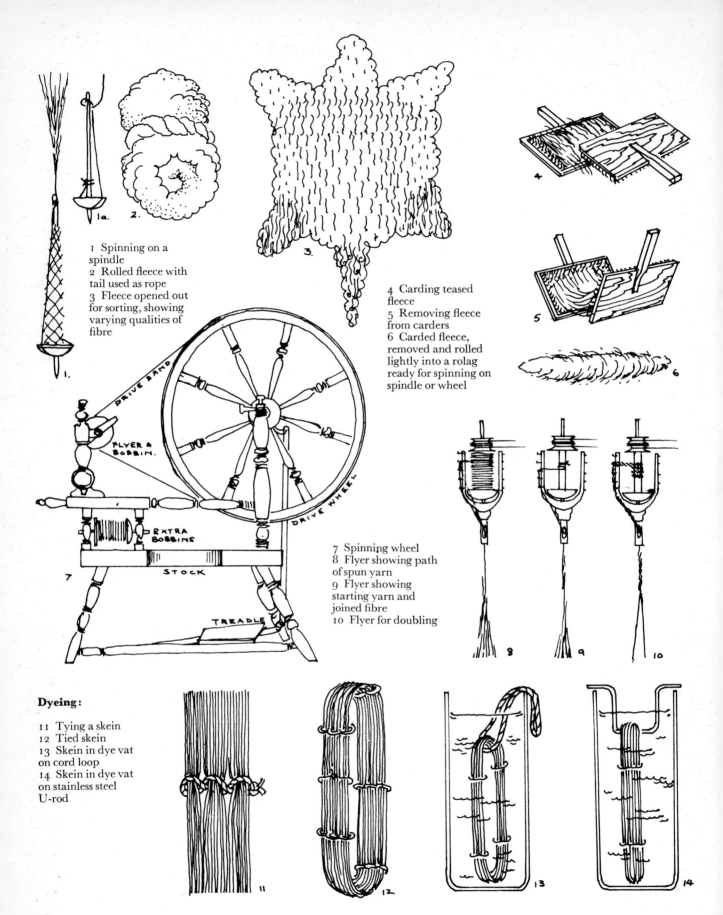

1 Spinning on a
spindle
2 Rolled fleece with
tail used as rope
3 Fleece opened out
for sorting, showing
varying qualities of
fibre

4 Carding teased
fleece
5 Removing fleece
from carders
6 Carded fleece,
removed and rolled
lightly into a rolag
ready for spinning on
spindle or wheel

DRIVE BAND

FLYER &
BOBBIN.

EXTRA
BOBBINS

STOCK

TREADLE

DRIVE WHEEL

7 Spinning wheel
8 Flyer showing path
of spun yarn
9 Flyer showing
starting yarn and
joined fibre
10 Flyer for doubling

Dyeing:

11 Tying a skein
12 Tied skein
13 Skein in dye vat
on cord loop
14 Skein in dye vat
on stainless steel
U-rod

properly balanced. A length of already spun wool yarn is tied to the middle of the shaft of the spindle, hitched around the notch, and then held in the left hand allowing the spindle to hang from the hand (21[10]). The rolag (21[6]) is taken into the right hand, some of the fibres are drawn gently out (18), and then these fibres are placed alongside the last few inches of the yarn coming from the spindle. The spindle is then set turning in the same direction as the twist of the yarn. This action twists the fibres with the yarn, joining the two together. More and more fibre is drawn gently from the rolag (not so far as to break the fibre mass) and twist imparted by the turning of the spindle. The spindle must be kept steady and must never reverse itself. Drawing out and twisting continues until the spindle nearly touches the ground with the amount of spun yarn produced. The yarn is then wound criss-cross onto the spindle, like cross-gartering, hitched around the notch at the top of the stick to make it firm, and production continues once more. The beginner should not worry about any lumps and bumps – the first essential is to get a continuous yarn; a smooth yarn comes later with practice.

To achieve an understanding of yarn and fibre it is invaluable to learn to spin by hand. Production will be speeded up when you move on to a spinning wheel. You can buy either an antique spinning wheel or a new one. However, an antique may well need to be repaired as they are fragile, and have small pieces which can easily get lost. Before attempting to spin familiarise yourself with the wheel (21[7]) by just treadling (start turning the wheel with your hand). The art is to see how slowly you can make the wheel turn without it losing momentum. If the wheel turns fast, the fibre will be taken in too rapidly and you will lose control. If the wheel turns slowly, and the fibre is therefore taken in gently, you will have plenty of time to manipulate it. As with the spindle, a length of existing yarn is attached to the bobbin, drawn over a guide hook and through the metal eye to the front of the wheel. The fibre from the rolag is drawn out, attached to the yarn, and the wheel set in motion (21[9]). Remember that the wheel takes the fibre in and gives it twist (strength) and the spinner's job is to concentrate

on drawing out between the left and right hand the correct amount of fibre for the desired yarn. One finds all one's fingers are needed for this, acting as a sort of opening-out comb and regulator.

The result of one spinning is a 'singles' yarn. Two or more singles, fed into the wheel and twisted together in the opposite direction for more strength and bulk, result in plyed or doubled yarns (21[10]). A plyed yarn with the twist to the left is called S twist, and one with the twist to the right is called Z twist. From here we move on to all sorts of fancy yarns. The decorative effects are produced by the quality of the raw material or materials; the density of fibre, which can be regular or irregular; the amount of twist in the component yarns; the relative speeds at which they are twisted together; and the way in which it is done (23). Fancy yarns add immeasurably to the tactile and visual interest of a fabric, but increase the cost.

Methods of industrial spinning (ring, cap, mule and flyer) are high-speed versions of hand production, i.e. pulling prepared fibre out to a required density, giving it twist and winding in onto a spindle preparatory to doubling it in various ways. It is essential for the designer to have a copious collection of yarn samples (24). Begin with the suppliers' sample cards and then continue to add samples of interesting yarns, remembering to keep records of the fibre content, count, description, supplier and cost. Yarn count is the means by which the size of yarns is described.

Allen and Dorothy Fannin and Susan Weitzman, all of New York, are great exponents of hand spinning in a fine art context (8).

Dyeing

Colour can be added to textiles at almost any stage: to the fibre, to the spun yarns, or to the finished cloth. The designer most often needs to dye at the yarn stage, as no matter how good the range of colour from the yarn suppliers, there will often come moments when these are not satisfactory.

The earliest and oldest method of dyeing is known as natural dyeing; 'vegetable dyeing', a name by which this is sometimes known, is something of a misnomer, as some of the elements are animal and mineral. It is a fascinating study with beautiful results and a valid and useful method for the textile constructor who requires small quantities of yarn and to whom matching batches of colour may not be essential. However, in practical terms to those whose textile output is considerable it may be little more than an aid to the understanding of colour and a basic exercise in the imparting of it. In this function it is, like hand-spinning, invaluable and one uses natural ingredients which are easily obtainable. The resulting colours are invariably aesthetically satisfying but, unfortunately, sometimes fugitive and very difficult to match accurately.

Synthetic dyes which are fast and capable of accurate matching are more practical. The dyes currently on the market are good (Dylon and Rit) and full instructions are always provided. The colour ranges, however, are sometimes limited. The dye method generally involves the dye, a fixing agent, and hot or cold water. The dyes produced by and for industry offer a far greater colour range and dyes can be found which are suitable for every variety of raw material; controlled conditions may well be required in which to operate, both for accuracy and safety (Chapter 3, Dye Room).

Whatever the method used there are some general 'do's and dont's' which should be observed if even dyeing is to be achieved. Before dyeing, if the yarn is in spool form, wind it from the spool to a skein on a skein winder (15[24]); do not make skeins too bulky; secure the ends of yarn by taking both ends and tying around the skein fairly loosely (21[12]). Tie the skein around four extra times in 'figure of eight' form, with plain, strong, white cotton, fairly loosely (21[11]) (skeins tied too loosely will tangle, skeins tied too tightly refuse the dye and one would be inadvertently producing 'tie and dye'). Weigh the yarn and bring to a level weight if necessary with some extra yarn (this makes the dye recipe simpler). String the skeins together in manageable bundles. The string should be of sufficient length to hang over the side of the dye bath (21[13]) and very strong (otherwise hang skeins on stainless steel U-rods [21(14)]). When dyeing fibre together with yarn put the fibre in a muslin bag. Soak the yarn in water overnight or in water and a wetting agent (e.g. Lissapol) for two hours, making sure that the yarn is well below the surface of the water. Wring the yarn by hand when the dye bath is ready and dye by the chosen method, keeping the yarn gently moving during the process. After dyeing, remove the yarn from the dye vat and rinse it in double sinks until the rinsing water is absolutely clear. Wring by hand. Straighten each separate skein while wet by inserting your hands and thumping them apart, hard. Dry slowly in a gentle warmth.

To begin experimental dyeing, try the following natural dye recipe to dye wool yellow, chosen because it can be carried out with easily obtainable elements:

Dissolve 25gm alum (obtainable from the chemist) in a vessel containing sufficient water to immerse 1,000gm of wool with plenty of room to spare. When the water is warm enter 1,000gm of wool fibre or yarn (well washed, and if the wool contains grease, remove the grease completely with soft soap and ammonia in the initial washing water). Heat the water and boil for one hour. Allow the whole thing to cool and then wring the wool by hand. The wool is now mordanted, that is, in a state to secure and hold the dye. Now put a quantity of onion skins into a vessel containing the same

(23) Fancy yarns

1 Wool cloud yarn
2 Wool heather mixture
3 Cotton snarl
4 Nylon filament
5 Wool roving
6 Plastic-coated nylon
7 Cotton gimp
8 Cotton knop
9 Mohair loop
10 Grandrelle
11 Wool spiral
12 Cotton piping cord
13 Gimp incorporating a slub yarn
14 Chenille yarn (Furwul)
15 Textured Taslan
16 Chenille yarn
17 Two-fold wool
18 Cotton gimp
Photo Alan Hill

(24) Yarn packages and other materials
1 Cheese of glass yarn
2 Pirn of rayon and lurex grandrelle
3 Stacked perspex tool boxes for beads
4 Wool skein
5 Wooden bobbin of mohair loop yarn

amount of water as before. Warm the water, enter the wool, raise to boiling point and boil for thirty minutes. Remove the wool from the dye liquid. The onion skins should have dyed it a clear glowing yellow colour. Rinse the wool until the rinsing water is clear, wring by hand and dry.

Now to move on to working with the synthetic dyes, beginning with those on sale to the public as cold and hot water dyes (Dylon and Rit – the instructions for application comes with the dye), and then to the dyes produced by the chemical companies for the specialist (Ciba and ICI Dyes – colour samples and recipes are obtainable from retail suppliers). Always keep a dye recipe card as (22) in a card index file to ensure accurate matching.

To diversify, try the following experiments and then make up a few of your own. (*i*) Tie a skein of yarn *very* tightly in several places, at random or in a pattern. When you dye, the yarn will refuse the dye where it has been tied tightly (tie and dye). (*ii*) Hang a skein of yarn half in and half out of a dye bath and dye. The skein can be left half coloured half white, or the other half can be dyed a different colour, or the whole thing dyed a different colour. (*iii*) Dye some cotton (or linen, or wool) yarn, fibre and cloth together in one dye bath to see how differently the same material turns out when dyed in a different form.

For the weaver, a very good time-saver when designing on the loom is, as mentioned in Chapter 1, to stain a white warp either with one colour at a time or with several different colours in sections. This obviates a lot of extra setting up of warps, and is most successful on cottons and some man-mades, though less successful on wool because of its moisture-resistance. Dissolved dyes (Procions are excellent) are used and applied to the warp with a wad of cotton wool. Always protect the loom carefully from dye-spots when doing this. Dry the warp gently with a heater or stain the warp the night before you require it. And remember, the resulting samples cannot safely be washed, but some preliminary design decisions have been reached before more orthodox dyeing is undertaken.

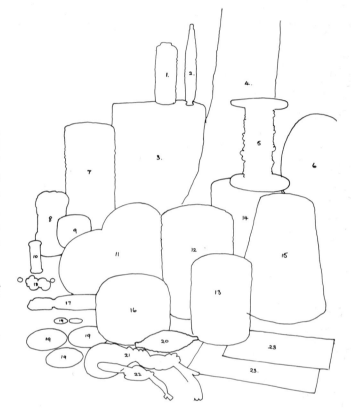

6 Reel of plastic tape
7 Cheese of jute roving
8 Machine wound and banded knitting wool
9 Ball of crochet cotton
10 Reel of lurex
11 Wool hank
12 Cheese of textured Taslan
13 Cheese of sisal string
14 Cheese of polypropylene
15 Cone of cotton
16 Wool wound for knitting (end from inside) on a domestic ball-winder
17 Hank of raffeine
18 Beads
19 Paillettes
20 Quill wound for roller shuttle
21 Plastic tubing
22 Lurex cord, with cotton core
23 Yarn sample cards
Photo Alan Hill

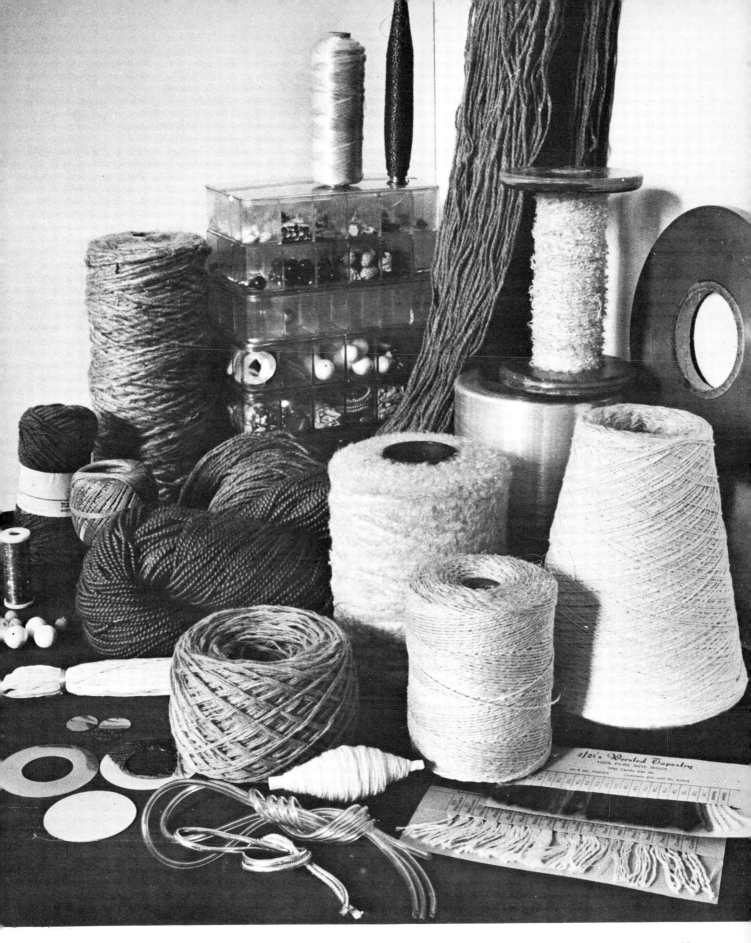

Suppliers

Raw materials
Davies-Watson, 15 Birdwood Road, Lower Hutt, New Zealand (wool)
Dryad Ltd, Northgates, Leicester, UK (various fibres)
Greentree Ranch, Box 461, Loveland, Colorado, USA (various fibres)
Hugh Griffiths, Brookdale, Beckington, Bath, UK (various fibres)
Ohio Wool Growers Association, 3900 Groves Road, Columbus, Ohio, USA (fleece and roving)

Yarns, etc.
Angora Ltd, Carr Mills, Birstall, Leeds, UK (wool, mohair, angora, nylon, Courtelle)
Eagle Jute Mills, Dundee, Scotland (jute fibre and yarn)
Ells & Farrier, 5 Princes Street, Hanover Square, London, UK (beads, fringes, sequins, braids)
Hugh Griffiths, Brookdale, Beckington, Bath, UK (an extremely wide variety of weaving yarns)
J. Hyslop Bathgate & Co, Galashiels, Scotland (weaving and knitting yarns)
Winwood Textile Co, Lisle Avenue, Kidderminster, UK (carpet yarns)
Lee Wards, 840 N. State, Elgin, Illinois, USA (craft materials)
Dryad Ltd, Northgates, Leicester, UK (most craft materials)
Holma-Helsinglands, A. B. 82065 Forsa, Sweden, sole agents in Britain William Hall (linen yarns, bleached, natural and dyed)
Hermit Wools Ltd, 89 Caledonia Street, Bradford, UK (knitting wools)
Atlas Handicrafts Ltd, Manchester 4, UK (raffeine and novacord)
Texere Yarns, 9 Peckover Street, Bradford, UK (handloom weaving yarns)
William Hall & Co (Monsall) Ltd, 177 Stanley Road, Cheadle Hulme, Cheshire, UK (spinners of a wide variety of yarns)
Daniel Illingworth & Sons, Whetley Mills, Bradford 8, UK (worsted yarns)

George M. Whiley Ltd, Victoria Road, Ruislip, Middlesex, UK (metallised film in sheet form)
E. Wykes & Sons, Barkby Road, Leicester, UK (elastic yarns)
A. K. Graupner, Corner House, Valley Road, Bradford, UK (wool, mohair, alpaca, odd lots)
T. M. Hunter, Brora, Scotland (Scottish tweed wools)
Craft Yarns of Rhode Island, 603 Mineral Point Avenue, Providence, Rhode Island, USA
Shuttlecraft, PO Box 6041, Providence, Rhode Island, USA
Borgs of Lund, PO Box 96, Lund, Sweden (wool, cowhair, linen)
P. C. Herwig, 264 Clinton Street, Brooklyn, New York, USA
Lily Mills, Shelby, North Carolina, USA (excellent for cotton yarns)
The Yarn Depot, 545 Sutter Street, San Francisco, California, USA
Frederick Fawcett Inc, 129 South Street, Boston, Massachusetts, USA (very good for linens)
Countryside Handweavers, Estes Park, Colorado, USA (Swedish rug yarn)
Contessa Yarns, PO Box 37, Lebanon, Connecticut, USA

Dyes
Dylon and ICI Procion from Dylon International Ltd, 139 Sydenham Road, London SE26
RIT Dyes from most stores (US)
Dylon Dyes from most stores (UK) and Dryad Ltd, Northgate, Leicester, UK
Natural Dyes and Ciba Dyes from Comack Chemicals, Moon Street, Islington, London N1
Natural Dyes from Dominion Herb Distributors Inc, 61 St Catherine Street West, Montreal, Canada
ICI Dyes from Skilbeck Bros Ltd, 5 Glengall Road, London SE15, UK
 and Pylam Products Co, 95–10 218th Street, Queens Village, New York, USA
 and Terra Cotta, Inc, 892 Massachusetts Avenue, Cambridge, Massachusetts, USA
 and Will Balk, Jr, 2147 'Q' Street NW 406, Washington, DC 20037, USA

and Fibrec Dye Center, 2795–16th Street, San
Francisco, California 94114, USA
Ciba Dyes from Ciba Chemical and Dye Co,
Fairlawn, New Jersey, USA
Procion Dyes from Glen Black, 1414 Grant Avenue,
San Francisco, USA

Dyeing equipment
Platt International Ltd, Dewsbury Road, Leeds, UK

Spinning wheels and accessories
Ashford Handicrafts Ltd, PO Box 12, Rakaia, New
Zealand (wheel kit)
Dryad Ltd, Northgates, Leicester, UK
Nilus Leclerc Ltd, L'Isletville, Quebec, Canada
Peter Teal, Mill House Studios, Panacombe, N Devon,
UK
Clemes & Clemes, 665 San Pablo Avenue, Pinole,
California, USA

Spinning kits (spindle, carders, wool)
Greentree Ranch, Box 461, Loveland, Colorado, USA
Spincraft, Box 332, Richardson, Texas, USA

Carders
Frye & Son Inc, Wilton, New Hampshire, USA

Further Study

Raw materials
Gale, Elizabeth *From Fibres to Fabrics* Allman, London
1968
Miller, Edward *Textile Properties & Behaviour* Batsford,
London 1968
Information sheets
British Man-Made Fibres Federation, 58 Whitworth
Street, Manchester, UK
British Wool Marketing Board, Kew Bridge House,
Brentford, Middlesex, UK
Cotton, Silk and Man-Made fibres Research
Association (Shirley Institute), Manchester, UK
The Woolbureau Inc, 3 Lexington Avenue, New York

Yarn production
Channing, Marion *The Textile Tools of Colonial Homes*
35 Main Street, Marion, Massachusetts, USA 1969
Davenport, Elsie *Your Handspinning* Sylvan Press,
London 1953
Fannin, Allen *Handspinning, Art & Technique* Reinhold,
New York 1971
Gale, Elizabeth *From Fibres to Fabrics* Allman, London
1968
Hooper, Luther *Handloom Weaving* Pitman, New York,
London 1920
Kluger, Marilyn *The Joy of Spinning* Simon Schuster,
New York 1971
Spinning Wool Dryad Press, Leicester, UK
Thompson, G. B. *Spinning Wheels* Ulster Folk
Museum, Belfast, Northern Ireland 1966
Watson, William *Textile Design and Colour* Longmans,
London, New York, Toronto 1920
Worst, Edward *Dyes and Dyeing* Craft & Hobby Book
Service, Pacific Grove, California USA 1970

Dyeing
Davenport, Elsie *Your Yarn Dyeing* Sylvan Press,
London 1955
Lesch, Alma *Vegetable Dyeing* Watson-Guptill, New
York 1970
Mairet, Ethel *Vegetable Dyes* Faber & Faber, London
1916
Thurston, Violetta *The Use of Vegetable Dyes* Dryad
Press, Leicester, UK

Information sheets on dyes
Dylon International, 139 Sydenham Road, London
SE26 and most stores, UK ICI Dyes Suppliers
RIT Dyes, most stores USA

5 Simple beginnings, winding and wrapping

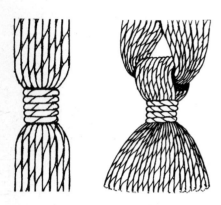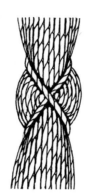

(25) Winding and wrapping

(26) Close up of three-dimensional hanging, Irene Waller. Photo Edward Martin

Fibre and yarns are so delightful in themselves that one can be absorbed in just looking and handling without immediately wanting to do anything further with them at all. Our own hair makes strands and the handling of them is an integral part of everyone's tactile experience, consciously or not.

Make a series of experiments to highlight and get to know the qualities of fibres, filaments and particularly yarns of all kinds. Take a series of squares cut from card (white or black), perspex, glass, metal or wood, and around each one wind a different sort of yarn in such a way as to achieve the maximum visual appreciation of each individual yarn's qualities. You will probably find that you have treated each one slightly differently. Take a yarn which you find pleasing and wind it from side to side of a square or circular frame in various ways to see what patterns you can form. Produce visual experiments with as many different yarns as possible – it will teach you a great deal. Place hair, filaments or fibre against a window or on perspex, glass or card; push it together and tease it out, and then secure it with hair spray or diluted PVA. Unravel frayed ends of thread and see what you have.

Now follow Anni Albers' dictum and 'just take strings and work with them'. In a chapter on 'tactile sensibility' Mrs Albers puts forward the idea that our sense of touch has become dulled because in so many parts of life – cooking, building, dressing – the end product is produced for us complete and we take less and less part in the formation of things. Our sense of touch is stunted and with it those creative and formative faculties which should be stimulated by it. Anni Albers believes that it is for textile designers in particular to revivify this sense 'in order to regain a faculty that once was so naturally ours'.

Wrapping yarn around itself, or wrapping it with another yarn, is one of the simplest steps forward, and the results are textile forms with which we are already familiar in the form of cotton reels, bracelets, embroidery skeins, tassels, belted clothes, whipped rope-ends and parcels.

The correct technique for neat wrapping or binding (whipping) for a solid area is as follows. Lay the end

(27) Three-dimensional
hanging, Irene Waller.
Threads trapped between
acrylic sheet, 11ft × 3½ft.
Photo Edward Martin

(28) Mural for Weoley
Castle Community Church,
Birmingham, Irene Waller.
Thread wound on perspex
shapes, 15ft × 7ft. Photo
John Moffat

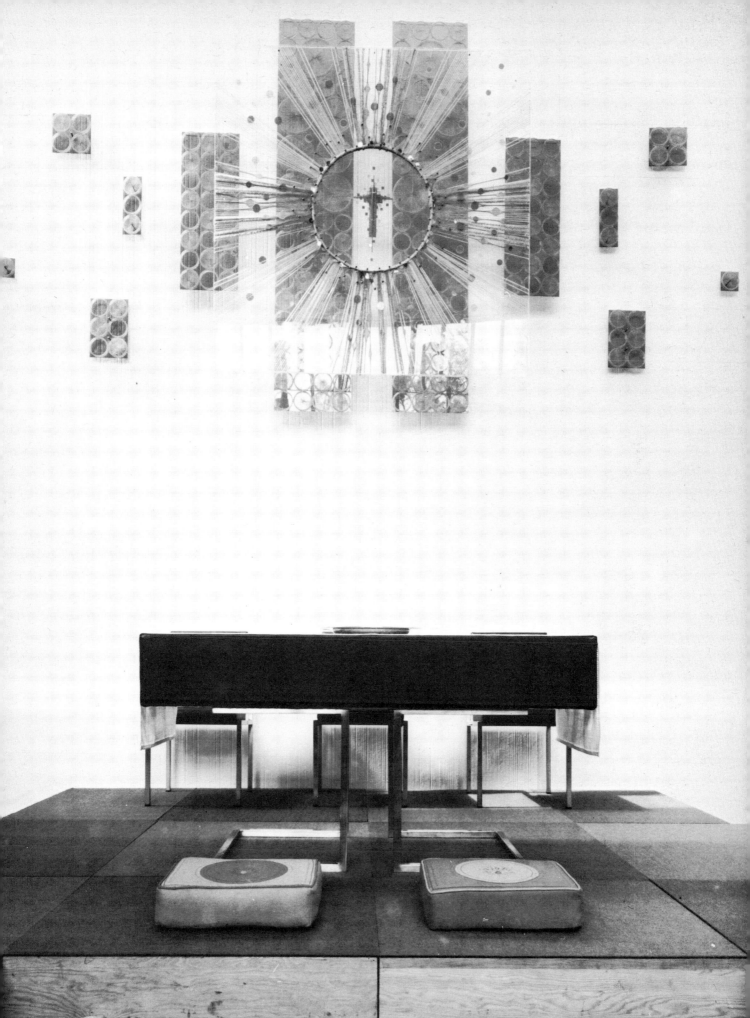

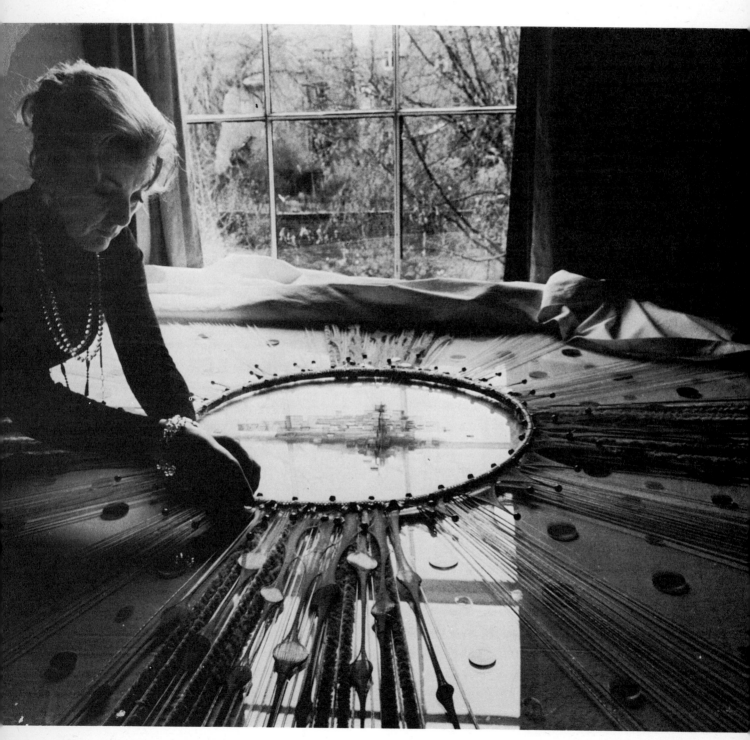

of the wrapping yarn along the length of the material to be covered; bring the wrapping yarn at right-angles to itself by holding firmly; begin to bind, round and round, taking care that each round lies neatly beside the one before; bind to half-way. Now lay a doubled loop of any strong yarn along the remaining length of the area to be wrapped, with the loop at the far end; continue binding leaving the two ends projecting. When the binding is finished insert the end of the wrapping yarn through the loop which is still projecting and pull the two free ends of the loop, drawing the end of the wrapping yarn under the wrapping and out at the middle of the wrapped area. The loop is then discarded and the end of the wrapping yarn snipped off.

Take a skein of yarn, a handful of strings, some linen or jute fibre (long staple), or even rolled cloth; bind it around tightly and regularly with some yarn, as regularly as cotton on a reel. The result will be a rod-like structure (see jacket). Bind it in patterns; cross-garter it; pay as much attention to the areas you don't bind as the areas you do and let them balloon out; cut across the ballooning areas with scissors so that the yarns spring out like tassels (25). Wind with wool, with silk, with wire, with cord, with ribbon.

Warp wrapping is a tapestry method of winding a colour around one single warp end to delineate a shape or area (Chapter 14). But try warp wrapping on a frame or a loom, over one end, then over two, or three; then merge with other single wrapped ends; then divide again, and so on. Almost tree-like forms will emerge.

Make some simple tassels. Cut a bunch of lengths of wool, say 8in. long; tie them once, tightly in the middle; place a large marble or wooden bead or polystyrene ball on the tie and smooth the lengths round and over it, holding the bunch of yarn beneath the ball tightly. Then carefully wrap it around with another yarn to keep the ball in place. Make some more ambitious tassels: long, short, thick, floppy, decorated (see Thérèse De Dillmont's *Encyclopaedia of Needlework*).

Make a ball using two circles of card, say 3in. across, with a 1in. hole cut in the middle of each.

Wind thick yarn (bulked yarns are good for this) round and round the double cards until you can force no more thread through the hole. Then cut carefully around the perimeter of the circle, insert a tying thread between the pieces of card, tie tightly and remove the cards by tearing them.

Make a sea or landscape, or abstract, by covering the entire surface of a rigid card with one-colour string laid or coiled to the contours of the design. This will demonstrate the effect of light, and the lustre and the direction of the yarn. Do the same with fibre and with textured yarn.

Sheila Hicks is one of the great exponents of these techniques. She uses variations of tasseling in her 'Prayer Rug' series; rod-like wrapping in her cascading linen and silk wall covering (jacket), and in her woollen ball and rod structures; winding in her wall covering of wound silk discs for the Ford Foundation, New York.

Clare Zeisler uses wrapping to make strong sculptural forms, immense in their impact. See in her 'Slinky' (52). Allen and Dorothy Fannin and Susan Weitzman all use yarn itself, sometimes almost totally unworked, to produce textural areas of tremendous delicacy and sensitivity (8).

The photographs accompanying this chapter set out to show how the very simplest manipulation of yarn has been used in large contexts.

Further study

De Dillmont, Thérèsè *Encyclopaedia of Needlework* Editions Thérèsè de Dillmont, Mulhouse, France 1930 (Information on tassels)

Hartung, Rolf *Creative Textile Craft* Batsford, London; Reinhold, New York 1966

Kaufman, Ruth *The New American Tapestry* Reinhold, New York 1968

Seyd, Mary *Designing with String* Batsford, London 1967

plus the books on Knotting in Chapter 6.

PVA from artists' supply stores

(30) Knots: overhand knot, reversed double half-hitch square knot, fisherman's knot

6 Knotted fabrics: netting, macramé and tatting

Knotting

Knots are, both in themselves and in the fabrics in which they are used, quite complex structures. But they are mentioned early in the book because one will come to the knot as a form of decoration and construction very quickly when beginning to manipulate thread.

Making a knot is usually defined as intertwining two parts of the same piece of cord, or two or more different cords, in such a way as to fasten them together. To the textile constructor the knot is something which allows him to create open fabrics with considerable strength and it is also immensely decorative, lending itself to all sorts of exciting design concepts. The following three types of fabric construction – netting, macramé, and tatting – all use the knot as an integral part of their structure.

Netting

Because knots are firm and immovable, they form the principle element in the production of the open, strong pliable and directionally stretchy fabric called net, which is used for both decorative and practical purposes. Netting is the knotting of loops of a continuous cord, twine or thread, onto one another in rows. It is also called plain filet and when it is decorated with darning or other stitchery it is known as filet lace or filet embroidery.

Netting proper, or plain filet, has a multiplicity of purposes and applications. In the decorative field it can be used for whole fashion garments or parts of garments (31) and for fashion accessories. One only has to think of netting in silver wire to realise that it can move into the realms of body jewellery. It can be used for window drapes, room dividers, screens (stretched on framing), or furnishing accessories, and is a very obvious possible component in flat wall hangings or three-dimensional sculptural textile constructions.

The fabric itself is called net, the individual loops, usually square or diamond in shape, are called meshes,

(31) Netting, Janet Griffiths, Birmingham College of Art and Design. Black chenille and tear-drop beads. Photo Alan Hill

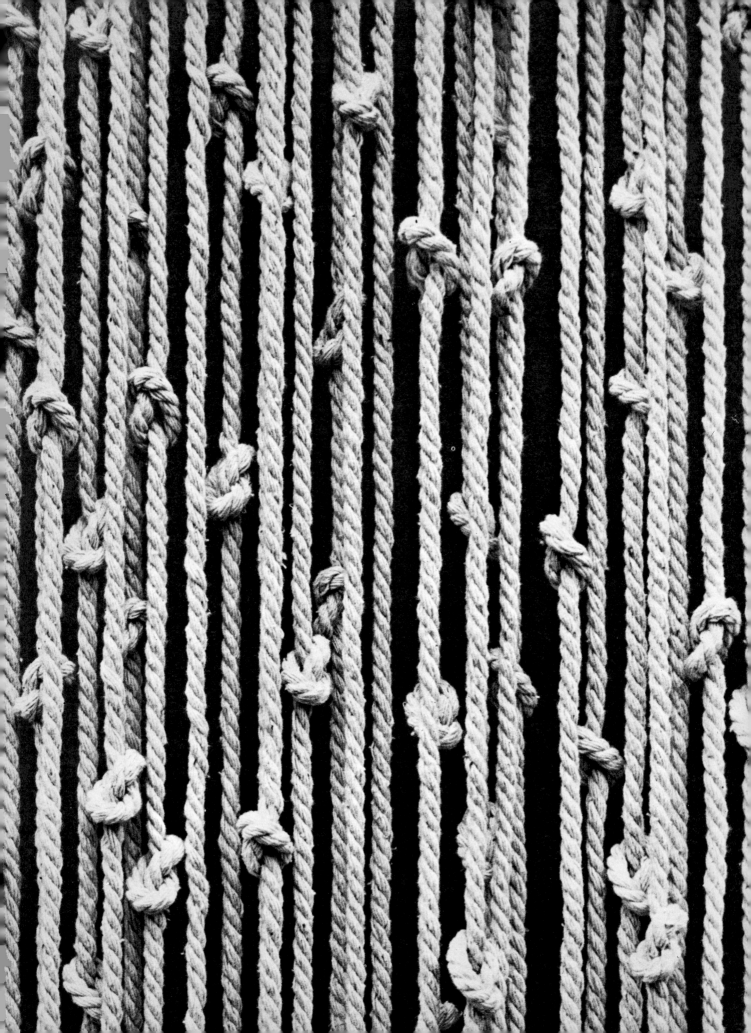

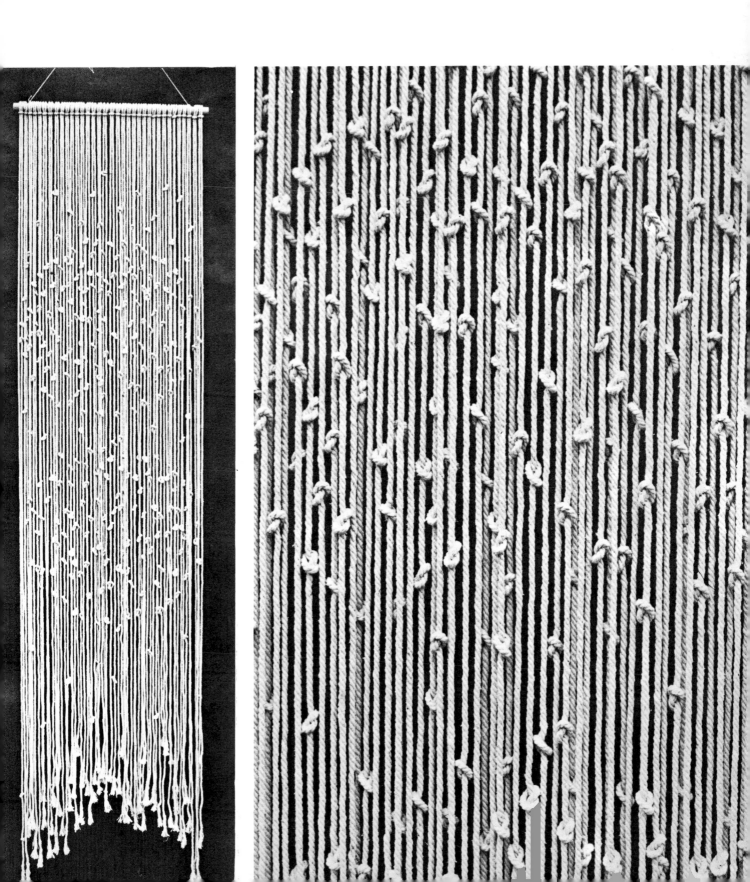

(32) (33) (34) Knotted hanging, Irene Waller. White rope, 6ft × 1½ft. Photo Alan Hill. Property of Mr and Mrs McClintock, Toronto

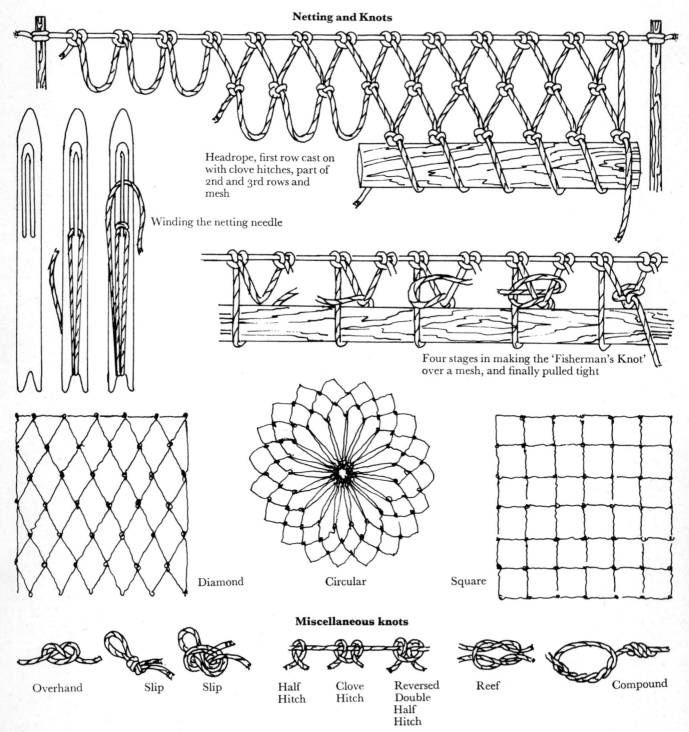

Netting and Knots

Headrope, first row cast on with clove hitches, part of 2nd and 3rd rows and mesh

Winding the netting needle

Four stages in making the 'Fisherman's Knot' over a mesh, and finally pulled tight

Diamond Circular Square

Miscellaneous knots

Overhand Slip Slip Half Hitch Clove Hitch Reversed Double Half Hitch Reef Compound

Lashing

Six steps in straight lashing. Start with clove hitch, end with reef

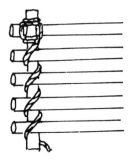

Single snake lashing

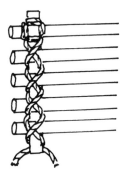

Double snake lashing – front

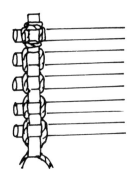

Double snake lashing – back

and the openness or closeness of the mesh is controlled by a measuring implement or loop gauge, which is also called the mesh. Necessary tools include a selection of netting needles and loop gauges in various sizes and a stable object to which to attach the work when you start. The beginning of the work can be either a taut head-rope needing two points for securing, or a large loop of rope, needing one.

The technique is comparatively simple (35). First decide the character of the net you wish to make, then choose an appropriate yarn and decide the size of the mesh. Having chosen a netting needle of a suitable size (when wound) to go through the mesh, wind it with the chosen yarn – not too much or it will be bulky. Some netting yarns require a good stretching at this stage to prevent kinking. Choose a loop-gauge of the correct size (ruler, pencil, piece of wood or card) and either set up the head-rope between two points, or make a large (8in. long) loop to act as the head-rope and slip this over something stable (on the diagram sheet a straight head-rope rather than a loop has been shown for clarity but they both have the same effect as after working the loop is opened out). You are now ready to begin and the instructions (35) should be followed. The knot shown opposite is a 'Fisherman's Knot' but there are others. The netting progresses across, then downwards in rows, and the work is turned for each row; the rows progress downwards.

Netting can be elaborated in a basic fashion by (i) varying the size of the meshes in the same fabric: this effect can be achieved by using different gauges but a larger mesh can also be obtained by winding the thread two or three times around the gauge; (ii) using double, treble or fancy threads; (iii) horizontal striping with colours, or different yarns; (iv) increasing and decreasing, i.e. in one row joining several loops with one knot and on the next row making extra loops; and (v) embellishing the netting with beads, tufts, etc.

The mesh of netting can hang either diagonally (as instructions); or square (in which case start with one mesh and increase on each row until the desired diagonal width is reached, then decrease until back

to one). It can be circular, the holding cord being drawn up for the centre and increasings made where necessary; flat; tubular (a great feature for three-dimensional sculptural experiments); or shaped.

Macramé

Macramé is decorative hand knotting, which creates geometric and lattice-like patterns and textures.

It is an old art, originating from the need to do something with the warp-ends left hanging at both ends of the cloth when a woven fabric is taken from the loom. Later macramé developed from just being a method of finishing off warp-ends into a separate art-form of its own. It has had a chequered history, sometimes being almost totally lost and forgotten, and sometimes enjoying a renaissance (as in Victorian times and nowadays), and has been practised by widely differing sections of society including both ladies at court and sailors.

Macramé can be extremely beautiful as the various knots from which it is composed form decorative textures and patterns which can be juxtaposed with each other, with areas of unknotted cord, or with areas of another material such as leather or suede. It is at its best when carried out in cords of a round compact character; made with fine cords it produces a delicate and 'lacey' fabric; made with coarse, hefty cords or ropes it can produce strong, forceful, and sometimes three-dimensional decorative statements (40). The technique can produce solid fabric with the knots very close together or open fabric with the knots spaced far apart and areas of unknotted cord (12). It can be made into fabric or objects for either fashion or furnishing and used as a fine art medium.

Basically it requires no tools but scissors, fingers, and something, like a bar or rope, on which to anchor it. As you progress, however, a working pad, pins for holding areas of work in place, and rubber bands for holding the working threads in little skeins are all useful. A good way of learning the technique is to complete a 'sampler' incorporating the basic knots, and instructions for this are on (36).

The first necessity is the yarn: each hanging length

of this must be roughly four times the length of the finished product. The 'knot bearers' need to be longer but extra yarn can be added by splicing or using adhesive. If (in later projects) you are knotting the warp ends, then they are all ready for working, requiring only the edge of the woven cloth to be secured, possibly by hem-stitching.

For the sampler and most other projects, the yarn must, then, be cut into lengths twice as long as needed (if you are a weaver, warping posts are helpful here) (36 [1]), and secured to either a holding cord or bar, (36 [2, 3, 6]), a piece of fabric (36 [4]), a handle, ring, or buckle (36 [5]), depending on the purpose of the work. Attach each cut piece of yarn to the holding element by doubling it (each piece has been eight times the finished length) making it into a reversed double half-hitch, as shown in (30), and slipping it on. If a more elaborate form of heading is required use beads, loops or crocheted chains. One can now begin knotting and the diagrams opposite show first the half knot (36 [7, 8, 9]) and then the square knot (36 [11, 12]). A series of half knots gives a twisted 'braid' (36 [10]) and a series of square knots gives a flat 'braid' (36 [13]). These braids can be used as edgings, belts, head-bands, wrist-straps, handbag handles, etc. Square knots using alternate groups of threads, will give solid fabric when knotted close and an open net-like fabric when knotted far apart. Bars of half hitches can either stabilise and hold the work together horizontally, or move over the face of the fabric at any angle or curve (36 [16–20]). The half knot, square knot and the half hitch are the three knots which form the basis of the technique. Experiment and design with them in order to get the feel of the work. There are, of course, other knots but these are embellishments and can follow later.

These basic knots, perhaps contrasted with areas of unknotted cord and other materials such as plexiglass, leather or suede, or decorated with beads and fringes, have been used to produce shaped fashion garments: tops, skirts (the holding cord is also the waistband), ponchos, jackets, tabards, cloaks and hats; bags of all sorts, sandal tops, jewellery (imagine a sunray-like collar in silver thread and beads), cur-

1.

Measuring
A and B are any available posts (warping posts, nails or chairbacks).
Distance A to B = 4 × length of finished work. B end cut, A end left
as loops.

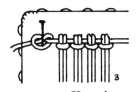

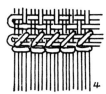

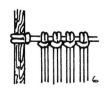

over a rod or bar
lashed to any two
available uprights

Knotting-on
over a holding cord
pinned by overhand
knot into heavy pad

Always using reversed double half stitch:

Warp-ends
(hemstitched)

Buckle or ring

Over holding cord
tied to available
uprights

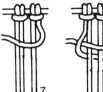

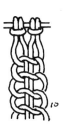

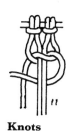

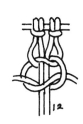

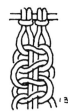

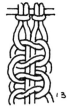

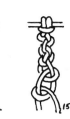

Knots

Step 1
half-knot

Step 2
half-knot

Step 3
half-knot

continuing
half-knots
form a
twisted braid

Step 4
square knot

Step 5
square knot

continuing
square knots
form a flat
braid

half-hitch
to left

half-hitches
to right and
left

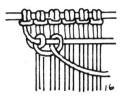

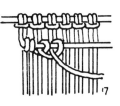

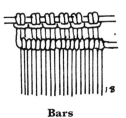

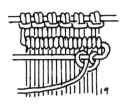

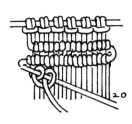

Bars

Thread one used as
knot-bearer. Thread
two making double
half-hitch

Thread three making
double half-hitch then
thread four, and so on

Bar complete

Knot-bearers
returning

Knot-bearer making
diagonal

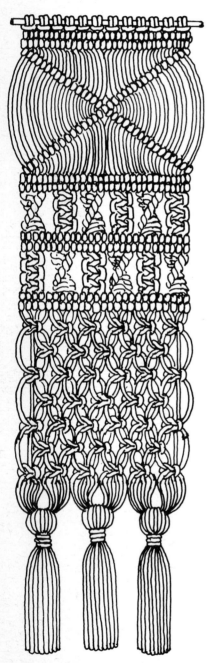

Exercise with bars, braids of
half-knots and square knots,
alternating square knots and
tassels

tains, room dividers and screens, light fittings, hammocks, chair seats and backs, wall hangings, and free forms. Open-work macramé looks well when lit from behind or with other materials like linen or PVC placed behind. Long flowing fringes are a natural development from these and can be finished with knots or beads or interspersed with tassels. Wall hangings and free forms can be hung from hefty bars or curtain poles and can have rods or wires inserted at intervals: free-standing forms can be mounted on armatures.

The development of individual design concepts is the prime concern of most people working in this field but, in fact, old macramé patterns can be 'read' from photographs or diagrams. In recent years there has been a wealth of really excellent books produced on the subject.

Tatting

Tatting is a method (hand only) of producing an extremely firm, hard-wearing but open structure, consisting basically of rings and bars (either straight or curved) joined together. These form a wealth of rosette-like intricacies, based on tiny circles, rows of circles and clusters of circles. (The Italian name for tatting, *occhi* or 'eyes' is very descriptive of its appearance.) Even when produced traditionally, in fine yarns, tatting is characterised by a rich, encrusted quality. This encrustation is the result of a series of stitches knotted over a running line which is then drawn up tightly into a round ring, or left to form straight or curved bars.

Its conventional use in fine yarns has been for placemats, dress trimmings, edgings and the like, but it is a technique eminently suitable, in the appropriate thread, for jewellery (42), small quantities of fashion fabric (41), garments, fashion accessories, isolated motifs for any purpose, borders and for ecclesiastical embellishment. It can be fabric on its own, or mounted on to, or set into another fabric. It is, unfortunately, a technique neglected by the creative designer, possibly because of its name, possibly because only fairly limited quantities can be produced, possibly because

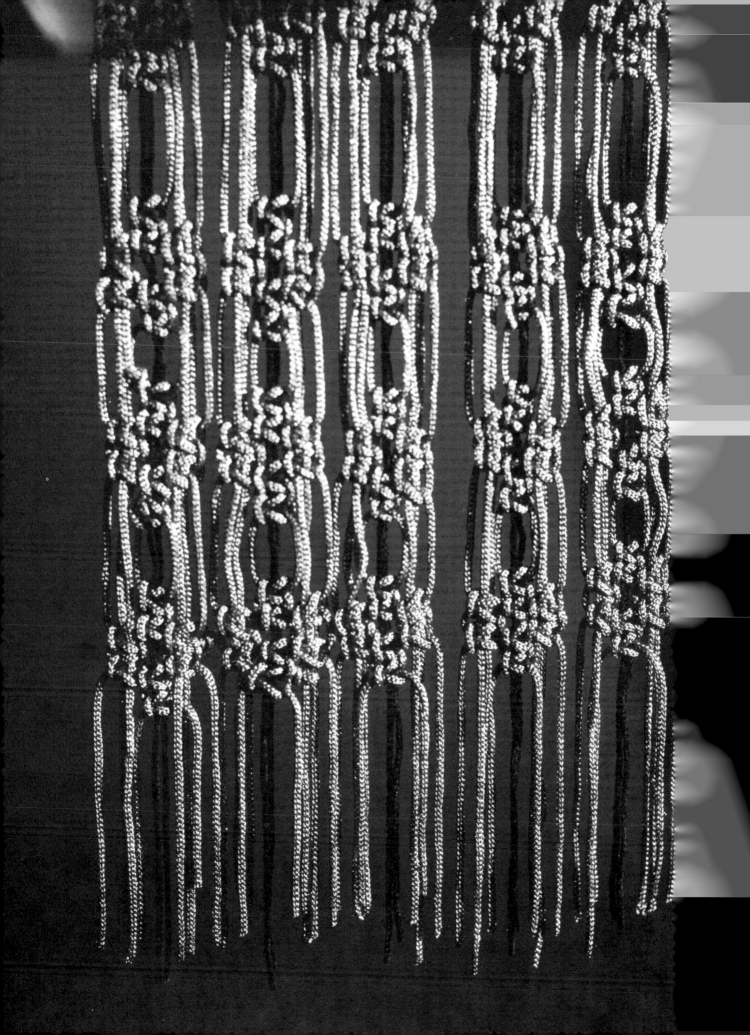

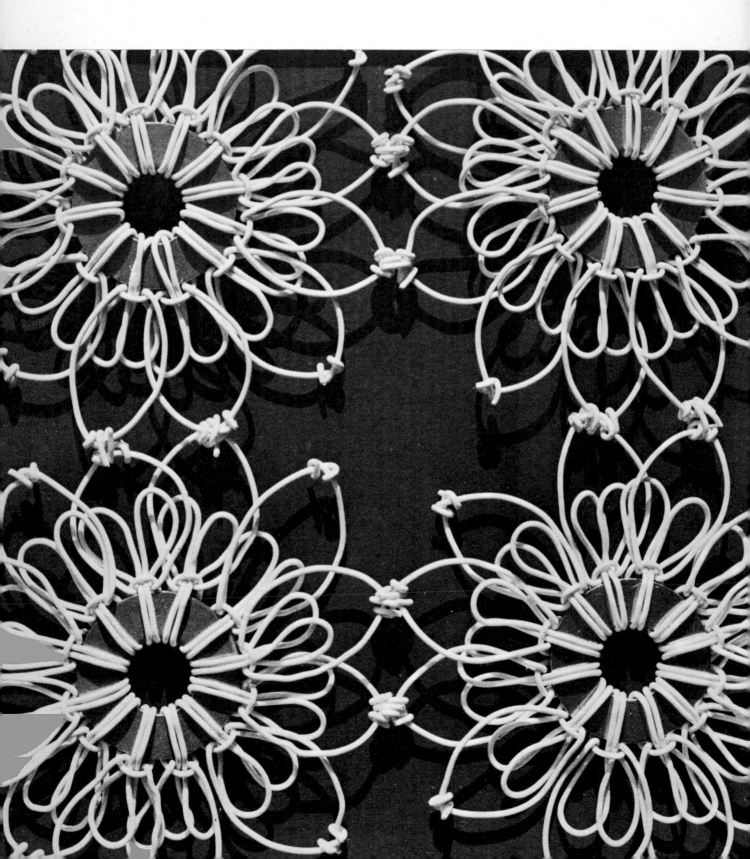

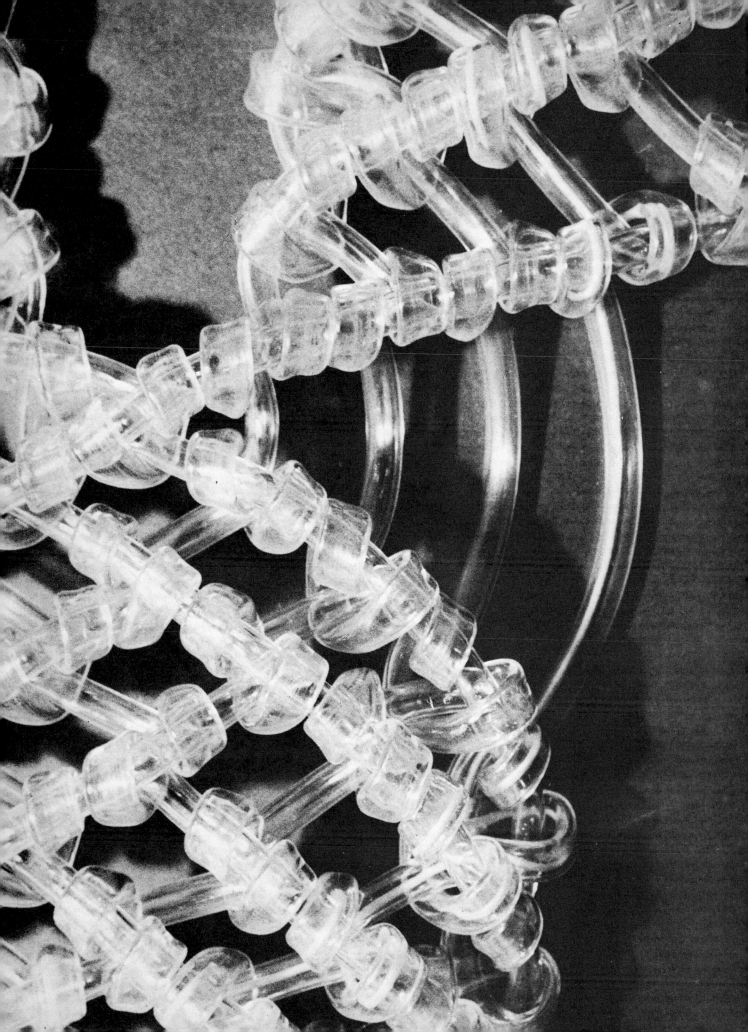

it is often produced in very boring yarns and colours. However it also requires what one can only describe as a 'knack' which is not always easy to understand from instruction books. If there is a straight choice between learning this technique from a book and learning from a demonstration by an expert, choose the latter.

The tools required, apart from dexterous fingers, are a tatting shuttle and a fine crochet hook; sometimes shuttles come with a hook attached. The whole thing, shuttle, yarn and work, can be enclosed in the hand. The yarn should be closely twisted, round and compact. Its maximum thickness will be dictated by the size of the tatting shuttle (the shuttle ends come together in order to hold the yarn in place). Only one knot is used, a half hitch and a reverse half hitch together, which forms tatting 'double stitch'. This stitch, repeated, makes the round, firm, knotted 'cord' of which the rings and semi-circular bars are composed.

Before describing the technique in detail a word or two about the 'knack' (43). This lies in the fact that although the double stitch is created with the shuttle thread coming from the right hand, when this is pulled taut the thread which is on the left hand takes over as the final visible double knot and the shuttle thread becomes the running line only. One is always working with two portions of thread. That over which the double stitch is actually worked, but which finally takes over, is always on the left hand (A). The other, which physically makes the double stitch but having been pulled taut ends up as the running line or core, always comes from the shuttle in the right hand (B). When a bar is made the two portions are *two different threads*: (A) is wound on a ball or an extra shuttle and. stretched over the fingers of the left hand; (B) comes from the shuttle held in the right hand. When a ring is produced the two portions are *different areas of the same thread*, (A) being wound around the fingers of the left hand and then held between finger and thumb to form a ring and (B), the remainder of the yarn, coming from the shuttle held in the right hand. The 'knack' lies entirely in making the left-hand thread, which is stretched around the fingers, double-stitch

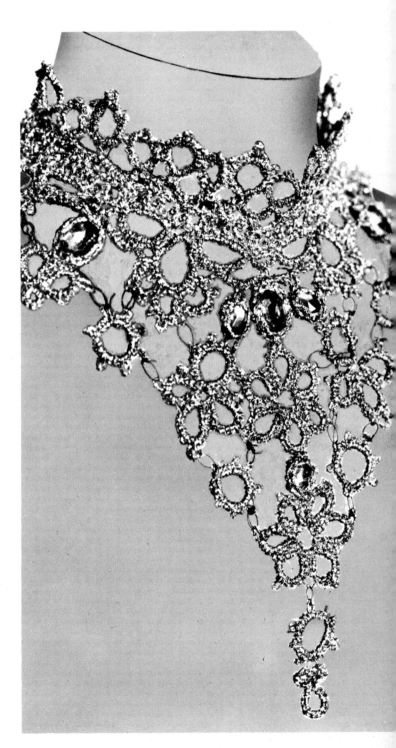

Thread always held in left hand; thread comes from back of shuttle

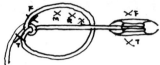

Shuttle always held in right hand between thumb and forefinger and held horizontally (x=fingers, L=little, R=ring, M=middle, F=first, T=thumb)

Ring around fingers of left hand, and held with finger and thumb

Shuttle thread knots over ring

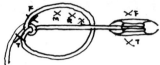

Pull! Forcing ring to knot over shuttle thread

These six movements make one double knot. The shuttle-thread makes the knots but the sharp pull forces the ring to knot over the shuttle-thread, thus allowing the shuttle-thread to slide thro' the knots as a running line to make the ring bigger as thread is used up, and smaller to make the final shape

Lift shuttle thread high with fingers of right hand

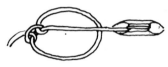

Shuttle thread knots over ring (different way)

Pull! Forcing ring to knot over shuttle thread = 1 double knot

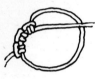

Make two more knots

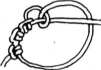

On the first half of the next double-knot leave an exaggerated loop which will push down into a picot

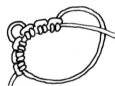

Make two and a half more knots

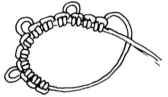

Continue until there are twelve double-knots and three picots

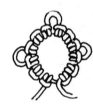

By pulling on the shuttle thread close the ring

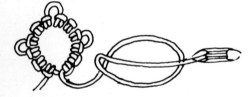

Start another ring ¼in. away

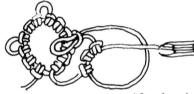

After three knots pull ring thread thro' third picot of last ring with hook

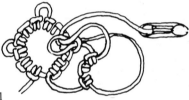

Pass shuttle thread thro' loop

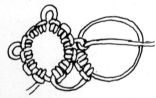

Pull ring-thread back into place and continue

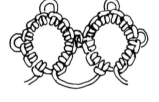

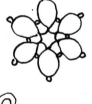

All the preceding movements make continuing joined rings. The simplest motif is six rings joined together to make a circle.

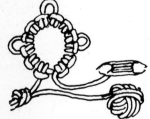

More complex work is composed of rings and chains. This needs two threads, one

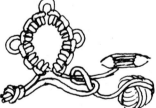

coming from the shuttle, and the second from a ball or a second shuttle

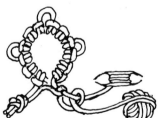

Bars could be produced (as left) by the shuttle thread making the same double-knot

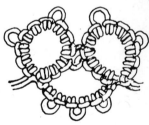

over the ball thread, but, with no 'pull' thus leaving the shuttle thread on top

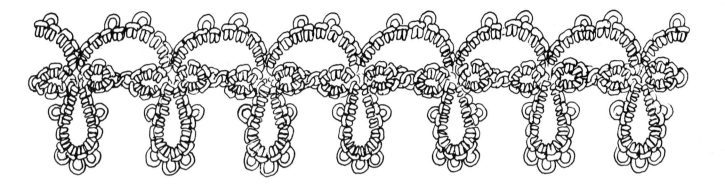

over the right, which is coming from the shuttle. This is achieved by slackening the fingers, and thus the thread of the left hand, and tugging the shuttle thread with the right hand hard, until a click is felt, which is the left-hand thread being forced over the right-hand one. A useful exercise before working is the sliding of the shuttle over and under thread (A) without displacing or dropping the shuttle itself. To practise this, stretch a piece of thread tightly between two objects or over the left-hand finger-tips and, holding the shuttle (no shuttle thread) horizontally between thumb and fore-finger of the right hand, take the shuttle back and forth over and under the thread without releasing it. This entails thread (A) sliding between shuttle and finger or shuttle and thumb. Tatting double stitches should lie snugly together, (B) totally covered by (A), if not the work will have an untidy look and a sloppy handle, instead of being firm, close and crisp.

Picots have not yet been mentioned, but are an important part of the technique. These loops of thread, sitting on the outer edge of the rings and bars, are produced simply by leaving a length of thread between the double stitches so that when the stitch is pushed close to the last one the extra thread pushes up into a loop. At one time the importance of picots was simply their decorative function but later it was realised that they were a means of joining ring to ring and piece to piece.

Diagram 43 gives visual and verbal instructions on the double stitch, picots, making rings, joining and making bars. It should be noted that the illustrated method of making bars with two threads (last line of diagram on facing page) is unorthodox. The correct accepted method is as follows: having made a ring with the shuttle thread, turn the work upside down, i.e. the ring is downwards between one's finger and thumb, with the ball thread held and tensioned over the fingers of the left hand; double-stitch with the shuttle-thread, and allow the ball-thread to 'take over' as the final visual double-stitch as usual. This method keeps the shuttle-thread always as the running line and is correct for fine work. However, if one is working in coarser threads the fact that half of the work, and thus the visual appearance of the knots, especially where picots occur, is facing the opposite side of the fabric, can be undesirable. If the method illustrated is used, an uninterrupted face and back of the fabric is retained.

There are many tatting instruction leaflets which give exact instructions for producing various articles and patterns, but in fact if a small sample of tatting is worked in the chosen thread, a design drawn out full size can be translated into numbers of stitches. When you have mastered the technique, try working in thicker threads, gold threads, string, cords and plastic; try tatting strips, areas, isolated motifs attached to

net, velvet or ribbon, and try decorating it with beads and stones. Photographs 41 and 42 show tatting as fabric and as jewellery.

Further study

Knotting

Allen-Williams, E. *Girl Guide Knot Book* Girl Guides Association, London 1969

Ashley, Clifford *The Ashley Book of Knots* Doubleday, New York 1944

Burgess & Nicholson *Help Yourself to Knotting and Lanyard Making* Girl Guides Association, London 1961

Graumont, Raoul and Hensel, John *Encyclopaedia of Knots and Fancy Rope-Work* Cornell Maritime Press, Cambridge, Maryland, USA 1958

Graumont, Raoul and Newstrom, Elmer *Square Knot Handicraft Guide* Cornell Maritime Press, Cambridge, Maryland, USA 1949

Smith, Harvey G. *The Marlinspike Sailor* John De Graff Inc, Tuckahoe, New York 1969

Tatting

Ashdown, E. A. *Tatting* Craft Notebook Series, USA 1961

Attenborough, B. *The Craft of Tatting* Bell, London 1972

De Dillmont, Thérèse *Encyclopaedia of Needlework* Editions T. de Dillmont, Mulhouse, France 1930

Learn Tatting J. & P. Coates Sewing Group Book No. 1088, 1969

Nicholls, Elgiva *New Look in Tatting* Tiranti, London 1959

Nicholls, Elgiva *Tatting* Studio Vista, London 1962

Netting

Collard, B. St G. *A Textbook of Netting* Dryad Press, Leicester, UK

*De Dillmont, Thérèse *Encyclopaedia of Needlework* Editions T. de Dillmont, Mulhouse, France 1930

Macramé

Andes, Eugene *Practical Macramé* Studio Vista, London 1971

*De Dillmont, Thérèse *Encyclopaedia of Needlework* Editions T. de Dillmont, Mulhouse, France 1930

Harvey, Virginia *Macramé, The Art of Creative Knotting* Reinhold, New York, Toronto, London 1967

Harvey, Virginia *Threads in Action* (a quarterly magazine) Box 468 Freeland, Washington, USA

*Meilach, Dona Z. *Macramé* Crown, New York; General Publishing Co, Canada 1971

Short, Eirian *Introducing Macramé* Batsford, London; Watson-Gupthill, New York 1970

General

*Emery, Irene *The Primary Structure of Fabrics* Textile Museum, Washington DC, USA 1966

*Hartung, Rolf *Creative Textile Craft* Batsford, London; Reinhold, New York 1966

Groves, Sylvia *The History of Needlework Tools* Hamlyn Publishing Group, Middlesex, UK 1966

Suppliers

Arthur Beale, 194 Shaftesbury Avenue, London WC2 (rope and cords)

Dryad Ltd, Northgates, Leicester, UK (general) (yarns and tools)

P. C. Herwig Company, 264 Clinton Street, Brooklyn, New York, USA (yarns)

Macramé & Weaving Supply Co, 63 E. Adams Street, Chicago, Illinois, USA

Ships chandlers

Hardware stores

Garden suppliers

Needlework shops

Yarn suppliers listed under Chapter 4

Tatting shuttles, knitting needles and crochet hooks

C. J. Bates Inc, Chester, Connecticut, USA

J. P. Coates Ltd, 155 St Vincent Street, Glasgow, Scotland

Abel Morrall, Clive Works, Redditch, Worcestershire, UK

The Needlewoman Shop, 146 Regent Street, London W1

Most needlework shops

7 Looped fabrics: knotless netting

The previous chapter, which considered ordinary knots and the complex structures they can produce, encompassed another element, the loop. Knotted netting, tatting and parts of macramé knotting all contain the loop as well as the knot as an integral element. Loops form the basis of an immense proportion of the textile field: open vertical loops in knitting (chapters 8, 9 and 10) and both vertical and horizontal loops in crochet (chapter 11). Between these two areas of textile construction i.e. knotting and knitting, there is a hand technique commonly referred to as 'knotless netting', probably best considered here (44).

'Knotless netting' is a term used in the past to describe various different sorts of fabric, some of which are not at all like net, but close looping producing solid fabric. Here, however, the term is applied simply to those netting fabrics which do not have knots in them. With this limitation knotless netting is exactly what it describes – the making of loops of a continuous thread, onto one another in rows, without using knots. The loops can be open, in which case the fabric could also be called a linked fabric (easily recognisable in a certain form of stout wire fencing); or the loops can be closed, i.e. one end crosses over the other (45). The technique has no firm holding construction, but can be made stable by stretching it over a frame, or producing it in metal or metal-core plastic yarns.

 (44) Knotless netting

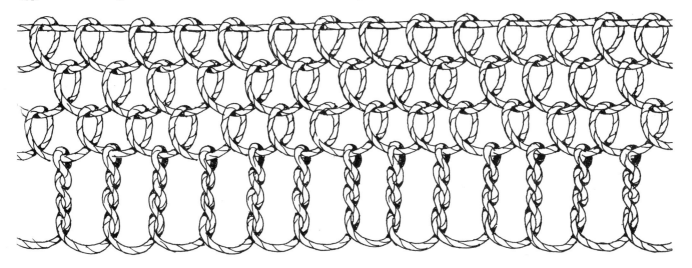

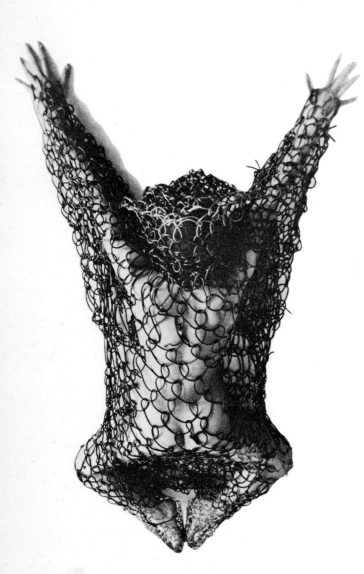

(45) Knotless netting *Fibrous Raiment* Debra Rapoport, California. Composed of plastic tubing. Photo Demetre Lagios

This method can obviously also be used to produce solid fabrics as well and is texturally very satisfactory when constructed in heavy yarns (such as heavy rope fenders) but of course it can no longer be called netting.

The closed loop is known in needlepoint lace as buttonhole stitch and in ropework as the half hitch. It can be given a twist or two before proceeding to the next loop which will make the construction more open and stable. It can become a 'cross-knit' loop, which means that the loop is passed not around the portion of thread between the loops of the row above but around the *crossing* of the loops. Closed loops can be connected with each other laterally as well as vertically.

Some of the above loops have, of course, been used in knitting, nets, lace and embroidery but all of them, and their variations, are worth investigating (see Bibliography).

Further study

*Albers, Anni *On Weaving* The Wesleyan University Press, Connecticut, USA 1963; Studio Vista, London 1966

De Dillmont, Thérèse, *Encyclopaedia of Needlework* Editions Thérèse de Dillmont, Mulhouse, France 1930

*Emery, Irene *The Primary Structure of Fabrics* Textile Museum, Washington DC, USA 1966

8 Looped fabrics: hand knitting

Hand knitting in its simplest form is the looping of a continuous yarn through itself to make successive rows of vertical open loops. The tools employed are two or more knitting 'pins' or 'needles'. The pins and the yarn can both vary in diameter, thus producing variation in loop size and fabric density. Smooth yarns which slide and loop easily are the most satisfactory to use in the first stages. The technique is easy to learn, is taught in most primary schools, practised widely in the home and is therefore the form of practical textile construction with which the largest number of people are familiar. The resulting fabrics are extremely stretchy (much more so in the horizontal than the vertical because of the loop shape), very pliable and can vary from fine and open (Shetland shawls) and (10) to heavy and dense with great textural depth (Arran sweaters). The horizontal sets of stitches are called rows; the vertical sets wales. If any one stitch is released or broken, it will also release the successive stitches below it, resulting in 'laddering'. The work can be carried out (47) from side to side to produce straight, flat fabric; worked round and round to produce tubular knitting; or worked from side to side to form shaped flat fabric by making or casting away stitches. The last two techniques can be combined to produce shaped tubes (e.g. stockings). Tubular knitting plus decreasing to a point where one can cast off completely, will produce domes (e.g. hats). When flat knitting is in progress the work is turned around at the end of every row; thus first one side of the work faces the knitter and then the other; when tubular knitting is in progress the same side of the knitting always faces the knitter. To produce the same result in both flat and tubular knitting a different sequence of stitch formation must therefore be followed. This ability to shape and three-dimensionalise while the fabric is in production obviates yarn wastage and some making-up processes and is a tremendous natural advantage in the shaping and making of garments, unlike weaving which is almost always flat and straight and has to be cut.

Knitting needs little equipment or space and can be taken up or tucked away at a moment's notice, particularly with the help of the old knitting pouches

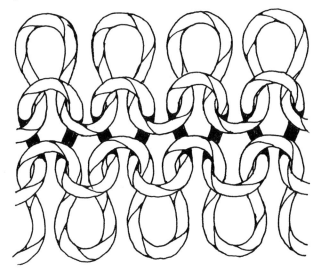

(46) Hand knitting, purl loops

Pins (needles) and gauge

To cast on: make a loop some distance from wool end

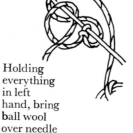

Slip loop onto needle, hold in right hand, with end of yarn make loop round left thumb

Slip loop onto needle

Holding everything in left hand, bring **ball** wool over needle

Slip loop off needle

Pull end tight allowing ball wool to make stitch continue . . .

First row (plain)

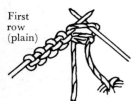

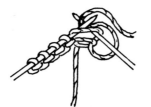

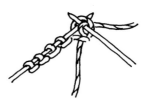

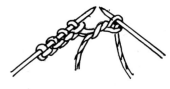

Holding cast-on stitches in left hand, insert 2nd pin front to back thro' 1st stitch

Loop ball wool around tip of right needle

Draw right needle gently back bringing it thro' to front, loop of ball wool with it

Slip remainder of stitch off left hand needle . . . continue . . .

Purl row

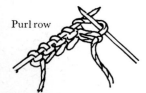

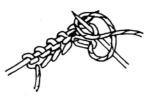

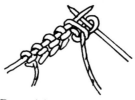

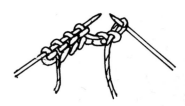

Insert right needle into 1st stitch from back to front.

Loop wool around tip of needle

Draw right needle gently back, taking it to back of work, loop with it

Slip remainder of stitch off left hand needle . . . continue . . .

To decrease: knit or purl two stitches together

To increase: knit into the front and then into the back of the same stitch

To cast off: knit two stitches, with left needle lift first stitch over second. Knit one stitch, lift first over second . . . continue . . .

Tension . . . is all important. It is the tightness or looseness of the yarn and is controlled by wrapping yarn around middle finger

Balls should be wound loosely

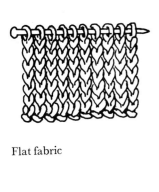

Flat fabric

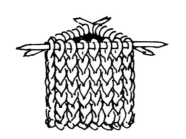

Circular fabric

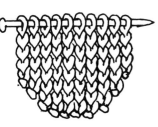

Shaped flat

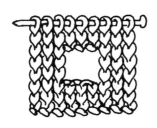

Shaped flat

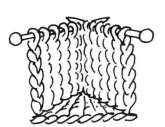

Three dimensional

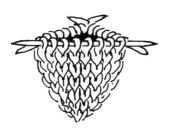

Three dimensional

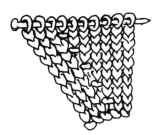

Fully fashioned

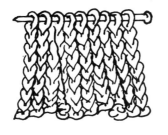

Flared

and knitting sheaths (needle rests), or just a convenient belt or pocket. Probably for this reason hand knitting has long been an integral part of everyday life in most countries. Men, women and children once knitted constantly, and at some periods produced work of great fineness and intricacy. By comparison the popular conception of hand knitting today would be considered gross. Yarns of hair-like fineness, wool, silk, cotton and metal threads were used to produce luxurious fabrics and even pictures. At the other end of the scale, coarse wool, felted, was used to produce cloth capable of keeping out the most rigorous elements.

Basically there are only two stitches: plain (loop thrown off the needles away from the knitter) and purl (loop thrown off the needles towards the knitter). These, used in varying sequences, and distortions of these, form limitless patterning. Following are some colour and stitch design variations.

Stocking stitch alternate rows of plain and purl, producing a smooth fabric of plain loops on one side and a rough fabric of purl loops on the other (46). In tubular knitting this is produced by continuously knitting plain.

Garter stitch all rows plain, producing texture on both sides. In tubular knitting one round must be plain, the next purl.

Colour striping new colours can be brought in when desired and are joined in at the edge.

Colour patterning (Fair-isle) using two or more colours, knitting one while floating the other at the back, to achieve various decorative pattern sequences.

Piqué knitting plain and purl intermixed in predetermined arrangements, e.g. moss stitch, basket stitch, Guernsey knitting.

Crossed knitting plain or purl into the back of the stitch producing a twisted stitch and a firmer fabric.

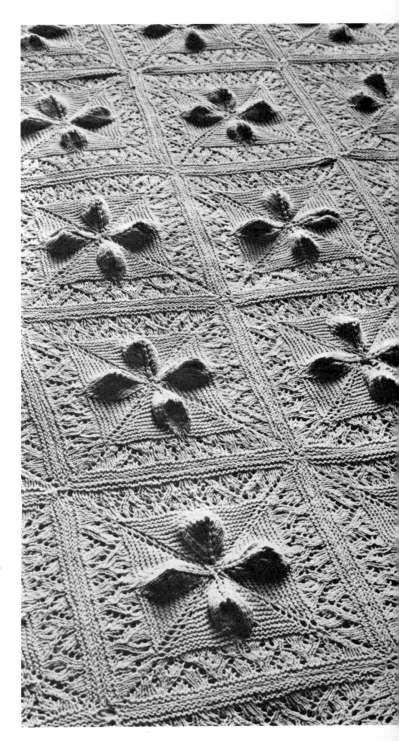

Knitting stitches together to decrease and to shape.

Knitting into the front and the back of the same stitch to increase and to shape.

Overs bringing the wool forward thus making an extra stitch and a hole. Overs can be followed by knitting two together, thus retaining the same number of stitches, and are used for knitted 'lace'.

Slipped stitches unknitted.

Bulk stitches knitting into the same stitch several times and then casting all over one stitch to create a lump (Arran knitting and blackberry stitches).

Stitch transfer moving stitches across the surface of the fabric by increasing on one side of them and decreasing on the other (Arran).

Twisting sets of stitches around each other cabling and Arran. This requires an extra knitting needle.

Slipping a stitch, knitting the next two together, passing the slipped stitch over this is also a way of making 'lace'.

Beaded and bead knitting beads threaded on the knitting yarn, or on an extra yarn, and moved into place when required (much used in the Victorian era for purses).

Weave-knitting a purl-faced fabric with an extra yarn passing through the stitches to make a second element which stabilises and decorates the fabric.

Tartan knitting akin to tapestry weaving in that different colours each create a separate design area of unbroken colour, yarns being looped around each other at the area edges.

Looped knitting loops formed around the finger to create pile fabrics and fringes.

Cabbage stitch plain knitting with the yarn taken round the two pins, then round one to form immense open stitches with long hoops.

Knitting instruction books use abbreviations to describe how to produce a given pattern or construction. These are always explained at the beginning of the instructions. The diagrams (47) show how to cast on (one method only) and how to produce the basic knitting stitches, with some reference to flat, tubular and shaped knitting. Methods of casting on and of knitting itself vary considerably from country to country; they can be an integral part of the whole design conception, particularly in garments.

Until recent years, knitting was mostly composed of the smooth even yarns which slide and loop easily, so a type of patterning evolved which gained its effect from its constructions (49). Nowadays, the tremendous range of textured yarns available, hitherto the province of the weaver (48), and the stabilizing of open knits by lamination (chapter 19 and [138]) have considerably widened design possibilities. Some worthwhile exercises are to produce plain knitting in the same yarn on various sizes of pins and then in very varied yarns, e.g. fine monofilaments, string, bouclé, wool roving, plastics, metal threads, wire, cellophane, ribbons, threaded beads, etc.; or to experiment in a plain yarn with some of the nineteen listed ways of producing pattern and then to try one or two of these patterns in something monstrous, like wool roving. Produce a piece of work with its bulk and density made variable by yarn, pin size and stitch variation, make the rows wave by knitting a few stitches with a small pin and the next few with a large pin or by using the cabbage stitch principle. Finally, try creating both flat and three-dimensional shapes; and, further, exploit the plasticity of knitting by holding it out with rods or by packing it with filling (either soft filling, like kapok, or hard filling, like boxes, balls and tubes).

Hand knitting is, like crochet, suitable for many types of clothes and accessories, assuming that the considerable natural stretch of the fabric suits the design of the garment, and there are some fashion conceptions, e.g. the sweater with no neck fastening or the body stocking, for which it is unsurpassable. In the furnishing field, unless it is laminated, its suitability is limited, but its qualities of stretch and the natural curves which it takes on make it an extremely fruitful technique for creating flat and three-dimensional shapes, like upholstery and cushions·

Mary Walker-Phillips in the USA, and Ann Sutton in Britain, are both exponents of knitting as a technique for producing art objects.

Further study

Aytes, B. *Adventures in Knitting* Doubleday, New York 1970

Aytes, B. *Knitting made Easy* Doubleday, New York 1968

De Dillmont, Thérèse *Encyclopaedia of Needlework* Editions Thérèse De Dillmont, Mulhouse, France 1930

Groves, Sylvia *The History of Needlework Tools* Hamlyn Publishing Group, Middlesex, UK 1966

Mon Tricot *800 Stitch Patterns* 41 Boulevard des Capucines, Paris, France

Mon Tricot, Editors *Knitting Dictionary* Crown, New York 1971

*Thomas, Mary *Mary Thomas' Knitting Book* Hodder & Stoughton, London 1938

Thomas, Mary *Mary Thomas' Book of Knitting Patterns* Hodder & Stoughton, London 1957

Thompson, G. *Patterns for Jerseys, Guernseys and Arrans* Batsford, London 1969

Walker, Barbara *Treasury of Knitting Patterns* Pitman

Walker, Barbara *The Craft of Lace Knitting* Charles Scribner, New York 1971

Walker, Barbara *The Craft of Cable-Stitch Knitting* Charles Scribner, New York 1971

Walker-Phillips, Mary *Step by Step Knitting* Golden Press, New York 1967

*Walker-Phillips, Mary *Creative Knitting, a New Art Form* Reinhold, New York 1971

9 Looped fabrics: knitting with domestic and semi-industrial machines

A considerable re-think is necessary in order to move from hand knitting to machine knitting. The speed at which fabric and patterns can be produced on a knitting machine can stimulate the type of mind which may be appalled by the slowness of the hand-produced equivalent. Equally because it is a machine, and it removes one a step away from the direct tactile experience of handling the yarn, to others it may be completely unacceptable. Fabric knitted on a machine retains the same essential basic qualities as the hand product and is much swifter to produce. A range of knitting machines can produce almost everything the hand knitter can, much more swiftly, and sometimes better (very fine and even fabrics [59]). A 'range' is needed because machines come in different gauges (i.e. needles per inch) and therefore each machine is fairly limited to the weight of fabric it will produce and the yarn it will take.

The mechanization of the knitting process

In hand knitting one stitch is created at a time by freely-moving knitting needles, supple fingers and yarn. In machine knitting, one row (course) is created at a time. Instead of two needles, there are as many needles in use as there are stitches and these are set, side by side, in a wide, table-height needle-bed (see [17] and [51]). A cam box (51 [5]) activates the needles, and enables them to take yarn and form loops; the cam box slides across the needle-bed from side to side obscuring the needles at the moment of action. This difference in the method of production can create unexpected voids between the hand and the machine conceptions.

Terminology and notation

The terminology and notation of machine knitting are quite different from those of hand knitting. A loop pulled through towards the knitter is called a face loop; a loop pulled through away from the knitter is called a back loop. A horizontal row of loops is called a course, a vertical row of loops is called a wale. A fabric com-

(50) Machine knitting: tuck stitch

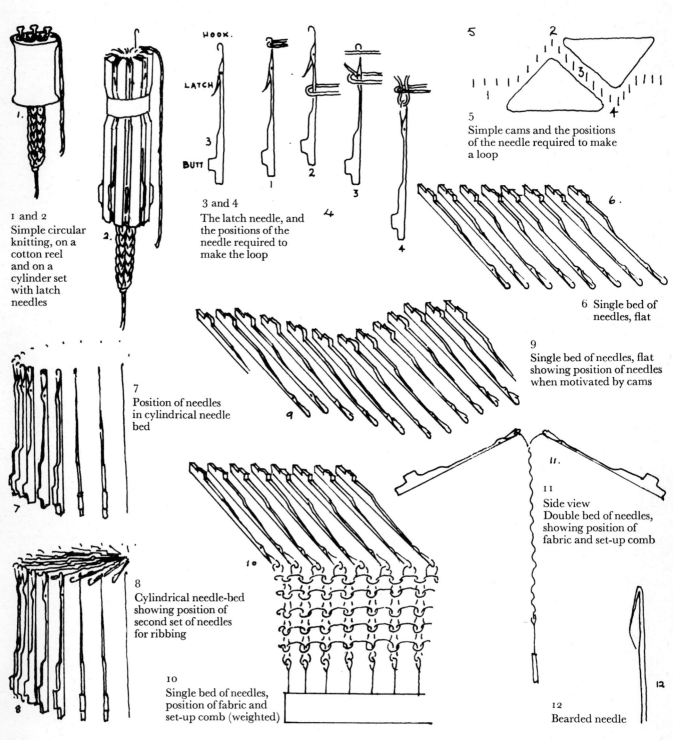

1 and 2
Simple circular knitting, on a cotton reel and on a cylinder set with latch needles

HOOK.

LATCH

BUTT

3 and 4
The latch needle, and the positions of the needle required to make the loop

5
Simple cams and the positions of the needle required to make a loop

6 Single bed of needles, flat

7
Position of needles in cylindrical needle bed

9
Single bed of needles, flat showing position of needles when motivated by cams

8
Cylindrical needle-bed showing position of second set of needles for ribbing

10
Single bed of needles, position of fabric and set-up comb (weighted)

11
Side view
Double bed of needles, showing position of fabric and set-up comb

12
Bearded needle

posed of nothing but face loops is called plain fabric, the front being the 'technical face' and the reverse the 'technical back'. A fabric composed of alternate face and back loops in vertical wales is called 1 × 1 rib. A fabric composed of alternate courses of face and back loops is called 1 × 1 purl. Notation is by symbols, but as there are many universal systems, the notation special to a machine, or a fabric type, or a region, has to be learned as it arises. In the most general notation system, each stitch is indicated in position on graph paper with possibly 'x' representing the face loop, 'o' the back loop, with further symbols to indicate missed stitches, tucked stitches, etc.

Fabric description

Because weaving was the first major method that man discovered for producing cloth in quantity, and because some sort of frame and thread-control mechanism was necessary from the earliest times, the loom mechanism itself was ignored as a means of cloth description right up to the invention of the Jacquard loom. Descriptions arose either from geographical locations, such as damask, or visual appearance, such as 'birdseye'. The knitting machine, on the other hand, is a comparatively late development which did not come entirely into its own until the Industrial Revolution. A large number of the constructions of which it is capable were new and had no hand-made historical equivalents; indeed new constructions are still appearing. This means that although in wovens· there is one name for one cloth, there are often several names for exactly the same cloth in knitteds and also for lace. For example, a rib fabric with raised horizontal ripples on it is known variously as Ripple, Ottoman or Bourrelet. A cloth may have no name, or be named after the machine.

The evolution of the knitting machine

Compared to the loom, the knitting machine has had a meteoric career. There were simple knitting frames (wooden pegs on boards) centuries ago, but the knitting machine in the embryo of the form we know was invented by the Reverend William Lee in 1589. Knitted fabrics now account for over half of the Western world's textiles, much of which is produced in man-made yarns which knit more easily than they weave.

Mechanization in the first instance consisted of setting small, hooked metal needles side by side in a bed or bar. Between the needles the yarn was pushed down by sinkers to form loops which were then thrown off collectively by movement of the needles against the sinkers. This invention speeded up hand knitting by at least twenty times. An adaptation of this original method is still used in some aspects of industrial knitting today, but the invention of the latch needle (about 1850), which could form its own loop, led to the construction of machines of a much wider variety. This needle (51[3]) has a latch which swings so that an enclosure can be made with the hook to trap the yarn and drag it through a previously formed loop. A projecting butt allows the cam to activate the needle. Because the needles are set, unlike hand knitting needles, in a bed, they can only cast off the loop one way, i.e. outwards, and therefore single bed machines can only produce plain based fabrics. Fabrics including face and back loops on the same side of the cloth require two needle beds.

So, in very general terms, we now have a mechanism which contains one latch needle for each wale of loops. Each needle is set in a trick or groove, in which it can slide back and forth, and the entire set of needles and grooves is set in a bed or bar. The bar is either single, linear and flat (51[6]) (for limited stitch-formation flat knitting); double and linear (51[11]), the two bars of needles being set facing each other at an angle of 90 degrees (for more complex stitch formations or simple tubular knitting); formed into a crown-like circle (51[7]) (for limited stitch-formation circular knitting); or a radial circle (51[8]), used in conjunction with the latter (to produce rib or 'double jersey' circular knitting). The butts of the needles protrude from the needle-bed so that the cams, in the cam box, sliding across the bed, contact them and

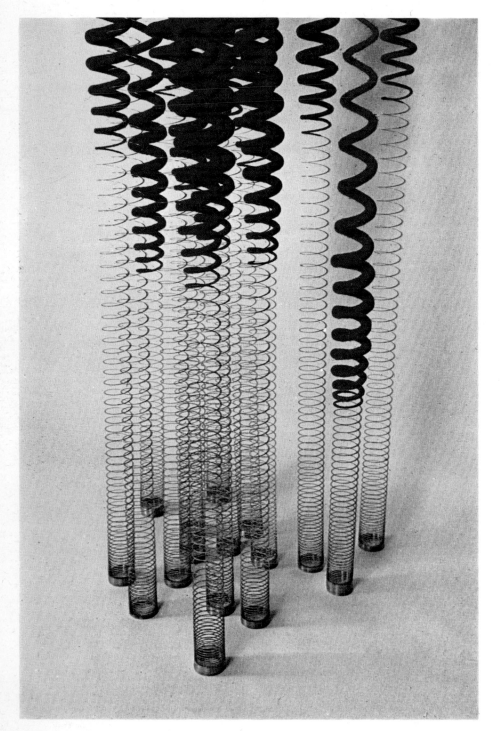

(52) Wrapping *Slinky* Claire Zeisler, Chicago. Springs wrapped with wool; floor to ceiling

(53) Machine knitted fabric, Doreen Hope, Birmingham College of Art and Design. Two yarns, fabric composed of a rayon gimp and a two-fold rayon, knitted on an unevenly spaced bed, stitches transferred manually at intervals (three-gauge machine). Photo Alan Hill

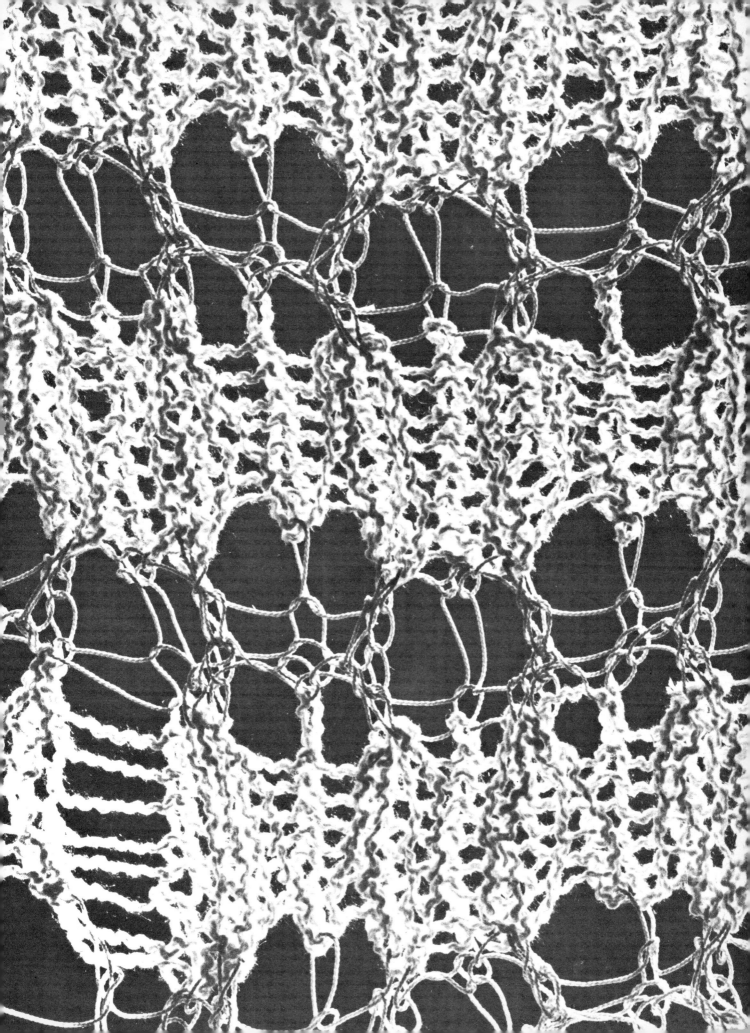

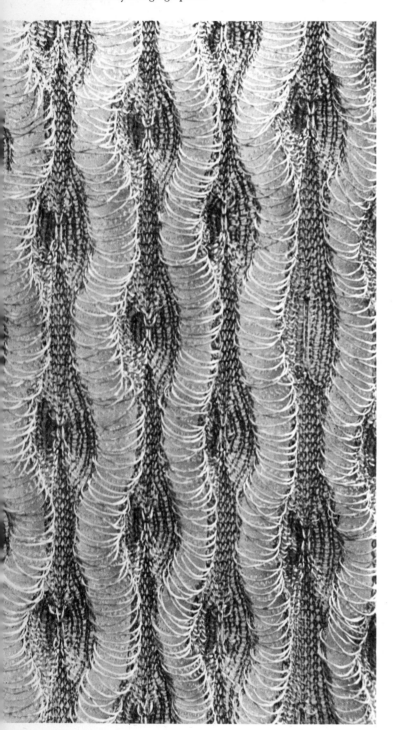

(54) Machine knitted fabric, Elisabeth Beeston, Birmingham College of Art and Design. Produced on a simple machine with knitted and non-knitted stripes. Two yarns used throughout (knit-de-knit bouclé and Duracol): as one yarn contracts the other bends. Shaping was achieved by bringing up one stitch from sixteen rows below. Photo *Birmingham Post*

activate the needles, into which the yarn is fed by a yarn feeder, for the making of a stitch. The cam box hides the actual operation of knitting, and this creates problems for some designers. It is helpful to remove and examine the cam box of a knitting machine to see how the needles are operated and how the stitch is formed. When the fabric is ejected from the machine it is controlled by sinkers and, occasionally, by weights (single bed) or weighted (double bed) (51 [11]).

Knitting machines

To understand the principles of knitting on machines it can be helpful to start practical work with familiar tools. The 'cotton reel and nails' which children use is in fact a simple knitting frame (51 [1]). The stitches are held on the nails, and the new loop is produced by bringing the yarn across each nail in turn and lifting the stitch over, the result being tubular knitting. Another version of this is the hollow cylinder of wood set with latch needles in grooves (51 [2]) in which the needles move up and down to produce the new loop. Both of these little gadgets will produce belts, frogging, roulé, headbands and other decorations.

Next in size and complexity is the mechanized version of sock knitting on four needles. This is a small circular hose-knitter holding about sixty needles vertically, with simple cams for needle operation; it can be held in the hands for working. Next, the metal hose-knitter: heavier, bigger and static, and with its second bed of needles set radially in a metal disc above and working at right angles to the cylinder, capable of producing both face and back loops. This is also quite useful for the quick sampling of new yarns. The general principle of these little machines is seen in (51 [7, 8]).

Next come the single-bed, flat, domestic machines (these vary but the best are now sturdy and well engineered). The simplest consists of one bed of needles, a yarn feeder and a simple cam box. It can only produce 'plain' knitting, i.e. all face loops one side, all back loops the other side, although it must be remembered that with time and ingenuity tremendous

(55) Machine knitted fabric, Brenda Lewis, Birmingham College of Art and Design. Tuck stitch on a plain fabric base with uneven needle spacing to produce ladder effect. Photo Alan Hill

variation is still possible and indeed the fabric in (54) was produced on just such a machine.

More sophisticated are those machines which mechanize stitch patterning by predetermined needle (17 [1]) facilitating the missing or non-knitting of some needles; the accumulation of two or more loops on the needle (tucking); the slipping of stitches; the laying-in of extra yarn for so-called weave-knitting; colour patterning (Fair-isle); and, in the case of some machines, loop-transfer between needles. Some machines have the possible constructions communicated to the knitter by pattern cards and the like. These machines should, after the initial inspiration-run, be used without the cards (which are pre-digested information) in order to see what the machine can do. This way the designer uses the machine in an individual and creative way.

Machines with two inclined beds of needles placed facing each other (17 [5, 6]), and with two cam boxes can achieve all the stitches of the single-bed machine, as well as circular knitting (left to right knitting on front bed only, right to left on back bed or vice versa); rib-based knitting (face and back loops together in the same course); pleating of many types (by exploiting the natural curl between face and back loop); racking (the moving of the front bed for a limited distance to right or left); and laying-in, or padding. Other techniques involve rib transfer, i.e. the transfer of loops from front to back to create areas of plain on rib or rib on plain, transfer of groups of loops on the bed that they were knitted on to produce 'lace-holes', inclined wales and 'cabling'. There are generally two or more yarn feeders; a greater number of tension (i.e. loop-size) possibilities; needle selection is sometimes by hand, sometimes mechanized. The majority of fabrics produced are reversible.

On all the preceding machines, 'weave-knitting' can be achieved by laying an extra yarn either across the needle heads in such manner that it is tucked into the structure and not knitted, or between the beds and knitting it in. Like brocading in weaving, the extra yarn plays no constructional part but is purely decoration and because of its comparatively straight path adds stability to the fabric. It is also possible to

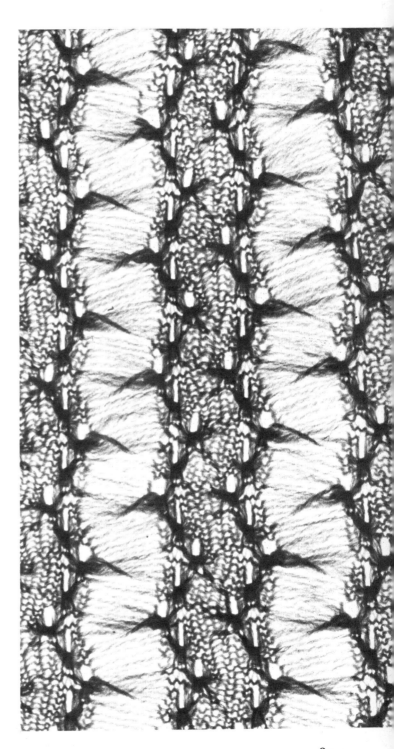

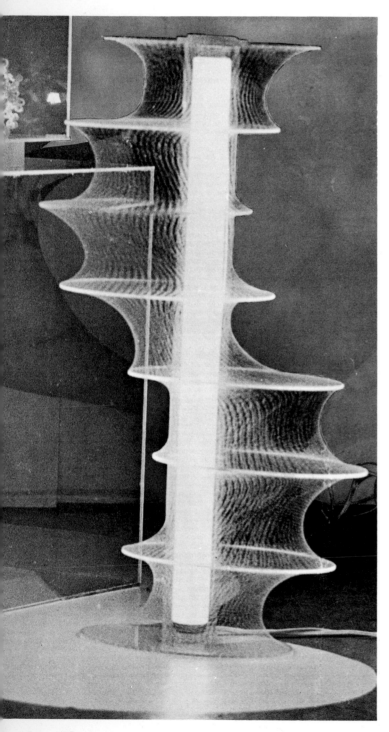

(56) Light fitting, Angela Fell, Birmingham College of Art and Design. Circular machine knitting using nylon thread and perspex shapes. Photo *Birmingham Post*

insert beads, strung to a pre-determined pattern, laid in on a thread and pushed down between the needle beds; or stuffer yarns; or rigid materials like cane.

Some domestic machines have an attachment which takes punched cards and works in a similar way to a dobby or Jacquard weaving mechanism (17 [3]). One repeat of the required design is transferred to the card in the form of punched holes. These select the needles, to knit or not to knit, over possibly a repeat of twenty-four stitches. The resulting graphically free designs can be knitted in a variety of constructions. The cards can also be locked in a chosen position so that areas of the design can be isolated and repeated.

In general, good knitting machines intended primarily for the domestic market are very useful, as they are intentionally versatile, generally easy to use, and portable. They can produce, by tension control, fabrics from light to medium weight; the gauges, however, are generally limited (average seven) and often require quite a lot of hand manipulation compared to industrial machines. Firm, immovable knitting tables are essential (15 [35]).

Semi-industrial machines, which are hand-manipulated for designing purposes, have a much wider variation of gauge ($2\frac{1}{2}$ to 14) and of needle size, and always have two needle-beds. They can therefore produce from fine and light to coarse and heavy fabrics, in a limitless variety of stitch constructions and an extremely wide variety of yarns (17 [5, 6]). The machines are generally fixed, thus giving a feeling of stability to the knitter, who stands to operate. They usually have more than one yarn carrier, the cams are individually operated and needle selection for tucking and missing is achieved by high and low butt needles, although some machines have a manual selection to give 'free' design areas.

Piece-shaping

Piece-shaping and fully-fashioning the edges of machine-knitted fabric is done with a stitch transfer tool (15 [28]). Having knitted a quality sample in a given yarn to ascertain how many courses and wales there are per inch and having drawn the required

(57) Floor covering produced by a laying-in technique on a Knitmaster machine. Photo Alan Hill

(58) Machine knitting, Doreen Hope, Birmingham College of Art and Design. Racked rib using two thicknesses of yarn (three-gauge machine). Photo Birmingham College of Art and Design, School of Photography

shape on paper, it is possible to calculate the knitting details of a garment portion in terms of wales, courses, number and frequency of fashionings and pattern information, and knit accordingly. Some domestic machines have a special attachment which takes into itself, rather like a typewriter, a scaled-down version of the shape required drawn in heavy lines on paper (this can be individually designed or put together from a given chart). As the knitting proceeds so the shape diagram moves and by watching the movement of the shape diagram against an equally scaled-down diagram of the needle-bed of loops, one can see when it is necessary to increase, decrease and change pattern.

Generalities

Most art colleges teaching Textile Design, certainly in England, are now equipped with knitting machines. The manufacturers of knitting machines have showrooms and agents in most big towns and these machines can be tried under tuition and in some cases at home. Second-hand machines always seem to be in plentiful supply.

To the machine knitter several things should be stressed which may not, at first, be self-evident. Have some sort of flag flying while you are creating con-

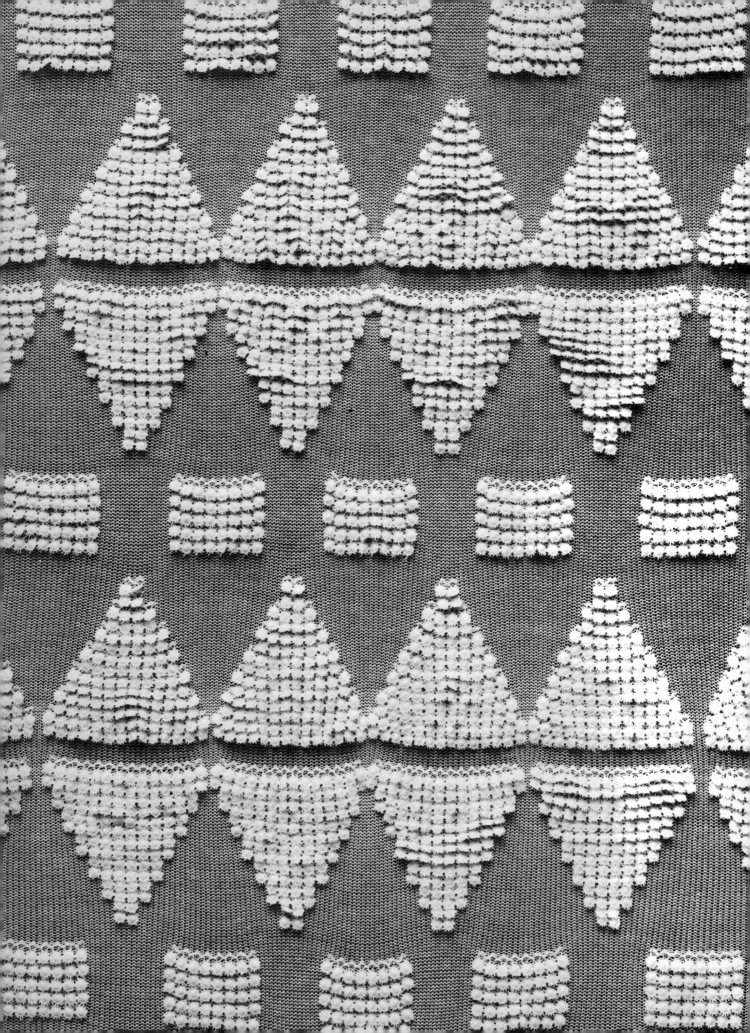

(59) Machine-knitted fabric,
Linda Gardener, Royal
College of Art. Cotton fabric
produced on a single-bed
machine with lace edging
hooked on during knitting.
Photo Royal College of Art,
School of Photography

(60) Machine-knitted
decorative panels, Brenda
Lewis, Birmingham College
of Art and Design. Coarse
black wool, natural wood
frames. Open pattern created
by needle spacing

structions to indicate to others that you must *not* be disturbed. Keep pattern notation course by course; careful notation as the work proceeds is most important in all forms of machine knitting, as it is neither desirable nor easy to remember at a later date how something was constructed. Yarn tension is a very important factor. Yarn must come either from a cone (if it is a slippery yarn, coming off too easily, then slip something loosely over it to act as a deterrent – a piece of stocking is fine) or a specially wound ball with the yarn coming from the middle (24 [16]). It is as well to wind the ball twice, to make sure there is no pull creating tighter tension here and there. Waxing while winding is generally necessary. And finally, take great care of the knitting machine. Learn exactly how it works from the machine's individual instruction manual: keep it clean, oiled, free from fluff and covered when not in use; and never force the cam box across the needles if it appears stuck.

The speed at which fabric can be designed, re-designed and produced on a knitting machine is incredibly satisfactory – it is certainly faster than the same procedure in woven fabrics. The design purposes to which machine knitting can be put are literally limitless, in fashion and furnishing and fine art objects. All the constructions listed in the preceding chapter which were produced by hand, can be produced on a machine, some of them much more accurately, such as 'laddering', i.e. missed stitches (54, 55, 60). The apparently complex three-dimensional fabric (54), was produced on a simple machine totally devoid of refinements and gadgets. Very fine yarns are easy to handle accurately because the fabric is weighted (59), and, given a coarse gauge machine with a large needle-hook, coarse and bulky yarns are equally easy to use (58). Photographs 61 and 62 illustrate the stretch qualities of machine knitting exploited in a wall hanging. Now refer back to page 75 in the preceding chapter and follow through some of the construction and yarn experiments suggested there. When the stretch quality of knits is undesirable they can be laminated (138). Photograph 57 shows a knitted floor covering, photograph 53 shows knitted curtain fabric, and 56 a light fitting.

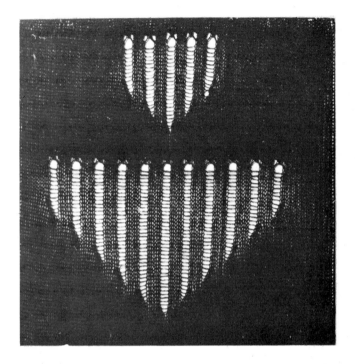

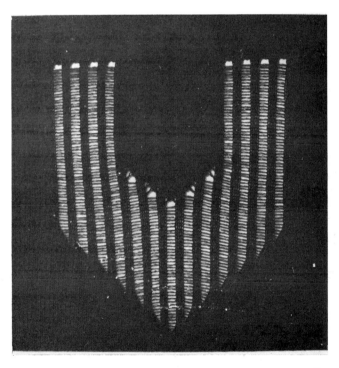

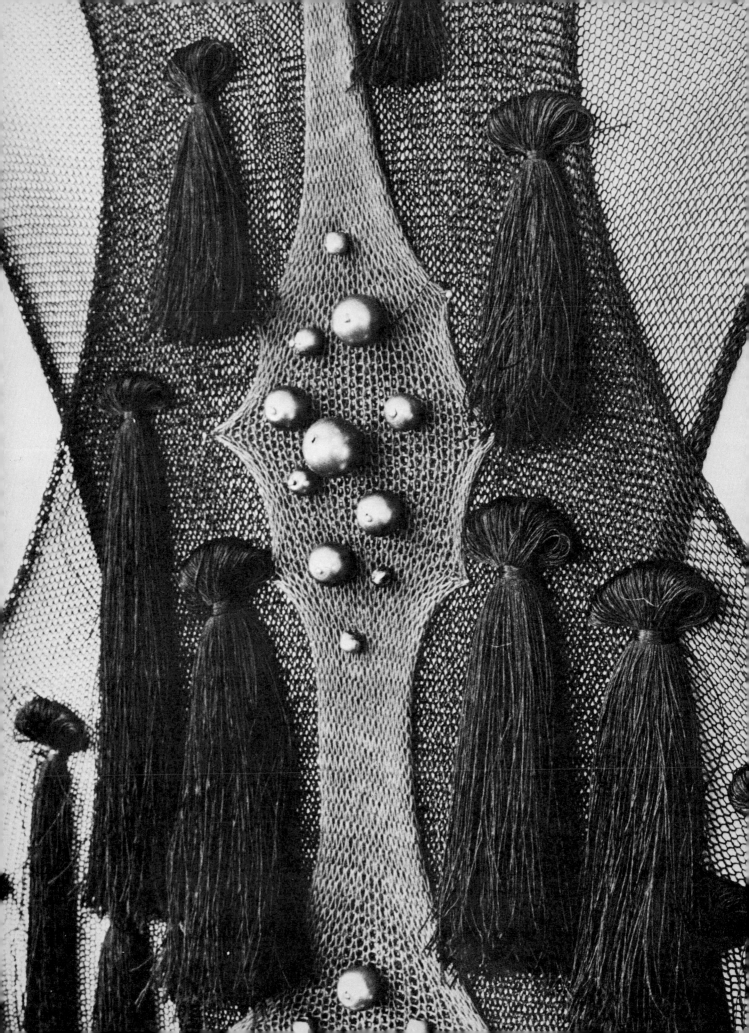

62

(61) Detail of 62

(62) Machine knitting and tassels *Queen* Irene Waller. The technique exploits the natural curl and stretch of knitting, 6ft × 2ft. Property of Miss Carol Waterhouse, London. Photo Alan Hill

Further study

Chamberlain, John F. T. I. *Principles of Machine Knitting* Textile Institute, Manchester, UK 1951

Prusa, Hans *Bindungslehre der Strickerei* Melliand Textil-brichte, Heidelberg 1958

Dubied Knitting Manual Dubied Machinery Co Ltd, Northampton Street, Leicester, UK

Knitting Machine Instruction Manuals (see Suppliers)

Suppliers

Domestic knitting machines

Knitmaster Ltd, 30 Elcho Street, Battersea, London SW11. Available through Sears Roebuck, USA

Jones Sewing Machine Co Ltd, 964 High Road, Finchley, London N12 *and* Brother International Corporation, 680 Fifth Avenue, New York, USA

The makers and suppliers of domestic knitting machines generally have tuition facilities available on request

Industrial and semi-industrial flat knitting machines

Dubied Machinery Co Ltd, PO Box 113, Northampton Street, Leicester, UK *and* The Dubied Machinery Co, 21–31 46th Avenue, Long Island City, New York, USA

Universal Machines, Oswald Donner & Co Ltd, 15 Jarrom Street, Leicester, UK *and* Universal Knitting Machine Corporation of America, 3080 Atlantic Avenue, Brooklyn, New York, USA

Santagostino Machines: Agent – Geoffrey Macpherson, West Bridgford, Nottingham, UK

Stoll Machines: Agent – L. A. Smith, 10 Station Street, Leicester, UK

The makers and suppliers of semi-industrial and industrial knitting machines install machinery and instruct operatives

For other knitting machine manufacturers see the *World Knitting Machinery Index*, published by the Hosiery Trade Journal, Millstone Lane, Leicester, UK

10 Looped fabrics: industrial weft knits, warp knits and stitch bonding

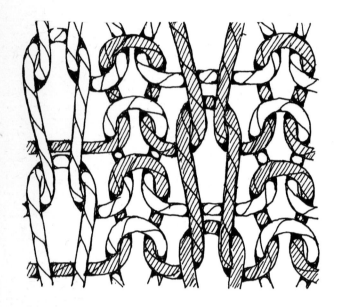

(63) Rib Jacquard

Industrial knitting moves us a step further still from the immediate tactile experience of handling yarn and in fact in some instances brings us near to the approach of the designer for prints.

Industrial weft knits

In the preceding chapter we have seen that most domestic and semi-industrial knitting machines have one or two straight needle-beds and are capable of producing flat or tubular yardage or shaped pieces. The knit constructions available are unlimited (sometimes obtained mechanically and sometimes by hand), but the gauge of the machine is never more than fourteen needles per inch, the average being seven. There are a few small circular knitting machines, limited in circumference and intended for the production of hosiery, although the designer can use them for sampling.

Because of the obvious extra speed and efficiency of the circular principle over the straight (no wastage of time or motion in turning back) circular machines have been developed in industry further than have flat for high-speed yardage. Circular machines are also in use for some types of garment production. Flat machines such as we have already discussed are used mostly for fully-fashioned garment production and stitch-shaped garment pieces.

Circular machines

Circular machines can produce from hose size up to cloth sixty inches in circumference, which is either left tubular or opened out. The cams and needle selection mechanisms are placed around the circumference of the machine against the needle-bed. Knitting is now very high speed and therefore yarn choice, to a certain extent, limited. The number of yarn feeders, or knitting points, can be up to ninety-six: this means that as many as ninety-six courses can be knitted in one revolution of the machine. To the knitting designer, one of the important features of the

circular knitting machine is that some of them free him graphically in the same sense that a Jacquard mechanism does the weaver (67). The gauge can now be very fine (twenty-two needles to the inch, exceptionally as many as twenty-eight), thus producing thirty to fifty loops per inch or 900 to 2,500 per square inch when the fabric is relaxed; this means that graphic forms and colour areas can be free and clearly delineated. The designer can now work aesthetically almost within the same terms of reference as a designer of prints (photograph 67). However, the areas available in which to design are often variable on the one machine and a knowledge of the manipulation of these areas is necessary.

Circular machines are of three basic types:

1 A plain web (single jersey) machine with one set of needles, set upright in the cylinder and producing plain and patterned single jersey, stripings, platings (two colours knitted together), laid-in constructions and pile fabrics.

2 A rib (double jersey) machine with, besides the cylinder of upright needles, a second set of needles set radially in a circular dial and producing ribs, variations of ribs, plain and patterned double jersey, interlock and relief constructions. It is these machines which give the designer true freedom, because of the Jacquard-like selection of needles. As with a Jacquard loom, the design-width limitation can be as little as eighteen wales or as much as the whole fabric circumference. The number of colours occurring in the design is generally limited to four.

3 A purl machine, with two cylinders, one set directly above the other positioned like a box and its lid, with double headed needles passing between them – this produces fabric with back and face loops in one wale, resulting in structural fabric design of face against back loops, often in self colour (compare piqué hand knitting).

Stitch-shaped garment production can be done on circular machines (generally rib or purl machines). These machines produce garment portions or blanks in which quite a lot of the constructional details of the garment are knitted in, e.g. the rib waistband and cuffs, and a patterned body. Shaping is produced either by changing progressively the size of loop, or by the type of structure (compare the different amount of surface area of knitting produced by twenty courses and wales of rib against twenty courses and wales of plain fabric). The garment portions are produced on the machine, one after another, like sausages, and when separated they need very little cutting to be converted into the final garment.

Flat machines

Fully-fashioned garments and garment portions (in which shaped pieces are achieved not by cutting but by adding or subtracting stitches), belts and trimmings are produced on mechanised flat machines. These are almost invariably the 'straight bar' type of machine, which is a direct evolutionary descendant of Lee's hand frame, and employs the same basic action. The machine is highly productive; as many as thirty-six garment portions being produced simultaneously. Although there are both rib and plain varieties of this machine the patterning scope is limited, most machines producing only plain fabric, with the occasional machine having loop transfer, striping, tucking or intarsia (areas of unbroken colour) attachments.

There is a large number of powered, flat, latch-needle machines of both rib and purl varieties in industry, mostly employed producing stitch-shaped garment portions. They are like scaled-up versions of the semi-industrial machines already described. Among this group of machines are the most versatile of all knitting machines, with full Jacquard selection (no design-width limitations and length only physically limited by number of cards or steels) to knit or miss, knit or tuck, or to transfer loops, and with limited fully-fashioning capabilities. The most interesting developments in the knitting world are in this type of machine; gauges are getting finer and fully fashioning mechanisms more refined.

The foregoing can only be a brief summary of weft-knitting methods, but within the field lies a

(64) *Limelight* Jack Lenor
Larsen Inc, New York. Warp
knit curtain fabric. Photo
Tom Crane

vast world of design possibilities. Fabric yardage is produced for every conceivable end use in both fashion and furnishing. The fashion end uses are easy to envisage, and in the furnishing field knits cover upholstery, curtains and carpets. Whole garments and part garments are produced, either by stitch shaping or fully fashioning; and accessories like hosiery, hats, belts, trimmings. All this is capable of being produced in every possible knit construction, from the hand-knitter's 'stocking stitch' to simulated terry towelling and fur fabrics. A designer in this field needs a detailed understanding of basic knit constructions and a knowledge of the capabilities of the particular machine for which he is designing.

Warp knits

The principle of warp knitting is different to weft knitting on three counts: the direction of the yarn path within the fabric; the loop; and the machine. Whereas in weft knitting the component threads travel across the fabric, in warp knitting the threads travel, as the name implies, up the fabric in a warp- or wale-wise direction, and are interlooped together. In weft knitting the loop construction is an open loop, in warp knitting both open and closed loops occur. The machines do not resemble anything so far described. The main visual impact is of a vertical sheet of yarns coming from beams, and the absence of yarn cones.

The general principle of warp knitting is as follows: the threads, at least one for every needle in operation, come from a beam or beams (like weaving) generally placed above the knitting mechanism. They then pass through guides, set in guide bars, which are responsible for wrapping the warp threads around the needles. The bearded needles (51[12]) are mounted almost vertically in a horizontal bar and move collectively.

To form a course of loops the guides, small flat metal fingers with holes in the ends, swing through the needles to the beard side and perform a wrapping motion of one or, very rarely, two, needle spaces, before swinging back to the stem side of the needles.

This wrapping action places at least one thread from the warps around each needle in a loop-like formation. The needles now lower and the yarn is drawn through previously knitted loop already on the stem of the needle. While this is taking place the guide bars move again laterally across the back of the needles. It is the magnitude of this movement (the underlap) that largely determines the construction of the fabric. Each guide bar can move independently and in different directions to form this underlap.

Most of the machines in industry have only one needle bar and form loops in one direction only, equivalent to the 'plain web' machine of weft knitting. There are, however, two needle bar machines (true Raschel) of coarse-gauge latch needle type, that produce two-faced or rib-like fabrics. There is even a warp knit equivalent of the purl machine known as the Waltex that forms loops first in one direction and then in the other, although this machine is very uncommon. Warp knitting machines nowadays use mostly bearded needles with latch needles for coarser gauge. The machines vary according to gauge, the number of independently-operated guide bars (equivalent to the number of shafts in a dobby) and, to a lesser degree, the addition of gadgets such as cut pressers, fall plates, and weft insertion devices.

Designing involves planning warp yarn types and the threading and striping arrangements. The paths of the guide bars are plotted on dotted paper and translated into numbers relating to the displacement of the guides from zero position at each overlap and underlap. From these number series, chains are made up which control the guide bars to produce the construction. At present there are no hand-operated warp knit machines, with the exception of the Waltex, that can be used at an experimental stage, and this presents difficulties for the designer. So-called sampling machines tend to be scaled-down, powered versions of production models needing warping and chain assembly as in the full-scale production model. Experienced designers tend, therefore, to think abstractly and work straight from conception to full-scale production. This approach requires a great knowledge of the effects produced by various constructions.

Though the machines are relatively simple, when compared to weft knitting, the products of warp knitting are tremendously complex in construction. Even the standard fabrics – lock-knit, shark-skin, queen's cord – contain two or three sets of threads in layers within the fabric, each set following different paths. In a Raschel lace fabric on a ground net thirty or more different groups of threads move independently of one another to form a laid-in design. There is an immense range of warp-knitted fabrics from hairnets to wool dress fabrics, including several standard fabrics produced in vast quantities from continuous filament man-made yarns for lingerie, shirtings, bed linen, and fabric for printing. Current interest lies in attaining very stable fabrics for men's suitings in particular. This has mostly involved laying in yarns, either fully across the fabric (weft inlay) or partially (Co-We-Nit). The would-be designer requires specialist training (see Courses of Study).

Stitch bonding

Laid-web fabrics are a development of the last twenty years. Warp knitting is sometimes an element in their composition, in which case they are produced on what are often called sewing-knitting machines. The method consists either of laying a web of fibre or yarn on a flat surface, and then holding it together by various means; or presenting a preformed fabric to the knitting area in order to be further embellished. Some of the various 'means' referred to involve fusing the fibres or yarns together and do not come within the scope of this book. But one of the means, stitch bonding, is covered here (65). In the latter the web is stitched together by a form of warp knitting. This technique produces a fabric characterised by slight vertical ridges. Stitch bonding by this means can be broken down into five categories:

1 The stitching of a web of fibre by itself (no stitching yarn involved, just the back of the web brought forward in a stitch formation) producing mainly interlinings and waddings (Arabera or Malivlies machines).

95

(65) Stitch-bonding. The three top fabrics were stitch bonded by Heron Fabrics, Lancashire. Photo Alan Hill

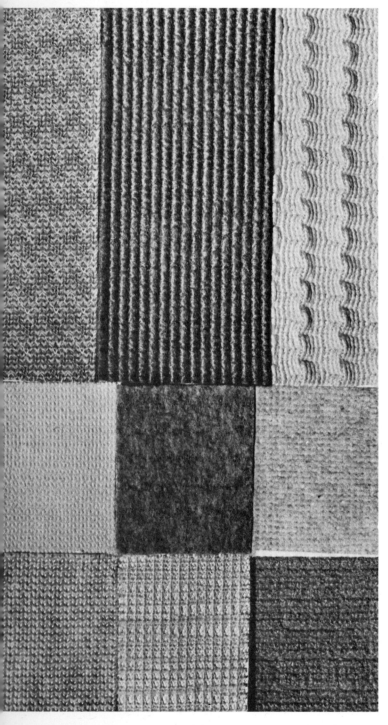

(65) Stitch-bonding. The three top fabrics were stitch bonded by Heron Fabrics, Lancashire. Photo Alan Hill

2 The stitching of a fibre web with a continuous filament yarn to create flat fabrics for household and fashion textiles (Arachne and Maliwatt machines).

3 The stitching of a fibre web in loop-stitch construction with a spun yarn to produce pile fabrics for upholsteries and floor coverings (Araloop or Maliwatt machines).

4 The stitching of a web of laid yarns by continuous filament yarn to create open leno-type fabrics for fashion and for curtain fabrics – this process has considerable design possibilities (Malimo and new Arutex 1800 machines).

5 The stitching of a pre-formed fabric (woven or knitted) with a loop stitch and a spun yarn to produce towellings and beachware; the height of the loop can be variable (Araloop and Malipol machines).

The whole process is incredibly high speed, the maximum amount created being about 450 metres an hour. Methods 1, 2, 3 and 4 require only the laying of a web and the warp knitting process, thus eliminating many of the usual textile procedures, and are therefore economical. The fabrics can be raised and finished in a wide variety of ways. Stitch bonds account for a smallish proportion of the textile market. Design possibilities lie within the variation of the web in colour and texture, the variation of the stitch in construction and yarn, and the treatment of the final fabric surface. Method 4 has possibly the most potential for really creative design development, but from the point of view of design this field is yet to be fully explored.

Conclusion

If we consider knitted fabrics as a whole, we see that knit yardage has invaded most of the fields hitherto provided for by weave – figured fashion and furnishing fabrics, towelling, shirtings, lingerie fabrics and linings, pile fabrics, simulated furs, carpets, etc. This is largely because of the economic advantage offered by the speed at which knitting can be produced, which in its turn has been aided by the special

qualities of man-made yarns. The fashion silhouette of the moment makes the knit structure in its original form an obvious one for realising fashion concepts. Because of these factors the knit structure is responsible for a very large proportion of the world's total textiles. Fabrics sometimes have properties all their own, and sometimes have to be viewed under a textile glass to be distinguishable as knits at all. They can be exploited either for their unique stretchy qualities (e.g. stretch chair covers and the rib against plain knit of stitch shaped garments) or these qualities can be stabilised (e.g. laminated jersey tailoring fabrics and already-lined curtain fabric), or they can be constructed with varying dimensional properties, from rigid to elastic.

The designer for knits is more dominated by the machine than is the designer for weaves because the machines are more complex. Not only does the designer need to have an extensive knowledge of knit fabric construction but also an understanding of the design capabilities, i.e. type of machine, number of needles per repeat, gauge, number of yarn feeders available, etc. of the particular machine to be utilised. Designers in this area should have fashion as their main design skill along with the capabilities and knowledge already outlined as needed of the textile designer. There is a movement of the knitting industry as a whole towards producing knitted garments rather than fabric from which garments are cut, as there are obvious and considerable savings in raw materials and labour. The weft knitting designers of the future then will be more and more fashion designers with textile construction skills.

Further study

Chamberlain, John FTI *Principles of Machine Knitting* The Textile Institute, Manchester, UK 1951

Johnson, Thomas H. *Tricot Fabric Design* Mcgraw-Hill, New York 1946

Krcma, Dr Radok *Manual of Nonwovens* Manchester Trade Press, UK 1971

Mills, R. W. *Fully Fashioned Garment Manufacture* Cassell, London 1965

Paling, Dennis FTI *Warp Knitting Technology* Columbine Press, UK 1965

Prusa, Hans *Bindungslehre der Strickerei* Melliand Textil-brichte, Heidelberg 1958

Stitch-Bonded Fabrics Shirley Institute, Pamphlet 100, Manchester, UK

Nonwovens 71 Manchester University Conference, Manchester Trade Press, UK 1971

Knitting Manuals, supplied by the knitting machinery suppliers

Suppliers

Weft-knit circular machines
Wildt-Mellor & Bromley Ltd, Adelaide Works, Aylestone Road, Leicester, UK

Stibbe-Monk Ltd, Great Central Street, Leicester, UK

Rimoldi (Gt Britain) Ltd, Manderval Road, Oadby Industrial Estate, Leicester, UK

Vernon Cooper, Gregory Boulevard, Nottingham, UK

Camber International, Leicester, UK

Warp-knitting machines
Coltex Ltd, Rectory Place, Loughborough, UK: Agent – Karl Mayer

Stitch-bonding machines
VEB Nahwirkmaschinenbau, Malimo
GDR 901 Karl-Marx-Stadt, Annabergerstrasse 97/99, Germany

For other machine manufacturers, see *World Knitting Machine Index* published by Hosiery Trades Journal, Millstone Lane, Leicester, UK

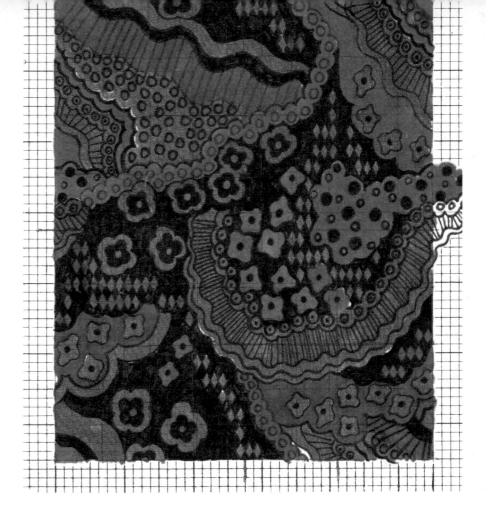

(66) Wall-hanging, Genny
Anderson, Birmingham
College of Art and Design.
The hanging incorporates
crochet in silver thread and
squares of metal, fur and
perspex. Photo Peter Keverne
(See Chapter 11)

(67) Jacquard knit, Brenda
Lewis for Jerseycraft. Painted
design and knitted fabric.
Dacron and cotton, in three
colours. Made on a GRJ
circular machine. Photo
Alan Hill
(See Chapter 10)

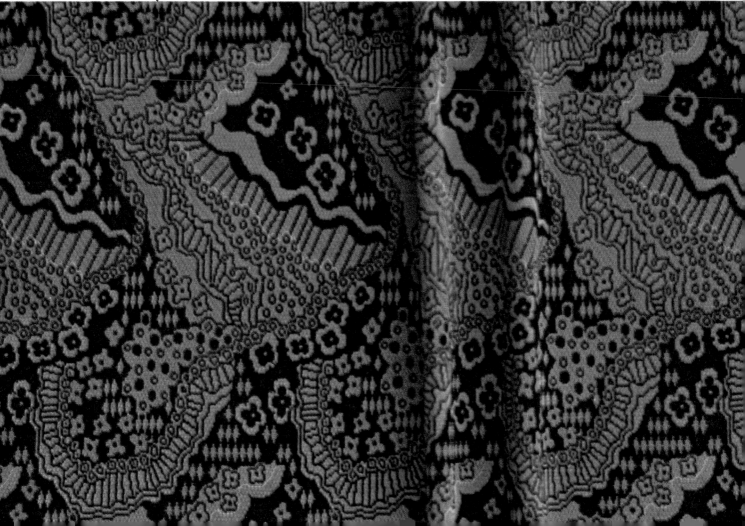

11 Looped fabrics: crochet

Crochet is the creating of fabric by hand, by both vertical and lateral inter-looping, and is therefore basically a more complex structure than knit. The only equipment needed is a crochet hook, and there is really only one stitch, the loop. It is the multitudinous variations of the loop which create the numerous patternings, though straight chaining often plays a large part in the construction. It has remained a hand method but it still has a certain kinship with warp knitting.

Crochet can be dense or open, fine or coarse, depending upon the size and type of yarn, size of hook and chosen stitch variation. The straight chaining makes it very adaptable for open work and this is why many kinds of crochet 'laces' have been developed. Solid crochet is, in general, a thicker construction than knitting. More stable and disinclined to curl, it stays satisfactorily flat and firm and does not ladder.

The most satisfactory yarns are those which slide easily and do not split. The work and the yarn are held in the left hand, the hook in the right. Correct yarn tension is incredibly important and is regulated by the fingers of the left hand. The working loop should be easy around the hook and not too tight. The work can be made flat and rectangular (the rows being worked backwards and forwards or in one direction only with a new thread for each row); flat and round and round, producing flat fabric circles; squares and polygons; cylindrical; or three-dimensional. There is little making up to do when producing garments or objects as all the shaping can be done as the work proceeds. The edges can be decorative and colour is easy to introduce, the new colour being joined on by splicing.

Starting with a slip-knot, a chain is made to form

(68) Crochet

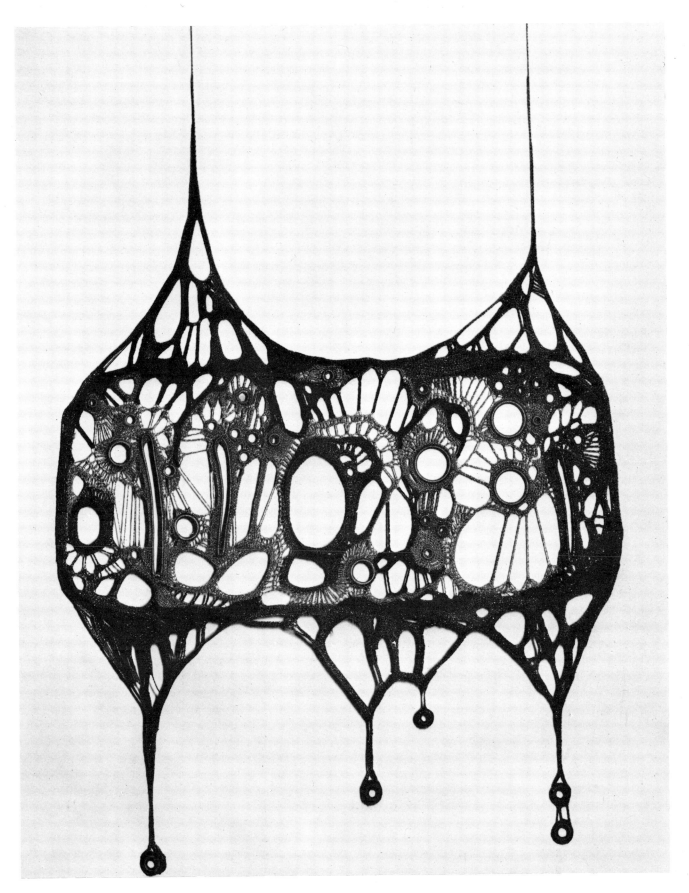

Crochet hooks vary in size. Fine to coarse.
Hook and yarn diameter must complement each other.

To begin: loop yarn, long end under. Catch this with hook (2), pull thro' and pull into a loop (not tightly). With yarn in left hand and hook in right, pass yarn over hook and pull thro' loop. This has made one stitch. Continue:

Slip-stitch or single crochet
With hook in loop, insert hook into next stitch, yarn over hook, draw thro' stitch and loop.

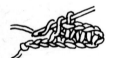

Double crochet
With hook in loop, insert hook into next stitch, yarn over hook, draw thro' stitch, yarn over hook, draw thro' two loops.

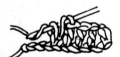

Half treble
With hook in loop, yarn over hook, insert hook in next stitch, yarn over hook, draw thro' one loop, yarn over hook, draw thro' all loops.

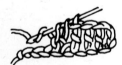

Treble
With hook in loop, yarn over hook, insert hook in next stitch, yarn over hook, draw thro', yarn over hook, draw thro' two loops, yarn over hook, draw thro' two loops.

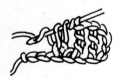

Double treble
With hook in loop, yarn twice over hook, insert hook in next stitch, yarn over hook, draw thro', yarn over hook, draw thro' two loops, yarn over hook, draw thro' two loops, yarn over hook, draw thro' two loops.

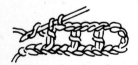

Spacing
With hook in loop, two or three chain, miss two or three stitches, treble or double treble into next stitch.

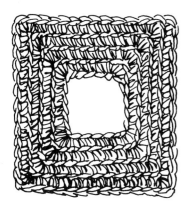

Make 24 chain, join with a single crochet. One double crochet into each of next 5 chain, three double crochet into next chain. Repeat 3 times. On each round increase number of one double crochet by two on each side of the square

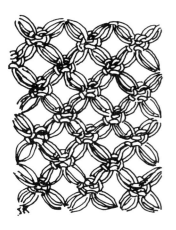

Make 1 stitch * pull loop to length of ½in. Yarn over hook, pull thro' keeping this loop small and keeping thumb and first finger left hand on the long 3-thread loop, insert hook between the double and single of these 3 threads, do 1 double crochet, continue from *. 2nd row, double crochet into 5th knot from hook, two ½in. loops, double crochet into 2nd knot onwards, etc.

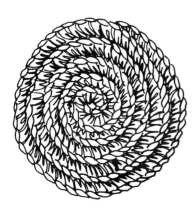

Make 4 chain, join with single crochet, make 3 double crochet into each loop (12 stitches), * double crochet in next loop, two double crochet in next loop, continue from *

the base for the first row (68). The first row is made by inserting the hook into the last loop of the chain, bringing the yarn over the hook and drawing through to make a new loop (slip-stitch), then into the next loop of the chain, and so on. After that, in general, pattern variations are achieved by the number of overs (yarn over hook) which are made and the order in which these are pulled through the loops. Diagram (70) shows how to cast on by chaining and how to make the basic stitch formations, slip-stitch, double crochet, half treble, treble, double treble and spacing, with the inclusion of one or two examples of fancy variations and some shape-making. Casting-off is achieved by pulling the working yarn through the last loop. These stitch formations are sufficient to begin a great deal of creative work, and should be experimented with in various thicknesses and types of yarn (see page 78 for suggestions), and with various sizes of hook. Try making an enormous hook from wood dowelling and crochet with rug wool. It was said at the beginning of this chapter that further patternings were innumerable. They include shell-like stitch formations; many variations of open 'lacey' patternings; knobbly textures descriptively called 'pineapple stitches'; looped surface fabrics like uncut pile; solid crochet with complex colour variations producing something akin to the visual effect of tapestry; and many other textures.

Variations of ordinary crochet are Tunisian crochet, Gros crochet, Irish crochet, and hairpin crochet.

Tunisian crochet is a cross between crochet and knitting, the crochet hook being long with a knob on the end. On the first row, instead of throwing off the old loop when making a stitch each loop is kept on the needle, thus forming a row of stitches; on the second row, with the work still facing the same way, the yarn is passed over the hook, drawn through the first loop yarn, over hook, draw through two loops, continuing in this way until one stitch remains. The third row is the same as the first, the fourth as second, and so on.

Gros crochet is made by first creating a crocheted, open, net-like ground, then crocheting isolated motifs which

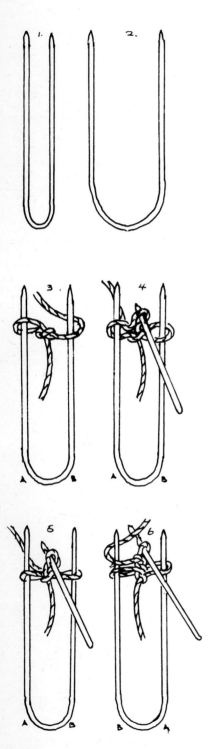

can be quite free in form and three-dimensional, and sewing these to the crochet ground.

Irish crochet is, again, isolated motifs on an open crochet ground but not sewn *onto* it as the ground is worked around the motifs. Originally it was an attempt to imitate lace and the motifs themselves were sometimes made to stand up from the ground by being worked over a padding cord.

Hairpin crochet is something quite different, both in method and result, and requires, as well as a crochet hook, a large steel or plastic U-shaped fork resembling a large hairpin (these come in varying widths) (71 [1, 2]). On this fork and with the aid of a crochet hook are produced strips of looped crochet (the loops face outwards from the centre and the crochet stitch runs down the middle rather like a fish-bone). The actual stitch is produced as follows. Make a large slip-loop half the width of the fork and insert the left prong of the fork (held U-shape) into this loop; hold the fork in the left hand; pass the thread round the front of the right prong to the back (71 [3]); insert a crochet hook into the slip-loop, catch the thread and draw it through the loop (71 [4]); pass the thread over the hook and draw it through the new loop (71 [5]). This is the basic stitch. Now turn the fork round one half-turn to the right, keeping the thread held over the fingers of the left hand. This will take the thread around what is now the left prong to the back and it is now ready to be drawn through, as before, by the crochet hook (71 [6]). The working edge must be kept near the top of the fork so that although the fork turns, the crochet hook can be passed over it, thus remaining in the same position and ready for the next stitch. The production of stitches continues until sufficient have been made or until the fork is full (in which case they are taken off, the top two or three repositioned on the fork and the work continued) and in this way strips of looped fabric are produced. These are then joined together with a crochet stitch. The actual centre stitch of the hairpin work, the chosen crochet joining stitch, and the number of loops taken onto the crochet hook at once for joining, can all vary.

(72) Hairpin crochet

1 Bands of hairpin crochet, crocheted together
2 Bands, with loops bunched together with beads
3 Bands, with tatting
4 With beaded ribbons, and used as fringe

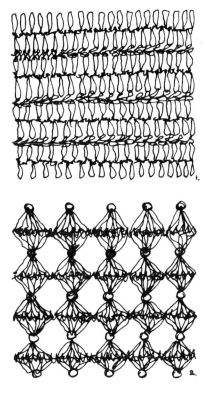

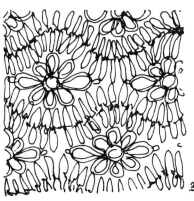

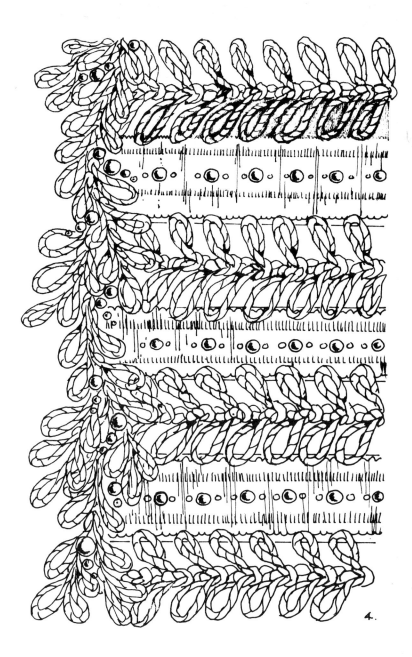

The strips can be joined by sewing onto ribbon instead (72 [4]). The name makes one think of the very fine hair-like work for which the technique was used so much in Victorian times, but consider producing the technique with soft thick wools, or roving, or metal yarns or jute, and one can immediately begin to see a contemporary application. The strips by themselves form quite good looped fringing (72 [4]).

To return to crochet in general, it can be used for any fashion purpose from great, thick, firm top coats or cloaks to lacey evening wear or jewelry. As furnishing it can be made into fabric yardage, solid or sheer, bed

covers and cushions. It can also be used as braids, edgings and isolated motifs (66). Eta Ingham-Morhardt's 'Pendant' (69) illustrates clearly the suitability of crochet in a fine art context, and although not illustrated in this book, the title of some textile objects by the sculptress, Ewa Jaroszynska, in sisal and hemp, 'Standing Forms', speaks for the technique's further adaptability.

Further study

Ashe, R. *Crocheting, for the New Look* Bantam, New York

Ashley, R. *Crocheting, the New Look* Grosset & Dunlap Inc, New York

Blackwell, Liz *A Treasury of Crochet Patterns* Charles Scribner, New York 1971

Book of Instant Crochet H. G. Twilley, London 1969

*De Dillmont, Thérèse *Encyclopaedia of Needlework* Editions Thérèse de Dillmont, Mulhouse, France 1930

Crochet D.M.C. Library, Comptoir Alsacienne de Broderie, Mulhouse, France

Groves, Sylvia *The History of Needlework Tools* Hamlyn Publishing Group, Middlesex, UK 1966

Kimmond, J. *Crochet Patterns* Batsford, London 1969

Koster, J. and Murray, M. *New Crochet & Hairpin Work* Calder, New York 1955

Learn to Crochet J. & P. Coates Sewing Group, Book no. 1065, Glasgow, UK

* *The Vogue Book of Crochet* Collins in association with Conde Nast, London 1971 (not available in USA)

Pattern and Instruction Books from needlework shops

Suppliers

Crochet yarns and hooks available from all needlework and knitting shops

Hairpin crochet prongs and all crochet necessities from The Needlewoman Shop, 146 Regent's Street, London W1

12 Interlaced fabrics: weaving without a loom

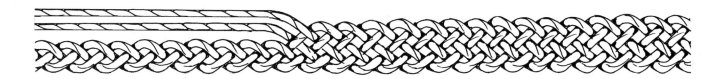

(73) Three- and five-strand plaiting

Anni Albers in *On Weaving* says that 'handweaving is a discipline able to convey understanding of the interaction between medium and process that results in form.'

Weaving is the interlacing of two sets of threads at right angles to each other. The warp (composed of individual warp-ends) is the vertical thread and the weft (composed of individual weft picks) is the horizontal thread in the cloth. The result is a basic construction of great stability and practicality with limitless design possibilities. Weaving is well known as a technique which requires a deal of equipment and preparation before one can begin to design and this prospect can act as a deterrent to the would-be designer. However, the generalization is not entirely true as it is quite possible to weave creatively without the use of a loom at all. In fact, weaving without a loom is probably the very best introduction to the technique, as, in the face of complex equipment, it is not always easy to remember that the machine is the servant of the designer.

Plaiting as an introduction

Plaiting or braiding can be a very good exercise for the potential weaver. On close examination plaiting will be seen to be an oblique interlacing or weaving on the diagonal but with multiple elements which become warp and weft by turns (73).* Most of us can plait with three threads but it is not always realized that plaiting can incorporate as many components as

* In *The Primary Structure of Fabrics*, 'plaiting' is defined as an interlinking technique and therefore to use it to describe braiding or oblique interlacing is incorrect. However, in Great Britain the term is used so often that I have decided to use it here.

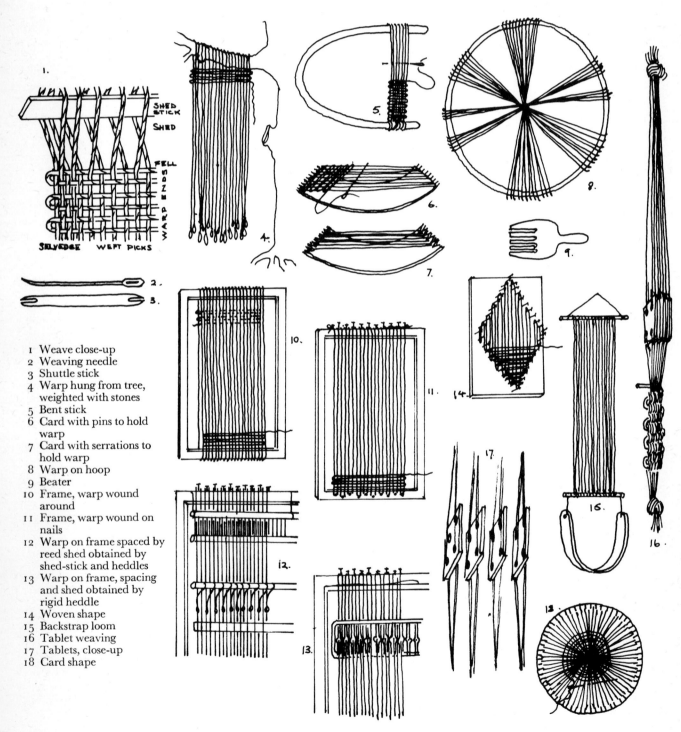

1 Weave close-up
2 Weaving needle
3 Shuttle stick
4 Warp hung from tree, weighted with stones
5 Bent stick
6 Card with pins to hold warp
7 Card with serrations to hold warp
8 Warp on hoop
9 Beater
10 Frame, warp wound around
11 Frame, warp wound on nails
12 Warp on frame spaced by reed shed obtained by shed-stick and heddles
13 Warp on frame, spacing and shed obtained by rigid heddle
14 Woven shape
15 Backstrap loom
16 Tablet weaving
17 Tablets, close-up
18 Card shape

the fingers can manipulate and that each of these can be composite (see [73], photograph 11, and [75]. Very wide plaiting can be accomplished by pinning it out on a Celotex board.

Weaving

The only equipment required for weaving is some form of frame on which to wind and tension the warp ends. Ancient weavers slung their warp ends over a tree branch and weighted them with stones (74 [4]) or attached them to a low horizontal branch and secured the other end of the warp to a rod and then to a belt around the waist (backstrap) (74 [15]). Another ancient loom of particular charm is a long pliable branch bent into a U-shape with the warp ends stretched between the two arms of the U (74 [5]). The latter principle is more applicable to our needs now, as it is a great advantage to be able to carry work around.

The only necessary equipment is a frame; it is possible to produce large scale work up to a length of 6ft, or one could weave in miniature on the sturdy prongs intended for wide hairpin crochet (71), but for work on a more normal scale, picture frames, deck-chair frames, old screen-printing frames, carpenter-made frames, light-fitting metal rings and children's hoops (13), are suitable. These frames only need the thread stretched over them (achieve accuracy by pencil marking); once this is done the threads can be held temporarily in place by sticky tape. Firm card rect-angles are fine for small samples, as the card can be bent into a concave shape to allow room for weaving (74 [6, 7]). Cards shaped in circles and semi-circles also have their uses (74 [18]).

The choice of the warp thread is all-important: it must be strong enough (e.g. a tightly twisted plyed yarn) to withstand the constant friction caused by the passage through it of the weft on the yarn carrier. Yarn spacing is the next consideration: if a closely woven fabric is required one spaces the warp ends close enough together to just allow the weft thickness be-tween them. If a repp is required (88 [8]) there must

Plaiting is weaving (one over one under and vice versa) on the diagonal, but with multiple elements
Plaiting can use as many threads as the hands can hold

1
Left over middle, right over middle

2
As for three with thread four passing under

3
Left over nearest two, right over nearest two

4 – 6
Left hand holds the left hand thread, right hand holds rest. Left hand thread passes over and under all rest

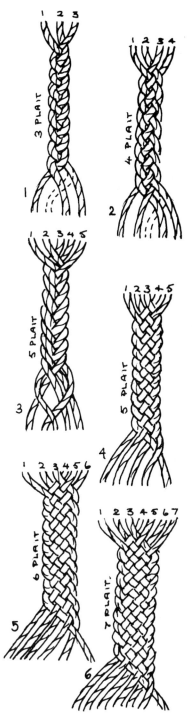

be twice as many warp ends as are needed to cover the weft completely to make a packed warp-faced fabric. If a tapestry or weft-faced fabric is required (88 [3]), the warp ends should have the space of three weft thicknesses between them. On the other hand, irregular spacing of and moving around of the warp ends can also be a creative force (13). Having chosen the yarn, decide on the spacing and wind the yarn onto the frame in one of the following ways. If the piece of work needs the warp ends to be regularly spaced, then this can be achieved by winding the warp ends on nails (74 [11]); in grooves; or by threading them through a spare reed (warp spacer) tied to one edge of the frame (74 [12]), but this latter only if the warp ends are finally to be cut as the work cannot be removed unless they are.

Next insert the weft. The simplest way of doing this is to thread yarn in a weaving needle and interlace over and under the threads right to left for one pick (row) and under and over left to right for the next. A quicker method is to insert a stick over and under through the threads, which when turned on its side provides one automatic over and under shed (opening in the threads), utilized when working left to right. This is called the natural shed. Weaving right to left the yarn has still to be interlaced by hand with the needle. If one makes string heddles as in (74 [12]) one has, together with the natural shed stick, two automatic sheds and one can pass thread through easily.

If the whole of the area of warp-thread is to be used, or if the warp is to remain on its working frame (another framing superimposed on top will cover the warp ends and can be visually pleasing), then these are the only methods of shedding available because they are removable. But if the work is to be taken from the frame and the ends cut, a simple and satisfactory method of shedding is to thread the warp ends through the holes and spaces of a rigid heddle (the widths and number of ends per inch of these are limited) while winding the warp on the frame (74 [13]).

For carrying the weft across the warp it is of course possible just to use the fingers. A large blunt needle or a weaving needle (74 [2]) is the next possibility (the ancient weavers wound their yarn very tightly on pointed quills). Finally there is the shuttle stick (74 [3]).

Suggestions for the final framing and mounting of work are in the last chapter. Working on a frame has distinct advantages; it is portable and cheap; several pieces of work can be in progress at once; and a large number of frames can be stacked in a small space. This method can be of the greatest use to painters, sculptors and designers in other media who have no wish to get involved with making cloth but feel the necessity to use fibre and thread.

Finally, there are one or two small gadgets which further make weaving without a loom possible. One is a set of tablets for tablet weaving. These are small square cards with a hole in each corner through which the warp ends are threaded singly. The tablets are stacked together like a set of playing cards and the four holes act as a four-shaft loom when the cards are turned. The work has to be attached to a stable object at one end and tied around the weaver's waist at the other. The width, but not the length, of work is limited and one can make belts, braids, headbands or ties of a warp-faced nature, very effective if produced in soft, thick, bright wools (74 [16, 17]). Another tool is the rigid heddle itself which, as stated before, can be used as the shedding mechanism but this time for a warp which, like tablet weaving, is attached at one end to a stable object and at the weaving end to the weaver's waist. The heddle speeds up weaving and ensures that it is accurate and well spaced (15 [13]). This has brought us round again to the 'backstrap' loom principle, which is merely the attaching of warp to weaver by means of a wide strap around the waist. Warp tensioning can be achieved simply by leaning slightly forward or back (74 [15]).

Design possibilities

The warp can have a very strong, decorative value of its own, with the weft playing a minor part (as in 91); warp and weft can interplay (76, 77); or, and this is particularly worthy of consideration, the warp can be regarded merely as a means of holding the weft. For

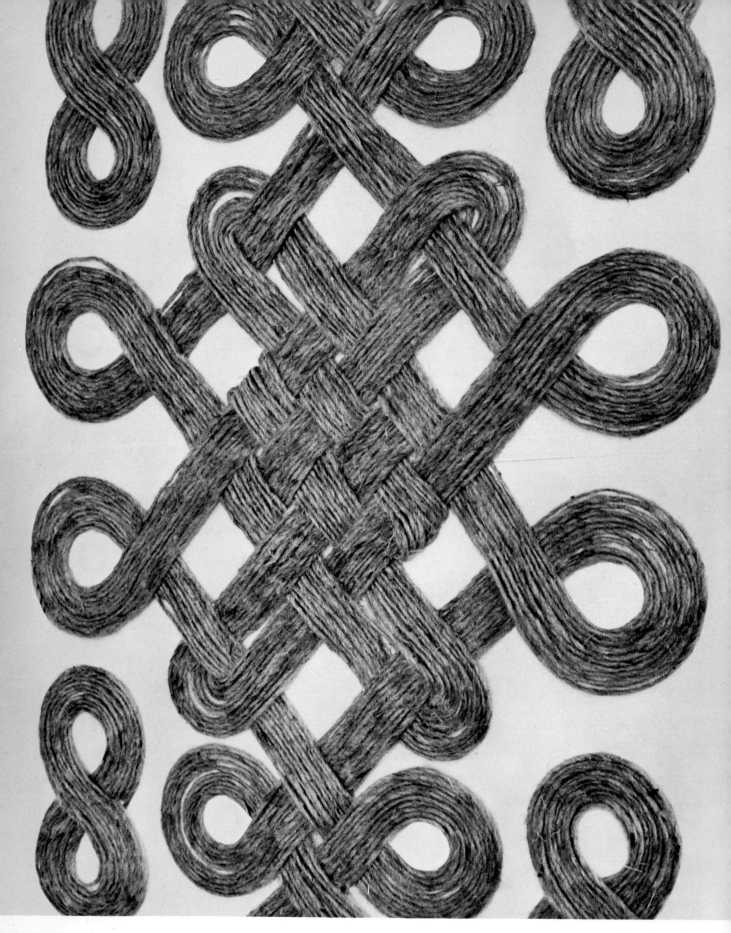

(77) Woven structure produced by hand manipulation, Celtic, Irene Waller. Jute yarns side by side, interlaced on celotex board and held with dilute PVA. Photo Alan Hill

(78) *Fabric destruction*, Irene Waller. The removal of threads from existing cloth is to form the design

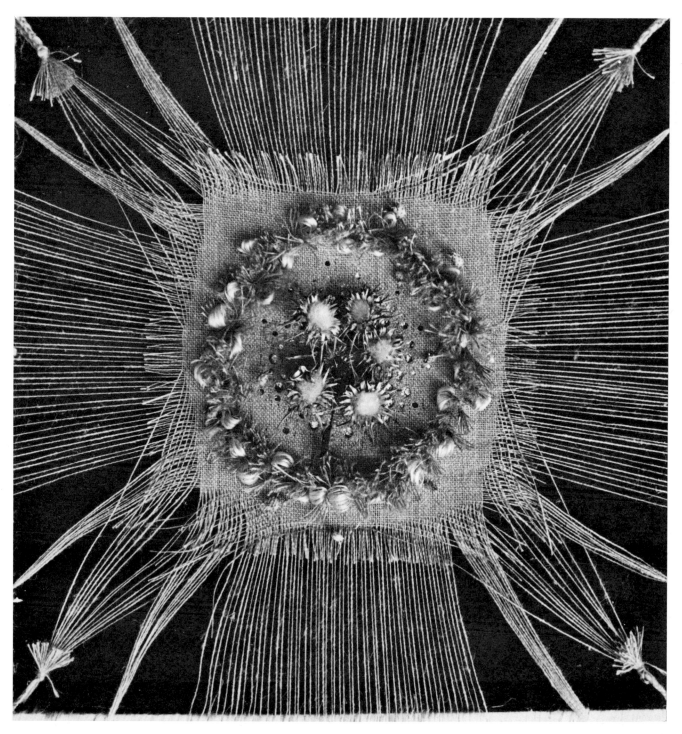

example, if a very fine nylon thread is used, the warp will make almost no demands and graphic images can be imposed by the weft without hindrance (94, 95). The weft need not be restricted to an absolutely horizontal path; it can wander at will, pressed down with the fingers, or with a beater or a fork (94). A full-scale drawing can while working be secured behind the work, or the design can be painted on to the warp ends.

The imagery and inventiveness capable of realization without a loom are endless and it must be realized that all the design possibilities which are available when producing plain weave on a loom (see pages 124–8) obviously apply here also and the reader is asked to refer now to that section. Photographs 13, 76 and 77 show three interpretations of the woven structure without the aid of a loom.

'Sprang' which is often described as a woven technique and, as such, might expect a place in this chapter since it does not need a loom, is dealt with later in the book because it is totally composed of twisting.

Further study

*Albers, Anni *On Weaving* Wesleyan University Press, Middleton, Connecticut, USA 1963; Studio Vista, London 1966

Allen-William, E. *Girl Guide Knot Book* (for plaiting) Girl Guide Association, London 1969

Atwater, Mary *Byways in Handweaving* (about braids) Collier-Macmillan, New York 1951

Rainey, Sarita *Weaving without a Loom* Davis Publications, Worcester, Massachusetts, USA 1966

Thorpe, Azalea and Larson, Jack *Elements of Weaving* Doubleday, New York 1967

Wilson, Jean *Weaving is for Anyone* Reinhold, New York; Studio Vista, London 1967

Tablet Weaving Dryad Press, Leicester, UK

*Rainey, Sarita *Wallhangings, Designing with Fabric and Thread* Davis Publications, Worcester, Massachusetts, USA 1966

Suppliers

Cards, tablets, rigid heddles, shuttle sticks, etc. from Dryad Ltd, Northgates, Leicester, UK

Tiny bead weaving frame from Ells & Farrier 5 Princes Street, Hanover Square, London W1 (mail-order from Montserrat Crafts, Chequers Parade, Prestwood, Buckinghamshire, UK)

13 Interlaced fabrics: preparation for weaving on looms

Looms are very versatile (16), being mainly a tensioning frame and thread manipulating mechanism. The manoeuvrability of the heddles (string or wire) (15 [11]) and the changeability of the reeds (warp spacer) (15[32]) means that any one loom can produce a wide variety of fabrics.

Weaving on a loom requires a great deal of mental and physical preparation. But the repetitious nature of the work frees the mind for other considerations. In order for this to happen the processes must be understood and thoroughly mastered so that they can be carried out accurately at speed. A group of people working together can save time by setting on long warps, on which all work in turn. Long warps are useful anyway as there is then always a warp available when an idea strikes. As indicated in Chapter 1, wide warps (when sampling) composed of various threadings and colour changes, or white warps stained with areas of different colours, are also great time savers. Two people working together are faster than one, but each weaver must be able to work alone and instructions are based on this premise.

Considering the design

Let us assume that you wish to set on a blanket of sample designs for upholstery fabric. You have never done this before, but you have a very clear idea about how you want the final design to look and feel, having considered the sort of interior into which it is to fit and what aesthetical and practical function it is to perform. (A 'blanket' is a piece of cloth composed of many design trials.)

First, set the design idea down in some tangible mock-up form (Chapter 1), and then consider the proper materials for the job (Chapter 4) – cotton warp and wool weft would be one possibility. Examine existing upholstery fabrics which are on the market; this will give information about warp sett (number of warp ends per inch), picks per inch, size of yarns, suitable weave structures, etc. Now consider the type of weave, bearing in mind that upholstery must be firm with no long floats liable to catch. (Weaves are

(79) Adjustable knot

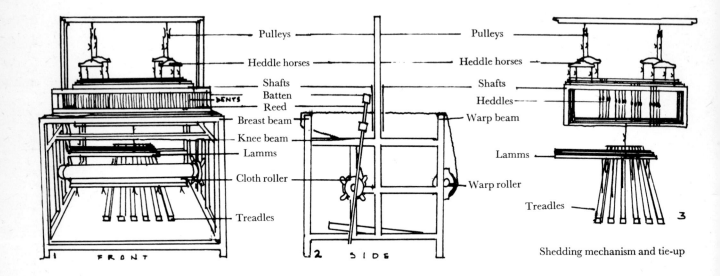

discussed in Chapters 14 and 15.) If your knowledge of weaves is only in embryo it is very helpful at this point to consult the textbooks which give both a description and a photograph of weaves as well as the weaving instructions (see Bibliography). Decide whether the chosen weave is exactly right or whether it requires modification. Lastly, decide how big a design sample is required to evaluate a cloth and how many variations (both in construction and in colour) should be set up. In my opinion, especially at the beginning of a design career, you can be prodigal at this stage, learning far more by putting on plenty of warp with many variations. Not only does it help solve the project in hand, but often side-issues are thrown up which can be halfway to solving another later project. Meanwhile the exercise is adding to your total experience and essential weave vocabulary. So, for example, you might decide to weave a design blanket 2 yards long by 36in. wide, threaded in the heddles in three different but related ways, each threading being composed of three different but related colourings. Each sample woven will therefore produce three different weaves, each in three different colour ways. This can be taken to excess, of course,

and result in wastage, if careful consideration is not given to relating colours and threadings.

The warp

Choose a strong, plyed warp yarn (test it by subjecting it to tension and friction) and decide whether it is suitable. Wind the yarn around a ruler with the yarn's own thickness left as spaces between (don't count the 'hairyness'); the result will be an average sett. The sett of a woven cloth is the number of warp ends per inch. To decide the sett in detail one must consider first the thickness of the warp yarn, then the thickness of the weft yarn, and then the chosen weave construction. A plain weave, in which all threads are weaving all the time, will require fewer warp ends per inch than a weave in which threads are only tied in occasionally, like a twill or a satin.

Warp calculations

Now calculate as follows: the length of the warp =

Warp removed from posts by chaining,
singles cross tied, grouped cross held
by cross-sticks and entered thro'
raddle and looped onto stick

The cross

Harness removed for
beaming. Batten removed

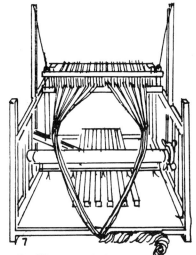

Raddle suspended. Warp
attached to cloth beam and
held firmly in two hands.
Beamed with paper

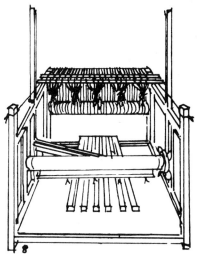

Raddle removed. Sticks put
in singles cross, cross
suspended for threading

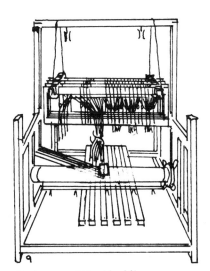

Ends entered thro' heddles.
Waiting ends weighted for
easy control

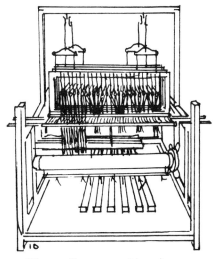

Tie up of harness at this point
(diag. 3).
Ends dented thro' reed placed flat

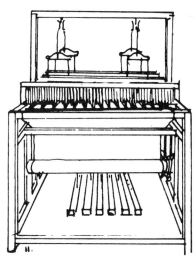

Batten replaced. Reed placed
in batten. Warp ends tied on

117

total length of the piece of cloth or the series of designs required, plus allowances for shrinkage, trial weaving and loom waste (variable according to the loom). The number of warp ends=sett×number of inches wide, plus allowance for shrinkage plus selvedge. The selvedge is $\frac{1}{4}$in. or $\frac{1}{2}$in. of close weaving at both edges, double the sett of the cloth. It should be plain weave, if possible. The ends are entered singly through the heddles and double through the reed. If a weave is complex the selvedge should be entered on extra shafts to obtain a plain weave. So, if the sett is twenty, the calculation for the blanket could be: length of warp=72in. plus 12in. (trial) plus 18in. (waste)=102in.

Number of ends=20×36, plus 20 (two $\frac{1}{4}$in. selvedges) =740.

No shrinkage allowance has been made in the above calculation – when designing, as opposed to weaving, cloth, shrinkage does not really matter. What does matter is to measure the samples both unwashed and washed and keep a very careful note of shrinkage measurement for later reference. The warp calculations are entered on a warp card (81 [8]), and the warp can now be made.

Warping

Warping is the making of yarn into the correct number of ends, of the correct length, for the desired cloth amount. Instructions are taken from the warp card (81 [8]).

For warping, there are three main pieces of equipment: warping posts, these can be put away in a cupboard but can only make a simple warp of limited length (15[12]); a warping board (this requires wall space, but enables the weaver to make a warp of up to about 10 yds, see (15 [34]); and a warping mill – a most efficient method for hand weaving, making very long warps possible with a minimum of effort (15[1]). A heck-block (15 [31]) used in conjunction with the warping mill places the warp on the mill and enables warping in twenties or more at a time. If you have no equipment at all, nails in the wall or chair backs can be used.

The principle of warping is to have two sets of double posts or pegs set as far apart as the calculated length of the total warp (15 [14]). The warping board and mill shorten the distance by zig-zagging the warp, in the case of the former, or by winding it around a circumference in the case of the latter. The warp thread is wound onto the equipment with the double posts used to form the 'crosses' (15 [12 and 34]). The crosses keep warp ends or groups of them in place. The warp, which can be made with one or many threads at a time, has two crosses: a very important singles cross at one end to keep each single warp end in its own place; and a grouped cross at the other to assist in raddling quickly. The raddle is the wooden comb used for spacing the warp onto the beam and has one space per $\frac{1}{2}$in. (15 [33]). When warping with more than one thread at once the threads will come from spools or cones on a creel. If the number of ends warped at a time=$\frac{1}{4}$in. across the width of the cloth then the resulting group in the cross will correspond to $\frac{1}{2}$in., i.e. one space in the raddle. *Note that beginners should warp with one thread only*. Both crosses are tied firmly on completion of the necessary number of warp ends, and the warp removed from the posts by chaining (i.e. using the hand as a crochet hook), starting from the singles cross and leaving the grouped cross unchained and protruding. Insert the cross-sticks into the grouped cross and release the tie. Drop each group into one space of the raddle, and thence onto a warp stick at the other side of the raddle (80[4]). Secure the top of the raddle firmly and attach the warp stick to the back-beam of the loom (in this description a counterbalance loom has been used.

Beaming

Beaming is the winding of the raddled warp onto the warp or back beam of the loom. Make sure that the loom is very firmly anchored (with a big loom, no problem; with a small loom, clamp it). With the raddle secured in front of the warp beam, face the loom and walk backwards, gently unchaining the warp. Then, when you are a fair distance away, grasp the warp

firmly and gently shake it so that any threads which have become displaced while raddling can shake back into place. Each thread was in place during the warping and each thread must be back in place during beaming.

Beaming should produce a firm, even cylinder of yarn. This can be achieved by a generous insertion of stiff paper or sticks wound on with the warp and protruding well either side of it. At intervals give an extra firm pull, as a loosely beamed warp takes a long time to settle down. The beaming can be carried out by standing either at the back or the front of the loom, depending on how much space there is available, but if you stand at the front, as has been described, all intervening harness must first be removed to get a clear path (80[6]). Beaming continues until the end of the warp with the singles cross is level with the breast-beam. Insert cross sticks into the singles cross, releasing the tie; the grouped cross has done its work and can now be dispensed with and the raddle removed. Settle the singles cross-stick in front of the back beam and either suspend or hold it with sticks (80[8]). Cut the warp loops ready for threading.

Threading

For notes on drafts see (105). Place the removed shafts back into the loom, with the correct number of heddles on each. In the case of a foot loom the shafts should rest on shaftblocks so that the lateral movement of the heddles is not obstructed (80[9]). Secure bundles of warp ends and thread according to the chosen weave. Have a good, clear working space when threading; move the threaded heddles decisively out of the way, check every repeat carefully and tie the repeats in loose bundles.

Tie-up

It is at this point that the tie-up is carried out (80[3]). There are always as many lamms as shafts, and shaft one is tied to lamm one and so on. There is nothing to prevent a further straight tie-up, i.e. lamm one to pedal one and so on, but difficulties arise when a weave needs, for instance, three shafts depressed at once, because this would need three pedals and three feet! So predetermine your pedallings or treadlings and, in this case, tie the three lamms all to one pedal. This makes the job of treadling easier and leaves as many other treadling possibilities as there are pedals available. For tying up on a counter-balance loom you need a ball of heavy loom cord and a knowledge of the adjustable knot, used wherever the distance between two objects is likely to need regulating (79). But with many looms, tying-up is simplified by set-length wires.

Denting and tie-on

Settle the chosen reed in front of the shafts (80 [10]), and thread (dent), making adequate selvedges (the selvedge is for strength and also the place for joining weft yarns). Replace the batten and insert the reed into it. Tie the warp to the front stick in bundles not more than 1in. wide, test the warp tension and tie a second knot when satisfied. Now everything is ready for weaving.

Shedding mechanisms

Before progressing to weaving, we must first describe the shedding mechanisms of other sorts of looms. When using a rigid heddle loom, just lift and lower the heddle, fitting it into the slots provided (16[1]). When using a table loom with shafts (16[2, 3]), the shafts generally slide up and down between runners on the loom canopy and only require to be hooked or tied on to the overhead levers which lift them; no more is needed for weaving to proceed because each shaft is directly lifted by its own lever.

Jack looms (the principle can be applied to table or foot looms) are looms in which, unlike counterbalance looms but rather like dobby looms, each shaft is operated individually and a rising shed is created.

Using a plain weave on four shafts as an example:

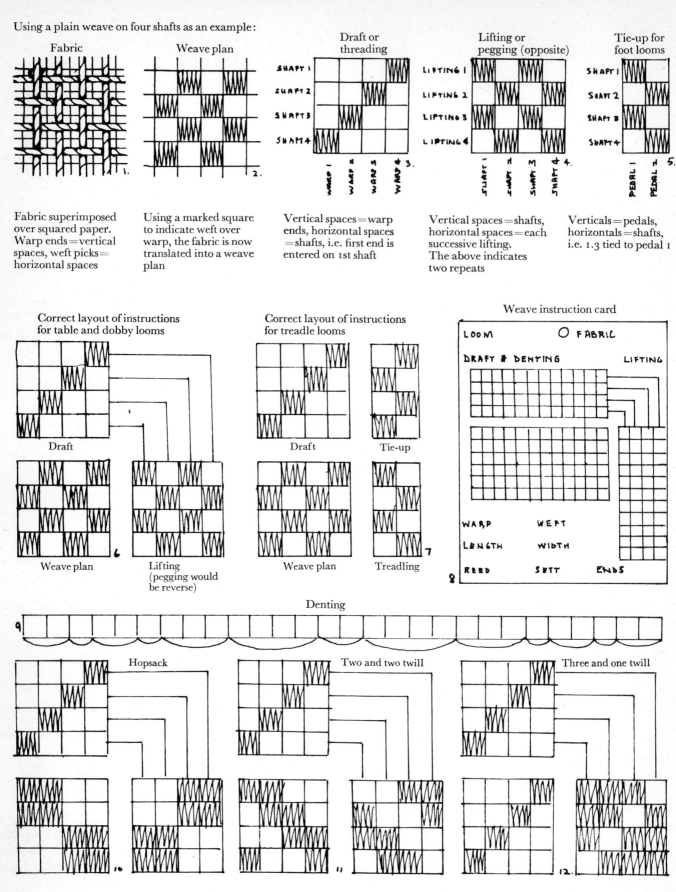

Fabric

Weave plan

Draft or threading

Lifting or pegging (opposite)

Tie-up for foot looms

Fabric superimposed over squared paper. Warp ends = vertical spaces, weft picks = horizontal spaces

Using a marked square to indicate weft over warp, the fabric is now translated into a weave plan

Vertical spaces = warp ends, horizontal spaces = shafts, i.e. first end is entered on 1st shaft

Vertical spaces = shafts, horizontal spaces = each successive lifting. The above indicates two repeats

Verticals = pedals, horizontals = shafts, i.e. 1.3 tied to pedal 1

Correct layout of instructions for table and dobby looms

Draft

Weave plan

Lifting (pegging would be reverse)

Correct layout of instructions for treadle looms

Draft

Tie-up

Weave plan

Treadling

Weave instruction card

LOOM O FABRIC

DRAFT & DENTING LIFTING

WARP WEFT
LENGTH WIDTH
REED SETT ENDS

Denting

Hopsack

Two and two twill

Three and one twill

The lamms are attached to the pedals to obtain the desired lifting sequence, just as on a counterbalance loom, but because the lamms are tied to cords which connect with jacks or pulleys above the shafts, which are, in turn, connected to the top of the shafts, the action of the pedal lowers the relevant lamms but lifts the relevant shafts. The jack principle is an excellent one, giving a very positive and foolproof shedding mechanism, and shafts can be added or removed as desired.

Countermarch looms are foot looms furnished with two sets of lamms between the shafts and the pedals and with 'jacks' at the top of the loom. The bottom of the shaft is attached to the top lamm; the top of the shaft has cords going up to the jacks, which are in turn connected by a long cord running through the middle of the shafts down to the other lamm. This gives a positive tie-up, as to depress a shaft the one lamm is attached to the pedal and to lift a shaft the other lamm is attached to the pedal. Countermarch looms are excellent for weavers wanting to produce considerable cloth yardage but the tie-up is complex and inflexible and the loom unsuitable for experimental designing.

Dobby looms require the weighted shafts to be tied onto the hooks which lift them, but weaving cannot proceed until the order in which the shafts are to be lifted is decided and translated into the 'pegging'. The dobby mechanism is only a mechanical aid to lifting shafts (16[6]). It is a set of upright hooks (as many as there are shafts) set in a frame; the hooks come against a revolving cylinder on which are placed a lacing of wooden bars called lags. Each lag has in it as many holes as there are hooks and shafts; there are as many lags in a lacing as there are liftings in a repeat and a shaft rises or falls depending upon whether the hole in the lag has been pegged or not. After this preparation, one foot pedal alone operates the turning of the cylinder and thus the operation of the shafts. The weaver stands to operate. Semi-automatic dobbies have a foot-switch. Dobby looms are excellent for designing, particularly Scandinavian ones which have the dobby mechanism mounted at the side of the loom within easy reach.

Weaving

Weaving should always begin with a contrasting coloured yarn to pick out any faults. The manner in which the weft is wound on the yarn carrier will determine the quality and speed of weaving. Weft sticks should only be used when shuttles are not available as they can catch the warp threads and are generally clumsy to unwind (15[2]). Roller shuttles were obviously designed for use when making wide cloth (remember, you throw and catch a shuttle) and are always a superior method as they are smooth and the yarn unwinds easily. They will not, however, run on threads alone and the warp requires the support of the shuttle race on the batten to support a shuttle (15 [3]). Shuttle quills are wound small and firm (24 [20]). Put the thread from the quill through the eye of the shuttle before inserting the quill in the shuttle.

When weaving, the order of action is: insert the weft; beat down; leaving the batten forward on the fell of the cloth, change shed; push batten back and so on. 'Pulling-in' is the weaver's bug-bear as it narrows the cloth and finally breaks the selvedge ends. The use of a tenterhook is neither good craftsmanship nor good for the cloth; correct width is properly achieved by leaving the weft pick in an arc instead of sending it straight through like a rod; this allows the pick enough yarn to pass over and under the warp ends, when the cloth is relaxed and thus the warp ends remain in place and undisturbed.

Drafts, liftings and weave plans

The construction of a weave is determined by the order in which the warp ends move up and down to allow weft picks to be inserted through them. The order in which the warp yarns move up and down is determined by the order in which they are entered or threaded through the heddles, the heddles in turn being strung on the shafts (this is known as the draft) and by the order in which the shafts are lifted or lowered to allow the weft to enter (this is called lifting,

treadling or pegging, depending upon the type of loom).

Weave constructions and the instructions for producing them are best recorded on squared paper; 8×8 is satisfactory as one is often using two, four, eight, twelve or sixteen shafts. In the weave plan, which is the 'picture' of the weave, imagine the vertical spaces to be warp ends and the horizontal spaces to be weft picks (81[1]). A marked square indicates weft over warp (81 [2]). In the draft the verticals represent the warp ends, the horizontals the shafts (81[3]). In the lifting the verticals represent the shafts and the horizontals each successive shaft-lifting (81 [4]). There are three or four parts to a complete set of weave instructions: the threading, entering or draft; the lifting, treadling or pegging; the resulting weave plan (81 [6]); and, in the case of treadle looms, the tie-up of lamms to pedals (81 [7]). Drafts and liftings can, of course, be written in numbers (Chapters 14 and 15) but this can become unwieldy with complex weaves. In very simple weaves the weave plan can be recognizable as the fabric, but in more complex weaves, particularly where threads are pushed around and distorted, the plan bears little visual resemblance to the fabric. Endless weave instructions can be found in books devoted to the purpose but it is necessary for the designer to understand logically what is happening, rather than simply to follow a 'recipe'.

It is most important to keep weaving details as a build-up of construction knowledge, and very necessary to be able to deduce weaves and liftings from woven cloth. To this end the following is a passage from *Designing on the Loom* by Mary Kirby. These instructions cannot be improved upon:

'To set down the design of a fabric on paper: cut a neat rectangle along the threads of warp and weft containing at least one full repeat of the design from the fabric to be analysed. Then, following along the top weft, mark on squared paper every point at which warp is over weft. When this has been done pull off that weft and plot the course of the next weft immediately below the first, continue in this way until the whole pattern is complete. This is

then the design. If the weave is fine a linen glass or fabric testing glass may be needed to magnify the threads.

'To find the draft from the design: mark out one repeat of the design on point paper, as above, with plenty of space above and to the right. Read down the length of the right-hand vertical line of squares and above it mark a square to represent the first end entered on the draft. Look carefully across the design to see whether any other vertical lines of squares are identical with the first. If so mark a square, immediately above and on the same horizontal line of the draft as the first. Work across the design in this way, taking a new line in the draft, that is a new shaft, for each different vertical sequence. When a square has been placed above every end the draft is complete. The number of horizontal lines used gives the number of shafts required.

'To find the shaft-lifting order from the design and draft: this time work horizontally across the lines of squares. Notice on which shafts all the ends raised in the top line are entered and mark them in a row to the right level with the line of the design to which they apply. Work down the design marking off each horizontal line in turn. This gives the peg plan or order of shaft lifting. Notice that the number of squares in the width of the peg plan always corresponds to the number of shafts in the draft, irrespective of the length of the draft or width of the design, while the number of squares in the length of the peg plan is equal to the number of picks in the length of the repeat of the design.'

Practising the above instructions will soon dispel many of the apparent complexities of deciphering and designing weave constructions. For drafts and liftings see (105).

Further study

* Chetwynd, Hilary *Simple Weaving* Studio Vista,

London, Watson-Guptill, New York 1969
*Kirby, Mary *Designing on the Loom* Studio Publications,
 London, New York 1955
Thorpe, Azalea and Larsen, Jack *Elements of Weaving*
 Doubleday, New York 1967
* Tovey, John *The Technique of Weaving* Batsford,
 London; Reinhold, New York 1965
* Tovey, John *Weaves and Pattern Drafting* Batsford,
 London; Reinhold, New York 1969
Wilson, Jean *Weaving is for Anyone* Studio Vista,
 London; Reinhold, New York 1967
Dryad Footpower Looms Dryad Press, Leicester, UK
Weaving for Two-Way Table Looms Dryad Press,
 Leicester, UK
Weaving on Four-Way Table Looms Dryad Press,
 Leicester, UK

Suppliers

Design Paper (squared)
William Allen & Co, Lower Parliament Street,
 Nottingham, UK

Loom cord
F. Uttley, Prospect Mill, Huddersfield, UK

Looms and accessories
Dryad Ltd, Northgates, Leicester and The Craft-tool
 Co, 1 Industrial Road, Wood Ridge, New Jersey,
 USA (table and foot looms, all accessories)
Harris Looms Ltd, North Grove Road, Hawkhurst,
 Kent, and Cooper Square Art Center, 37 East
 8th Street, New York, USA (table looms, foot
 looms and looms for dobbies)
Herald Looms, Bailey Manufacturing Co., 118 Lee
 Street, Lodi, Ohio, USA (compact jack looms)
Macomber Looms, 166 Essex Street, Saugus,
 Massachusetts, USA (these looms are, without
 doubt, superb jack looms)
Nilus Leclerc Inc, L'Isletville, Quebec, Canada, and
 2 Montcalm Avenue, Plattsburg, New York,
 USA (a wide range of excellent looms)
Purrington Looms, Quivet Drive, East Dennis,

Massachusetts, USA (folding looms, very useful if
 there is little space, or if one travels a lot!)
Messrs Stansfield, Almondbury, Yorkshire, UK
 (looms to take dobbies and Jacquards)

Dobby mechanisms
Callaghan-Renard Ltd, 5 East Street, Chichester,
 Sussex, UK

14 Interlaced fabrics: two shaft weaves

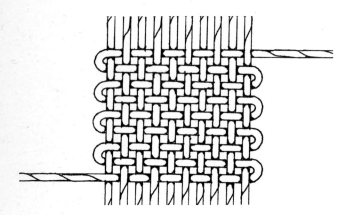

(82) Plain weave

Plain weave is the simplest possible way in which warp and weft can be interlaced; it can be produced quite easily with almost no mechanical aid (as we have seen in Chapter 12), and is familiar to most people in the form of darning. It can be made mechanically on either a rigid heddle loom or a two-way loom, or two of the shafts of *any* sort of loom. It is the most stable and practical weave there is, basically the same on both sides, aesthetically satisfying in its simplicity (probably because its lack of structural complexity necessitates the careful choice of yarn and colour) and capable of infinite and limitless exploration and elaboration. In fact, it would be quite possible for the weaver to move no further than producing a basically plain construction on two shafts, with certain elaborations, and still not run out of design ideas.

A straight plain (or tabby) weave should have the same number of ends in warp and weft (82). The order of threading through the heddles on two shafts is 1 2 1 2 and the order of lifting or treadling is also 1 2 1 2. It can be elaborated in various ways:

1 The simplest is the effect of the yarn alone. The use of S and Z twists (Chapter 4) in, say, 1in. stripes of each, would produce very subtle lustre/matt 1in. stripes either in the warp or the weft or both. Likewise, if yarns are twisted very tightly, far beyond the natural twist, their inclination will be to untwist in the opposite direction when relaxed. If this factor is exploited and S and Z tight twists woven together in the same cloth in both weft and warp, when released from the loom and given a finishing process the cloth will crinkle and pucker (crepon weave).

2 The tension of yarns affects the cloth enormously. Seersucker, for instance, is a weave composed of alternate warp stripes of tight and loose tension (coming from different beams). The difference in tension produces puckered stripes when the cloth is released from the loom. One way of achieving this in the horizontal is to weave in weft stripes of elasticized yarn.

3 The doubling of every thread produces hopsack or basket weave (88 [1] also shows selvedge treatment). Obviously this principle can be extended. The

(opposite above)
(83) Two-shaft weave.
Crossed warp with cellophane and grass weft

(opposite below)
(84) Two-shaft weave,
Patricia Keddie, Birmingham College of Art and Design. Upholstery fabric with weft of twisted yarns. Photo Alan Hill

(85) Linen sheer curtain in plain weave, Emily Gaussen, Royal College of Art. Printed and embellished with free-shuttling. Photo Royal College of Art, School of Photography

(86) Two-shaft weave, Doreen Hope, Birmingham College of Art and Design. Crossed warps with graduated weft of fancy yarns and grouped plain yarns. Photo Alan Hill

(87) Plain weave, Pat Grocock, Birmingham College of Art and Design. Decorated by free-shuttling with mohair loop-yarn. Photo Alan Hill

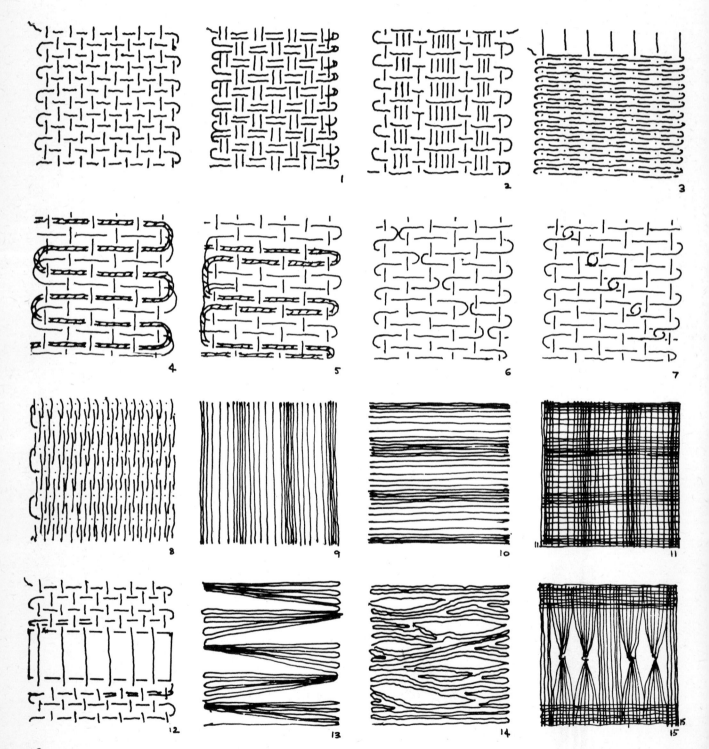

16

17

18

19

doubling, trebling and so on of warp and weft threads in sequence or at random produces texture weaves (88[2]).

4 The off-balancing of warp/weft content relationship results in tapestry (crammed weft packed over sparse warp (88[3]) and warp-faced rib and repp (crammed warp packed over sparse weft (88 [8]). Tapestry is a vast subject all of its own and is referred to again later in this chapter.

5 Warp spacing and weft spacing and both together (88 [9, 10, 11]) result in open fabrics; if large weft spaces are required the insertion of sticks or paper while weaving is helpful (88 [12]).

6 Warp colour striping, weft colour striping and both together (88 [9, 10, 11]) produce vertical or horizontal striping, checks, ginghams and tartans (plaid is *not* a cloth in the strict sense of the word, it is a garment although the word has come to be used to describe tartan).

7 The irregular pushing around of the weft by means of the fingers or adjustment of the batten (88 [13, 14]) gives fugitive results but can be held by bonding, starch or diluted PVA.

8 Fancy yarns in warp and weft, or both, give limitless possibilities, although the weft obviously lends itself to this form of elaboration more than the warp (83, 86). Fancy-twisted weft yarns can give a weft effect so dominant that the warp almost disappears (84).

9 Weaving with beads (pre-threaded, inserted into the shed and then manipulated into place) (96, 97); ribbons (crushed, uncrushed or looped); fur (116); fringes (96) (either manufactured, or strips of cloth, fringed); braids (96, 97), etc. gives luxury effects for fashion fabrics and hangings.

10 Stiff wefts like cane, metal, glass or perspex rod, slivers of wood, etc. are excellent for blinds and room dividers (91).

11 Free shuttling is the working on the surface with an extra yarn, so that it plays no part in the construction (85, 87).

12 Lifting of groups of warp ends out of position (this can be done with a cut-up rigid heddle) and placing them elsewhere can break up the vertical/

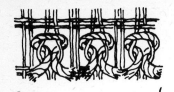 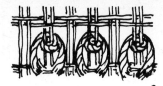 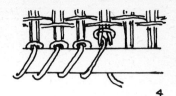

89 1 2 3 4

horizontal (91).

13 Manual twisting of warp ends to simulate leno weaving (83) allows sparse weft to be held firmly in place.

14 The tying of bundles of threads together gives open effects (88 [15]) and again breaks up the vertical/horizontal.

The above list gives some of the means of achieving textile variation simply by the use of two shafts; there are many more.

Tapestry

Tapestry weaving is an area of research all of its own (photographs 9, 13, 88 [3, 4, 5, 6, 7] 92, 93, 100). Basically a plain construction with a strong sparse warp and a crammed weft technique, it gives complete coverage of warp by the weft and thus is capable of producing areas of unbroken colour. This characteristic frees the weaves graphically more than any other technique and tapestry weaving has therefore been used to imitate even a painter's finest brushwork. 'High warp' tapestry is woven on a vertical loom; 'low warp' on a horizontal loom and, if necessary, many people can work on a tapestry at once. It is often easier to work with the back of the cloth facing the weaver because of the many ends caused by the different areas of colour. The cartoon, if there is one, is placed behind the warp and can be painted onto the warp threads. Photographs 9, 13, 92, 93, 100 show varied uses of tapestry technique. (88 [4]) shows vertical striping; (88 [5]) shows horizontal striping; and (88 [6, 7]) show two methods of joining areas of colour. The warp must be very strong cotton, linen or jute, often doubled; the weft is most usually wool because of its covering properties and good lustre and colour. Tapestry can, however, be made fine or coarse. Tapestry weft can either progress levelly, with each total pick, whether composed of one colour or many, being put in at once right across the weft and being beaten down with the loom batten; or it can be worked in blocks, and a whole colour area finished before another is begun. This would have to be beaten down with a tapestry fork or the fingers. Equally, the weft can

meander, rather like the weave (88 [14]). This method can be used to emphasize sinuous and flowing shapes, and is pressed down with the fingers, but with this method care must be taken not to let the whole fabric 'bubble'.

Soumak (88 [17]) is a method of wrapping warp-ends and can be used either as a total covering or in areas. It looks rather like embroidered stem-stitch and can also be used as a means of producing free-moving lines.

Tapestry technique but with a jute weft, as well as a jute warp, is generally the backing weave for pile wall-hangings, rugs and floor coverings. The woollen surface-knots for this can be long or short, cut or looped, crammed or sparse, according to the effect you wish to get. (89 [1] is the Turkish knot; (89 [2]) the single-warp knot (although here it is shown over double warp); (89 [3]) the Persian knot. (89 [4]) is another method of making the Turkish knot which can be either cut or left in loops; the stick used is as deep as the length of the required pile and if two sticks are used together it is easy to slit between the sticks with a blade to produce a cut pile.

Concerning tufting in general: when tufts are put in singly the yarn is prepared by winding it around two sticks or a special pile-cutting bar; it is cut, and then inserted in the chosen manner, the pile being sheared afterwards to a uniform length. Tufts can be composed of single yarns or bundles of mixed yarns (136). A tuft composed of long linen and shorter wool yarns will make a very satisfactory texture. Loop and cut pile can be intermixed. Because each tuft is put in singly, design possibilities are now totally free; the clarity of the design outlines is affected only by the fineness or coarseness of the tufts and the length of the pile. When designing tapestry and tufted articles it is most important to produce a small sample before beginning, in order to obtain a good handle for the job, neither too stiff and boardlike, nor too sloppy.

Devoré

Finally, a word about Devoré, or burn-out prints, which are relevant here because they are visually

(89) Weaving on two shafts. Knots

(90) Devoré Fabric, Vicky
Mockett, Royal College of Art

(91) Hanging *Macrogauze 35*
Peter Collingwood,
Colchester. Black linen and
straight steel rods. 84in × 20in.
Photo Charles Seely

91

90

equivalent to free-shuttling and cut brocades, but
can be produced on plain weave (88 [19], 90). The
general principle is to create a cloth (plain or otherwise)
of two different raw materials elements, so constructed
that one or other of the raw materials can be partially
removed without destroying the cloth. A design is then
printed onto the woven cloth with a chemical solution
which will attack one of the raw materials. The cloth
is then heat-treated or soaked in acetone and finally
washed; the attacked areas then disintegrate, leaving
a pattern. (There are other ramifications, like burning
shapes right through a fabric, or burning off pile.) A
specific recipe for use on a cotton and nylon mixture
(cotton destroyed) is as follows:

1 Weave a plain cloth with double warp ends and
weft picks, each composed of one cotton and one
nylon yarn.

2 Make enough burn-out paste composed of the
following proportions to print the cloth area: 30 parts
aluminium sulphate; 15 parts water; 50 parts thicken-
ing (301 extra); 5 parts glycerine.

3 Print the cloth and dry.

4 Heat treat in an electric oven at 180°C for 30
seconds (for small samples it is possible to heat treat
with a hot iron – protect the print from the iron with a
cloth and iron until the printed areas turn brown).

5 Wash off the fabric in water at 60°C containing
two parts-Lissapol, NX, with vigorous agitation for 15
minutes.

6 Rinse in cold water.

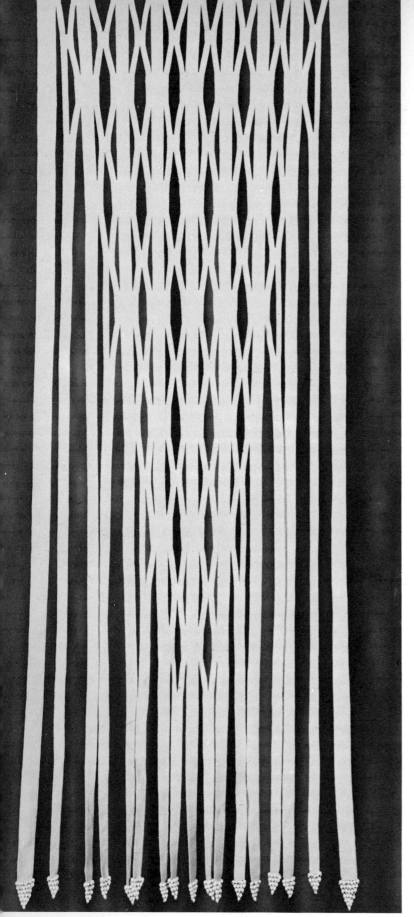

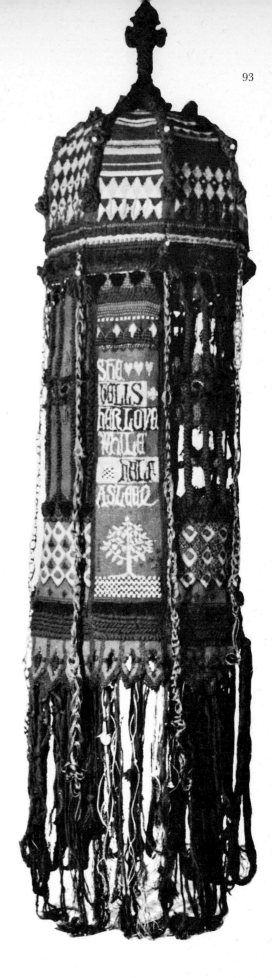

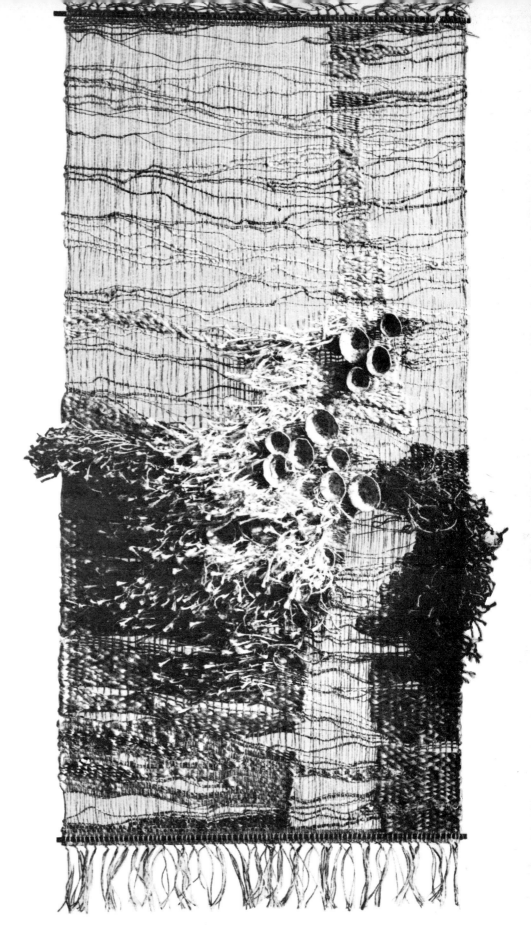

(92) Cotton tapestry 94
Seraglio Curtain Marguerite
Elliot, Galashiels. Photo
Tom Scott

(93) Three-dimensional
tapestry, Maureen Hodge,
Edinburgh. Photo Tom
Scott. By permission of
Scottish Arts Council

(94) Hanging *Yellow Fissure*
Robert Mabon, Beaconsfield.
Linen, jute, hemp, sisal and
stoneware. 46in × 24in.
Photo J. Jameson

(95) Plain weave with
looped surface *Eruption*
Tadek Beutlich, Sussex.
Black mohair warp, black
mohair, unspun jute and dyed
sisal weft. Woven in three
sections and sewn together

(96) Spaced weft hanging,
Irene Waller. White. Cotton
warp, fringe, braid and bead
weft

(97) Detail of 96

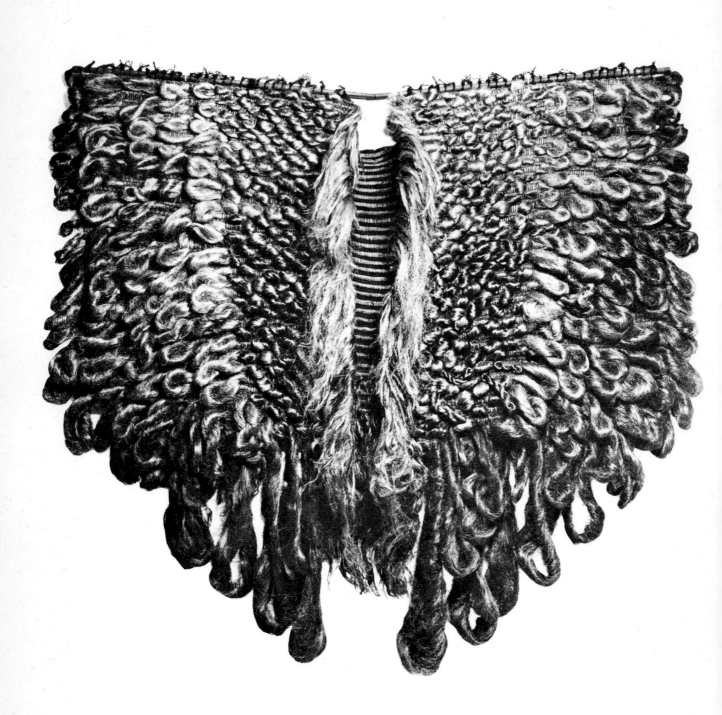

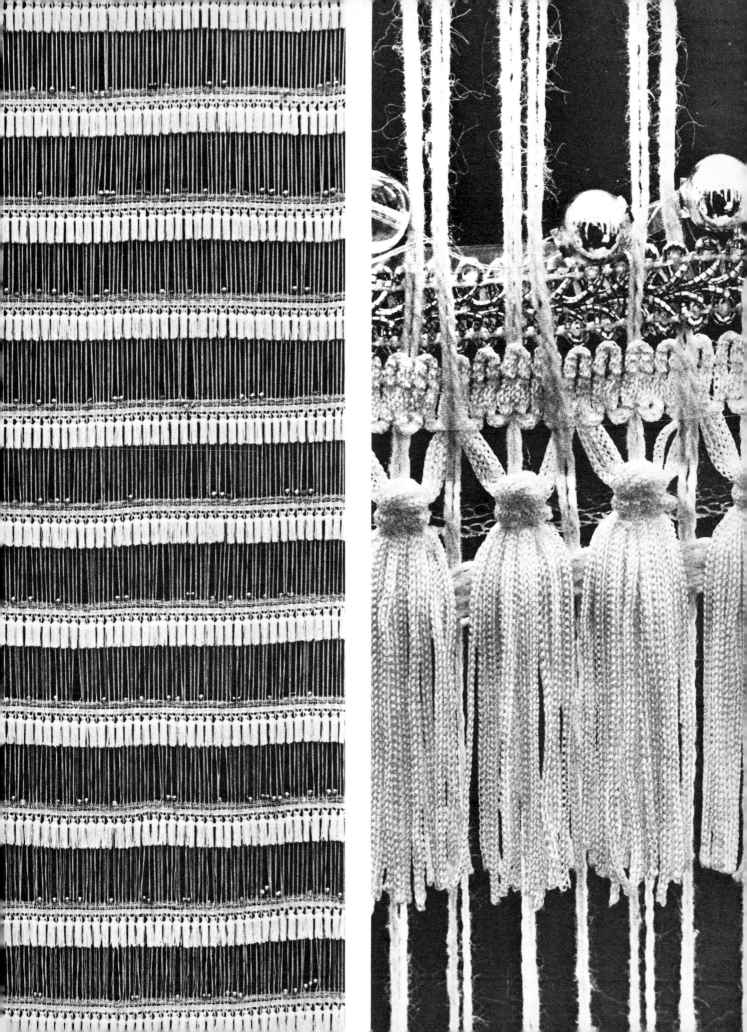

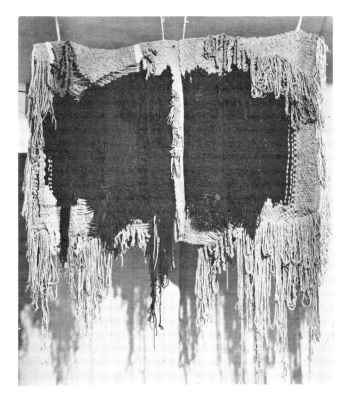

far left
(98) *Triptych* Tadek Beutlich, Sussex

(99) Painting *Vietnam 68* Josef Grau-Garriga, Barcelona

(100) Tapestry *Frontera de Sang* Josef Grau-Garriga. It is interesting to study the same artist working in two different media

Further study

* Albers, Anni *On Weaving* Wesleyan University Press, Middleton, Connecticut, USA 1963; Studio Vista, London 1966
* Beutlich, Tadek *The Technique of Woven Tapestry* Batsford, London; Watson-Guptill, New York 1967
* Collingwood, Peter *The Technique of Rug Weaving* Faber and Faber, London; Watson-Guptill, New York 1967
Grierson, Ronald *Woven Rugs* Dryad Press, Leicester, UK 1950
Hartung, Rolf *Creative Textile Craft* Batsford, London; Reinhold, New York 1964
* Kirby, Mary *Designing on the Loom* Studio Publications, London, New York 1955
Seagroatt, Margaret *Rug Weaving for Beginners* Studio Vista, London 1971
* Tattersall, C. *Carpet Knotting & Weaving* Victoria & Albert Museum, London 1920
Thorpe, Azalea and Larson, Jack *Elements of Weaving* Doubleday, New York 1967
Weeks, Jeanne *Rugs and Carpets of Europe and the Western World* Chilton Book Co, New York 1970
Wilson, Jean *Weaving is for Anyone* Studio Vista, London; Reinhold, New York 1967

A technical information leaflet on Devoré techniques, available only to colleges, not to individuals, is obtainable from Courtaulds Ltd, Service & Development Dyehouse, PO Box 5, Spondon, Derby, UK.

Suppliers

Thickening 301 Extra from Textile Dyestuffs & Chemicals Ltd, Atlas Mill Road, Brighouse, Yorkshire, UK
Lissapol NX from ICI Ltd, PO Box 42, Hexagon House, Blackley, Manchester 9, UK

Interlaced fabrics: four to sixteen shaft weaves

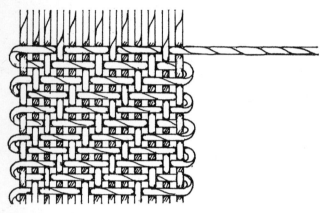

(101) Weft-faced twill

(102) Overshot weave on four shafts, Elaine Fairbanks, Birmingham College of Art and Design. Contemporary adaptation of a traditional weave in black and white chenille. Photo Alan Hill

Two shafts make only plain weave and its elaborations mechanically possible, but with more shafts available, plain weave is only the beginning, and warp ends drafted in various sequences, weft picks inserted through the shafts lifted in various sequences, and permutations of both, create more complex weave constructions. However, to avoid panic and confusion, it could be said that there are only two basic weaves, plain and twill, all the rest (with one or two exceptions) being derivations. Plain weave (90), for instance, is obviously the parent of hopsack, repp, tapestry, distorted warp and weft effects, some colour and weave effects, double cloth, mock-leno, Bedford cords, piqués, brocading, pile weaves and spot patterns. Twill (shown weft-faced in photograph 101) is equally the parent of fancy twills, broken twills, chevrons, herringbones, diamond weaves, birdseye, some colour and weave effects and satins. Gauze and honeycomb weave are exceptional and the latter could be said to be derived from plain. The designer should learn the basic weaves like a pianist learns his scales, then progress to the derivatives.

Textbooks each have their own carefully worked-out method of getting over to a new weaver in a logical fashion just how the complexities work. The important thing at this stage is to understand the logical progression of woven fabric construction and not merely to refer to books of weaves as if to a cookery book. A suggested planned course of practical study is as follows (see [103]).

Exercise 1 set on a warp of light tone 2/2½s worsted tapestry yarn or similar, ten ends per inch, 4in. wide plus selvedge, 2yd long, draft 1 2 3 4 and weave with a darker tone (white contrasting with black is not necessarily a good way of learning the construction of weaves clearly as the sharp tones detract from the three-dimensional qualities of the weave). To achieve the already familiar plain weave you will find that you must lift shafts 1 and 3 together and then 2 and 4 together. Now try your own variations of shaft lifting and see what happens, keeping your lifting notes on point paper all the time and weaving 4in. of each satisfactory variation. You will find that you have

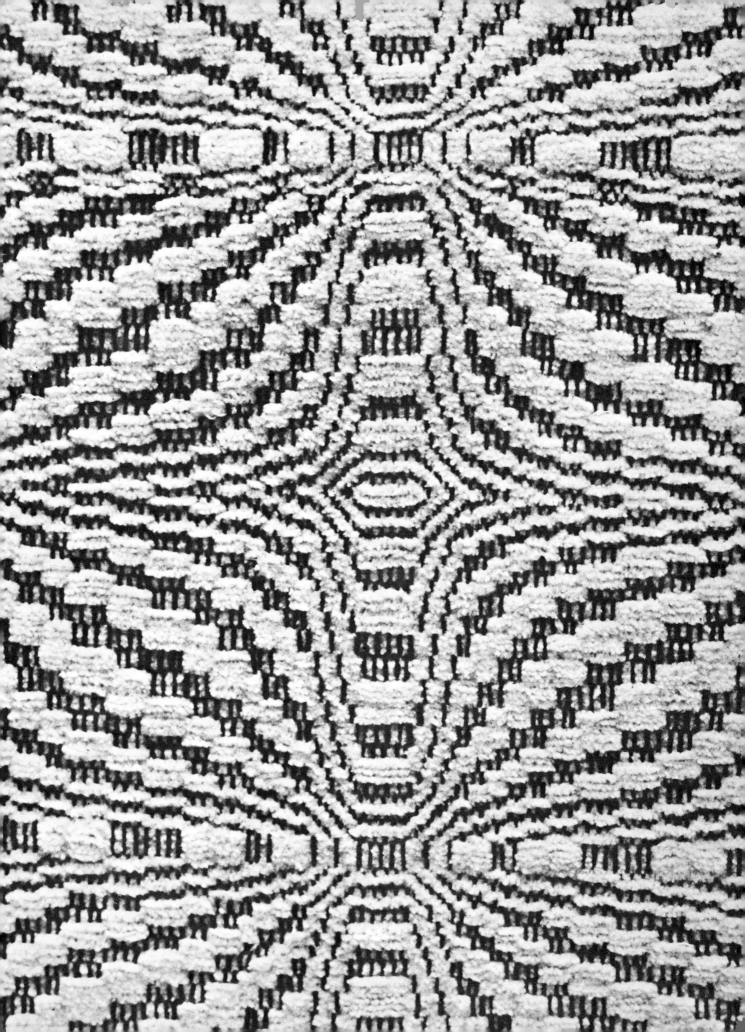

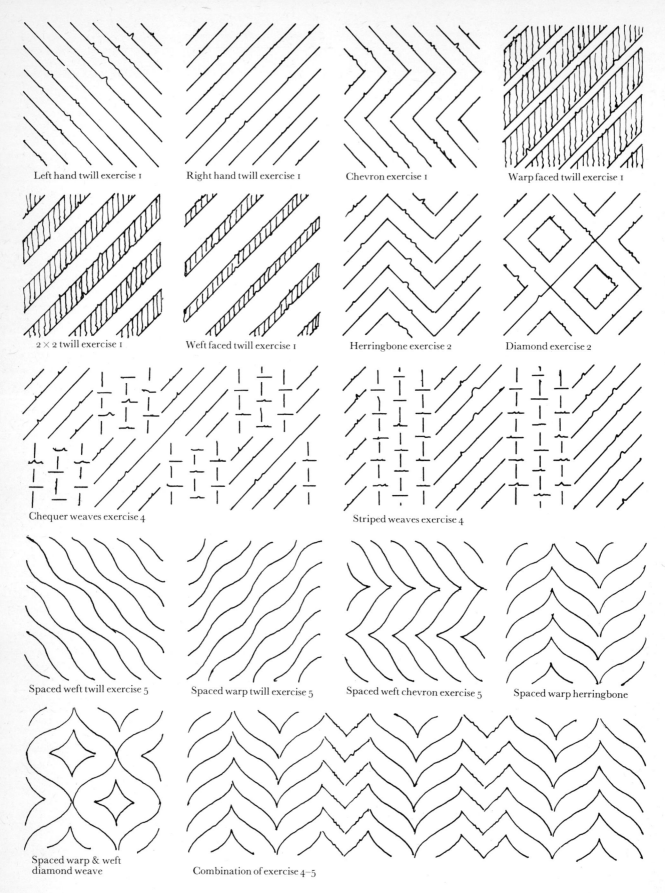

Left hand twill exercise 1

Right hand twill exercise 1

Chevron exercise 1

Warp faced twill exercise 1

2 × 2 twill exercise 1

Weft faced twill exercise 1

Herringbone exercise 2

Diamond exercise 2

Chequer weaves exercise 4

Striped weaves exercise 4

Spaced weft twill exercise 5

Spaced warp twill exercise 5

Spaced weft chevron exercise 5

Spaced warp herringbone

Spaced warp & weft
diamond weave

Combination of exercise 4–5

created weaves which you will recognize as everyday ones: the two basics plain and twill; hopsack; varying twills; chevrons and broken weaves; and by using two colours, tiny simple brocaded spots and stripes (82, 88 [1], 101, 103 [lines 1 and 2]).

Exercise 2 set on a second warp, same yarn, colour and sett, but 12in. wide plus selvedge, 4yd long; and draft it 4in. of 1 2 3 4, 4in. of 1 3 2 4, and 4in. of 1 2 3 4 3 2. With the same weft as before, repeat the exact liftings you did on the first warp, and you will now have all the first weaves once more plus twice as many again, including herringbones, diamond weaves and more broken weaves (103 [line 2]).

Exercise 3 set on a third warp exactly the same as warp two, but with colour striping in the warp, e.g. two light, two dark in draft 1, three light, one dark in draft 2, and three light, three dark in draft 3. You will now have a blanket of 'colour and weave' designs recognizable in one form as tweed.

Exercise 4 in this warp introduce two new elements at once (a) colour ways and (b) weaves mixed together to form larger scale designs. Same yarn and sett, but 35in. wide plus selvedge and 6yd long. Use three allied colours, e.g. purple, turquoise and blue, and draft 2in. of each colour at 1 2 3 4, 2in. of each colour at 1 3 2 4, 3in. of each colour at 1 2 3 4 3 2, and (1in. of purple at 1 2 3 4 and 1in. blue at 1 3 2 4) seven times. Weave as before, but with the addition of 14in. of a twill lifting and 14in. of 1in. 1 and 2, 2 and 3, 3 and 4, 4 and 1, and 1in. 1 and 3, 3 and 2, 2 and 4, 4 and 1. This blanket will contain all former weaves with extra colourways, plus a fair piece of a textured stripe and another of a textured chequer pattern (103 [line 3]).

Exercise 5 now repeat any of the preceding warps but dent the ends irregularly through the reed, perhaps 1 2 2 3 4 3 2 2 1. This will cause twills, chevrons, herringbones and diamonds to curve, and the addition of spaced weft produces even more curves (103 [lines 4, 5]).

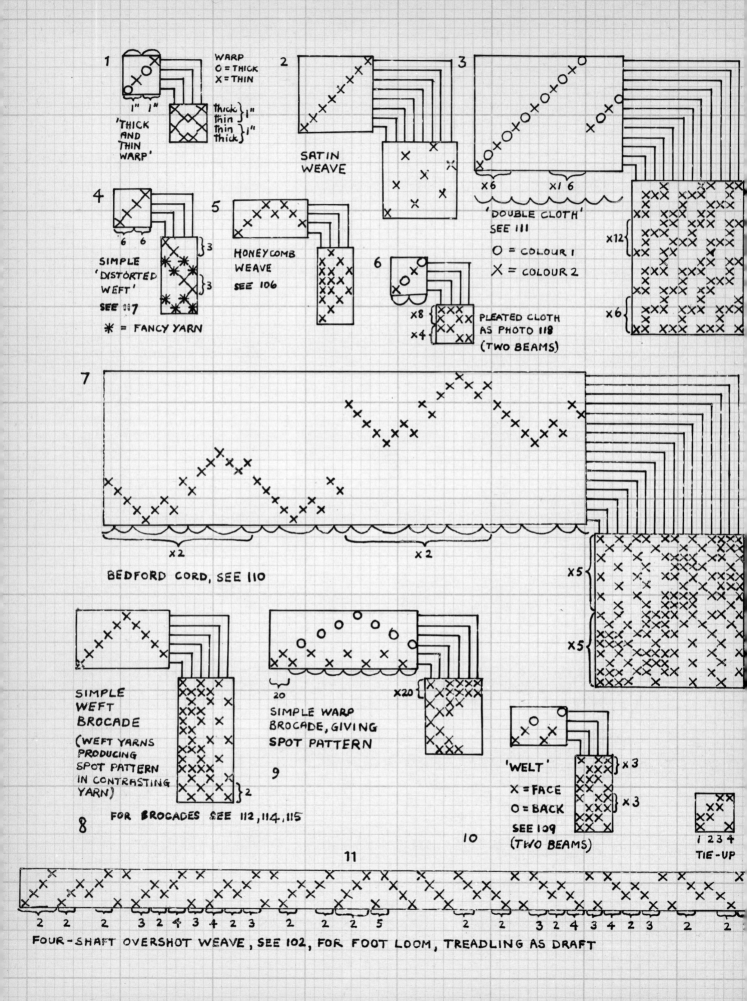

1 WARP
O = THICK
X = THIN

1" 1"
'THICK AND THIN WARP'

thick } 1"
thin
thin } 1"
thick

2 SATIN WEAVE

3

x6 x1 6

'DOUBLE CLOTH' SEE 111

O = COLOUR 1
X = COLOUR 2

x12

x6

4 SIMPLE 'DISTORTED WEFT' SEE 107

6 6

3

3

* = FANCY YARN

5 HONEYCOMB WEAVE SEE 106

6

x8
x4

PLEATED CLOTH AS PHOTO 118 (TWO BEAMS)

7

x2 x2

BEDFORD CORD, SEE 110

x5

x5

8 SIMPLE WEFT BROCADE

(WEFT YARNS PRODUCING SPOT PATTERN IN CONTRASTING YARN)

2

FOR BROCADES SEE 112,114,115

9 SIMPLE WARP BROCADE, GIVING SPOT PATTERN

20

x20

10 'WELT'

X = FACE
O = BACK

SEE 109 (TWO BEAMS)

x3
x3

TIE-UP
1 2 3 4

11

2 2 2 3 2 3 4 3 4 2 3 2 2 2 5 2 2 3 3 2 4 3 4 2 3 2 2

FOUR-SHAFT OVERSHOT WEAVE, SEE 102, FOR FOOT LOOM, TREADLING AS DRAFT

The preceding exercises (diagrams of most of them are in [103]) will have produced a considerable number of sample designs. When they have been washed and finished (Chapter 20) they can either be left in blanket form, in which case a 4in. square window should be cut in a card to isolate each weave for assessment; or they can be cut up into the individual sample designs in which case the sample edges are latexed and mounted separately on design cards with weave notes.

The basics and many derivatives covered here are a sound base from which to proceed further. Now let us consider some more complex derivatives which, because of their usefulness, have come to be known under certain headings.

1 'Thick and thin warp' is a not very graceful description of a very useful technique, which is to make plain weave with alternatively very thick and very fine warp ends, of contrasting colours and dented one thick and one thin together. It will be found that two effects will be achieved: on odd picks almost complete coverage of the weft by the warp and on even picks almost complete display of the weft (fancy yarns can be useful wefts). Taking this a little further, with more shafts, if you thread 1in. on shafts 1 and 2, and 1in. on 3 and 4, and so on, it is possible to lift the thick yarns on one stripe and simultaneously thin yarns on the other and vice versa; if thick and thin alternate weft yarns are used, stripes and checks can be produced. More shafts allow the production of complex geometric shapes formed by the obscured or displayed weft (draft and lifting diagram 105 [1]). The technique is used for both dress and furnishing but is particularly good for upholstery as pattern can be achieved totally without loose float-threads – a very practical weave.

2 Double cloths are just what their name implies: two or more cloths woven simultaneously one above the other and linked in various ways. If only two shafts are required for plain weave, four will enable two cloths to be woven, and six shafts, three cloths. The simplest method of weaving double cloth is to weave two cloths of the same yarn and colour, making an open side with two selvedges on the left and a closed side on the right (weave right to left and left to right on top cloth, then right to left and left to right on bottom cloth). The woven fabric will open out into fabric twice the width of the loom and one can also produce a cloth three or four times as wide. Two cloths, generally of different colours, can be interchanged horizontally, the undercloth coming to the top and the top cloth going below, and padding can be inserted in between them. With more shafts, vertical as well as horizontal changes can be made (111). Two cloths may stay always one above the other and be held together by an extra fine warp or weft thread, although this method is now often simulated by laminating. The cloths can vary from each other in colour, weave texture and weight, draft and lifting (105 [3]). When denting double cloth remember that two cloths are being woven simultaneously. Double cloths are used for fashion as reversible coatings and for furnishing as reversible covers and blankets, but their structurally three-dimensional nature also makes them a mine of ideas for abstract structures, such as Kay Sekimaki's 'Nobori' (120).

3 From double cloths it seems logical to move on to welts and piqués, because in these weaves there is again an upper and a lower element (i.e. two separate warps wound on two beams) producing the now three-dimensional weave effect. The lower warp, however, is not woven as in double cloth but is used as detaining and backing threads to force the woven surface of the cloth into raised rounded ribs (sometimes padded). The ribs run across the cloth, welts being straight ribs, and piqués curved ribs (photograph 109, and 105 [10]). The fabrics are not reversible.

4 At first glance, Bedford cords look like welts turned at 90 degrees, i.e. vertical raised rounded ribs, but they are a different construction. The surface ribs and the backing floats are not separate elements but the same picks interchanging. The cloth produced is therefore warp-faced and not reversible (110 and 105 [7]).

5 Now consider: only two shafts are necessary to make plain weave, but there are four or more to play

(106) Honeycombe weave,
Margaret Haddon, Birming-
ham College of Art and
Design. Photo Alan Hill

(107) Distorted warp and
weft casement weave
Waterford Jack Lenor Larsen
Inc, New York. Cream-white
and silver

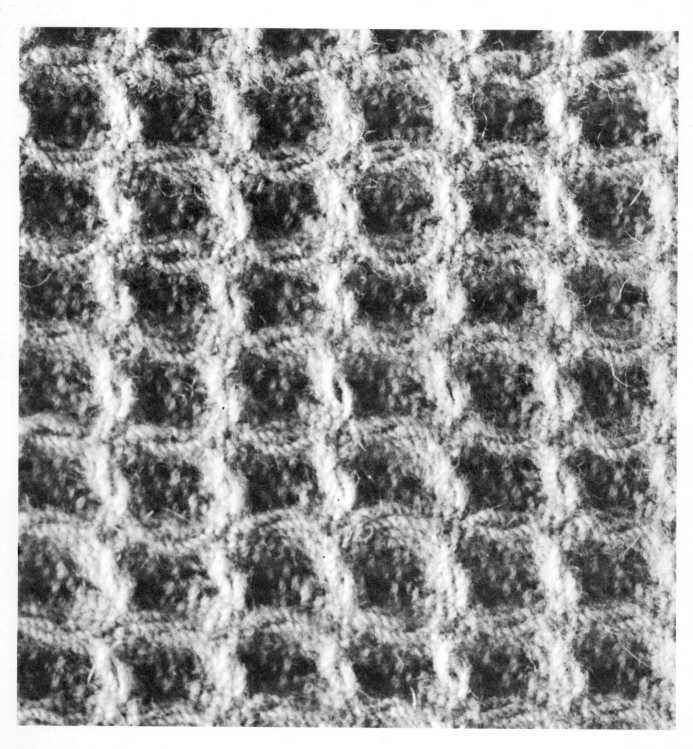

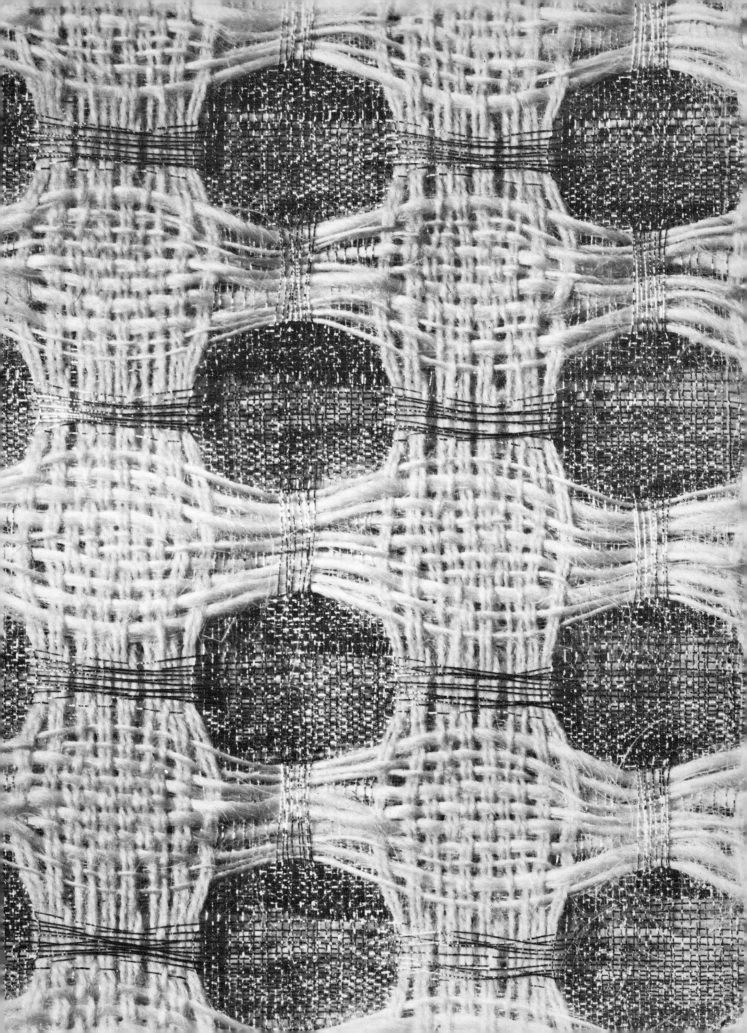

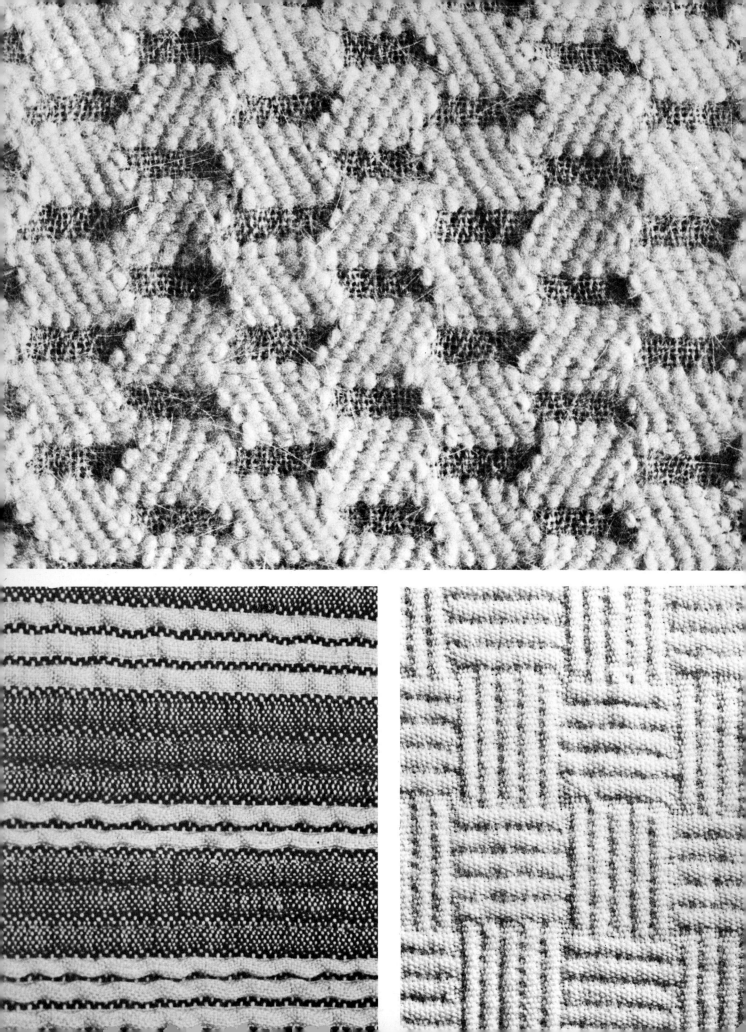

left top
(108) Twill free-shuttling on a plain ground, Pat Grocock, Birmingham College of Art and Design. White

far left bottom
(109) Padded welt weave, Jenni Allen, London. Black and white, with a spiral yarn as filler. Photo Alan Hill

left bottom
(110) Bedford cord in white wool, Janet Oliver, Royal College of Art, School of Photography

right top
(111) Double cloth, Wendy Andrews, Royal College of Art. White to grey wools. Photo Royal College of Art, School of Photography

(112) All-over weft brocade in blue. Elaine Fairbanks, Birmingham College of Art and Design. Photo Alan Hill

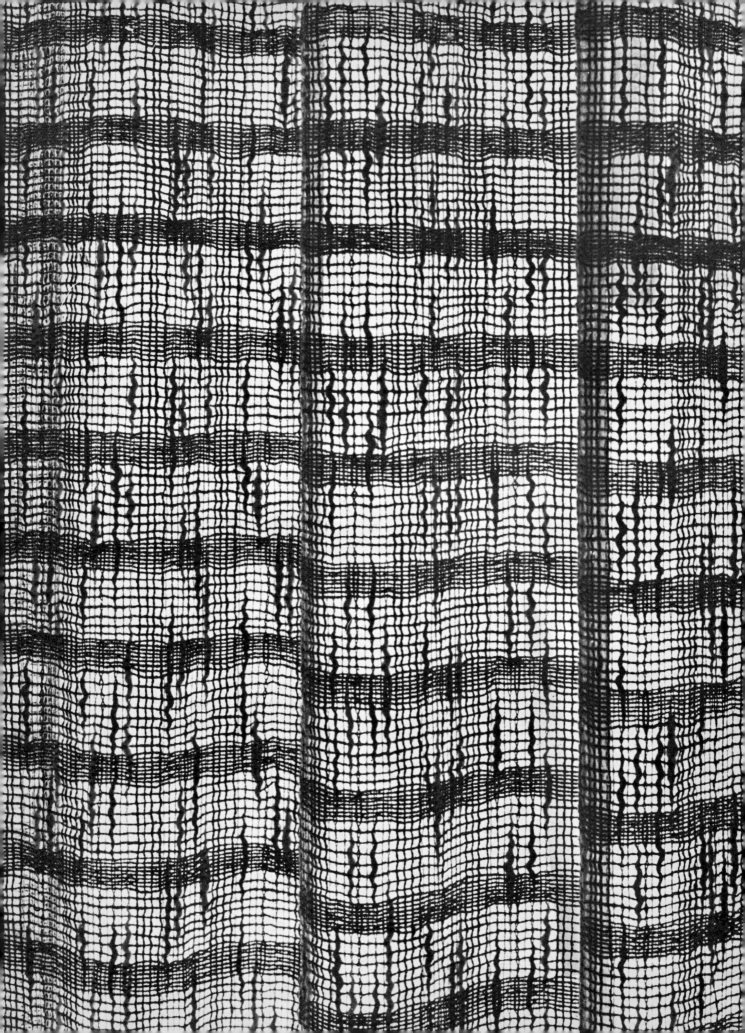

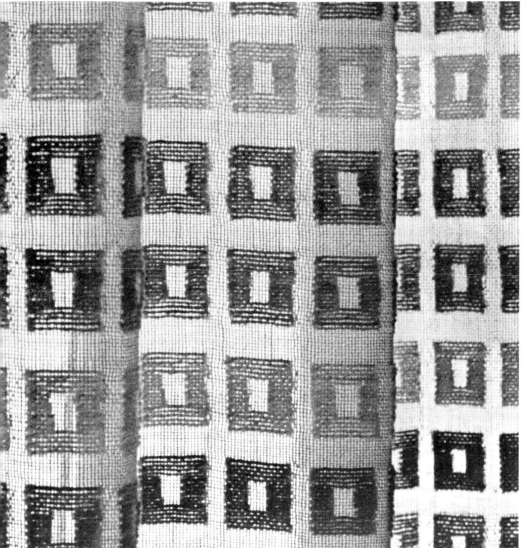

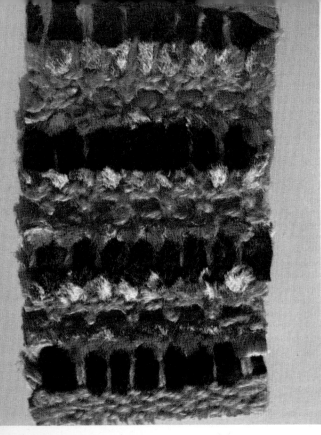

(116) Two-shaft weave, Doreen Hope, Birmingham College of Art and Design. Jute warp, jute and fur fabric weft. The warp is sometimes knotted. Photo Alan Hill

(118) Pleated fabric in cotton, Janet Oliver, Royal College of Art. The irregularities are produced by ironing. In thermoplastic yarns this effect would be permanent. Photo Royal College of Art, School of Photography

(119) Detail of (118)

(117) Distorted weft weave, Janet Griffiths. Photo Alan Hill

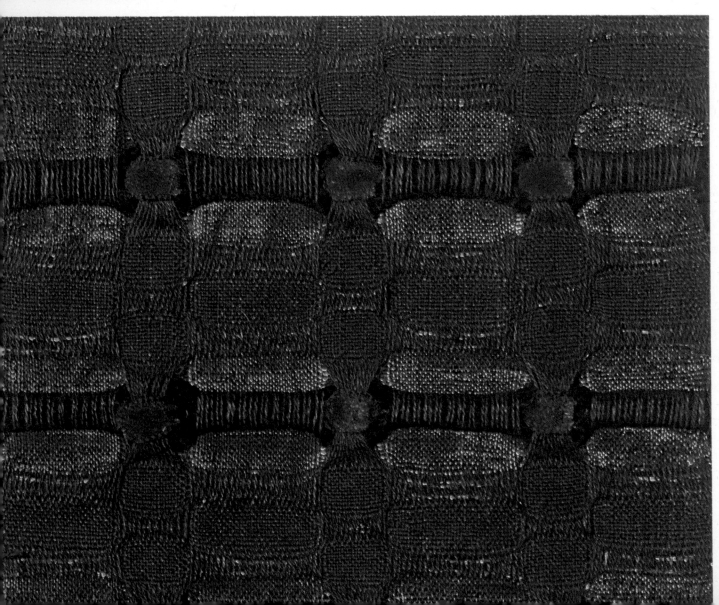

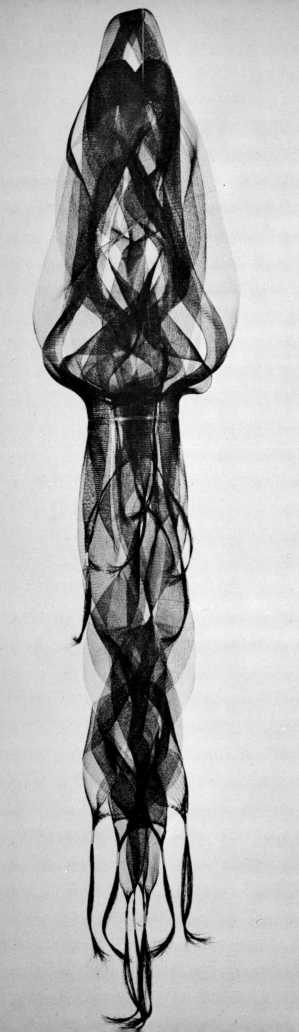

(120) Tubular and quadruple weave *Nobori* Kay Sekimaki, California. Black nylon monofilament, 90in × 19in. Photo Stone and Steccati

with. If we thread 1in. of warp on shafts 1 and 2, the next inch on 3 and 4, the next inch on 5 and 6, and so on, returning to 1 and 2 when all are used, then by lifting 1 and 2 together we will lift a whole block of threads leaving other blocks down. We can weave plain on some of the inch stripes, leaving others unwoven, and vice versa. We can also weave plain right across the whole cloth by first lifting all the odds and then all the evens. This general concept opens up distorted weft weaves (117), distorted warp weaves (107), checks, spot patterns, vertical stripes of weft floats which can be cut or uncut, and over-shot weave (121). It also leads on to brocading.

6 Brocading is the introduction of extra threads, often in a different colour, to form figured patterning. Brocading in the warp or in the weft begins to give a measure of graphic freedom and fluidity of design. Brocaded warp ends or weft picks are 'extra'; they are of decorative, rather than structural significance and could be removed from the cloth without it falling apart. They pass either above or below the basic cloth, which, to achieve graphic fluidity, must be capable of being 'split' at any point. This of course it can be, if each warp end in the repeat is set on a different shaft. Warp brocades drape well as the extra yarn is in the vertical, but are limiting when designing, as any change which may be required is in the warp and is time-consuming to make. Weft brocades do not drape so well because of the extra bulk in the horizontal but are much more versatile when designing, since weft changes are less of a problem. The cloth is not generally reversible. Design motifs can be striped, all over, or spot (for weaves, diagram 105 [8, 9] and photographs 112, 114, 115). The more shafts there are available (sixteen if possible) the greater the design possibilities; a dobby loom is excellent for designing brocades. Because the brocaded decoration is floats of yarn, colour and lustre can both be important design factors, but the same factor means that brocades do not resist abrasion well.

7 Gauze weaves (113), in which pairs of warp ends cross over each other, forming vertical crossings, are most useful for producing see-through or rigid-weft

(121) Overshot weave panel *Quasar* Wyn Evans. Overshot weave combined with metal. Photo Jack Adams

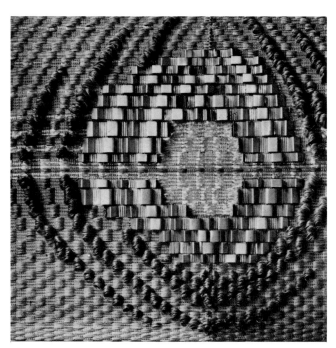

fabrics as the warps clamp the weft tightly and both warp and weft can be widely spaced. These have been mentioned before as it is a technique which can be done manually, but for speedy weaving extra gauze shafts equipped with specially designed heddles are required to be dropped into the loom (see Suppliers). Gauze and plain can be woven together in the same cloth. There is a special draft notation.

8 Satin weave, a derivation of twill, leaves long weft floats on the surface of the fabric in order to display a lustrous yarn to advantage, but unlike twill, the floats are tied down irregularly so as not to create any visual distraction (105 [2]).

9 The foregoing has attempted to trace the progression from basic to complex weaves. The need for complex weaves is obvious when designing and producing cloth yardage, because the way weft and warp are interlaced is one of the chief design factors, but complex weaves also open up all sorts of vistas for those who create wall hangings and abstract objects, and who so often linger exclusively in the field of simple weave construction (120, 121).

Further study

Atwater, Mary *The Shuttlecraft Book of American Handweaving* Collier-Macmillan, New York 1951

Black, Mary *New Key to Weaving* Bruce Publishing Co, Milwaukee, USA 1957

Blumenau, Lili *The Art and Craft of Handweaving* Crown, New York 1955

Blumenau, Lili *Creative Design in Wallhangings* Allen & Unwin, London 1963

Chetwynd, Hilary *Simple Weaving* Studio Vista, London; Watson-Guptill, New York 1969

Cyrus, U. *Manual of Swedish Handweaving* Charles T. Branford Co, Boston, USA 1956

Hooper, Luther *Handloom Weaving* Pitman, New York, London 1920

*Kirby, Mary *Designing on the Loom* Studio Publications, London, New York, Toronto 1955

Mairet, Ethel *Handweaving Today* Faber & Faber, London 1939

Regensteiner, Elsa *The Art of Weaving* Studio Vista, London 1970

Simpson and Weir *The Weaver's Craft* Dryad Press, Leicester, UK 1963

Thorpe, Azalea and Larson, Jack *Elements of Weaving* Doubleday, New York, 1967

*Tovey, John *The Technique of Weaving* Batsford, London; Reinhold, New York 1965

*Tovey, John *Weaves and Pattern Drafting* Batsford, London; Reinhold, New York 1969

*Watson, William, FTI *Advanced Textile Design* Longmans, London, New York, Toronto 1912

Watson, William, FTI *Textile Design and Colour* Longmans, London, New York, Toronto 1912

Znamierowski, Nell *Step by Step Weaving* Golden Press, New York 1967

Suppliers

Looms and accessories See chapters 3 and 13

Dobby mechanisms
Callaghan Renard, East Street, Chichester, UK

Gauze weaving shafts and instructions
Jones Textilaties Ltd, Blackburn, Lancashire, UK

16 Interlaced fabrics: Jacquard weaves

In the Middle Ages man's desire to create gorgeous figured cloths resulted in the invention of the draw-loom. It dispensed with shafts and individual warp ends were drawn up by a drawboy seated on top of the loom. The Jacquard loom is merely a mechanization of this principle and gives the same graphic freedom. There is no such thing as a 'Jacquard weave' since cloths woven on a Jacquard loom rely, as much as any other cloth, on the basic and derivative weaves dealt with in the last chapter (see 124, 125). The main difference is that now any number of weaves can be used together; a change of weave can be made at any point within the repeat area; the repeat can be as small as one wishes or as wide as the whole loom; and the weaves can either meet each other sharply or be melded together to give shaded effects (as shown in 122 and 123). Essentially, a design for a cloth to be woven on a Jacquard loom must not only be artistically and graphically excellent, but must be composed with an intimate knowledge of yarns and basic weave constructions in order to achieve woven life and correct tonal and textural values. The weaver now has the freedom of the designer for prints.

The looms themselves, unlike the fabric they produce, are very 'unfree' and do not have the versatility of, say, dobby looms. The Jacquard mechanism (16 [7]) is mounted, like a dobby, above the loom, and has in it a predetermined number of hooks, and

(122) Jacquard weave, producing a shading from dark to light

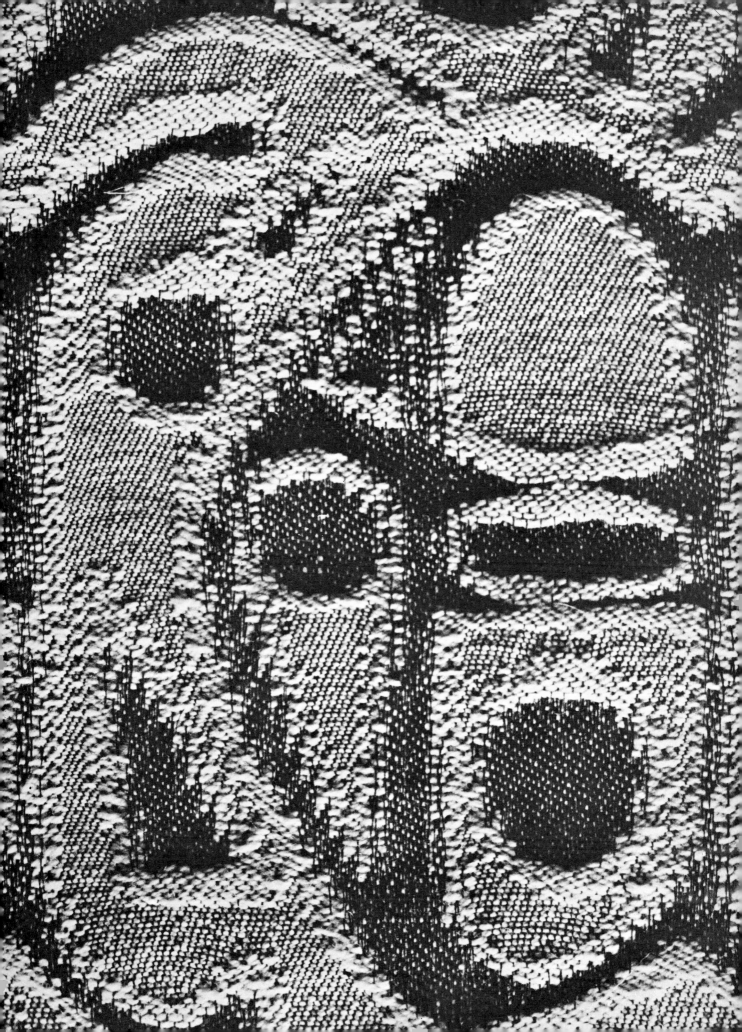

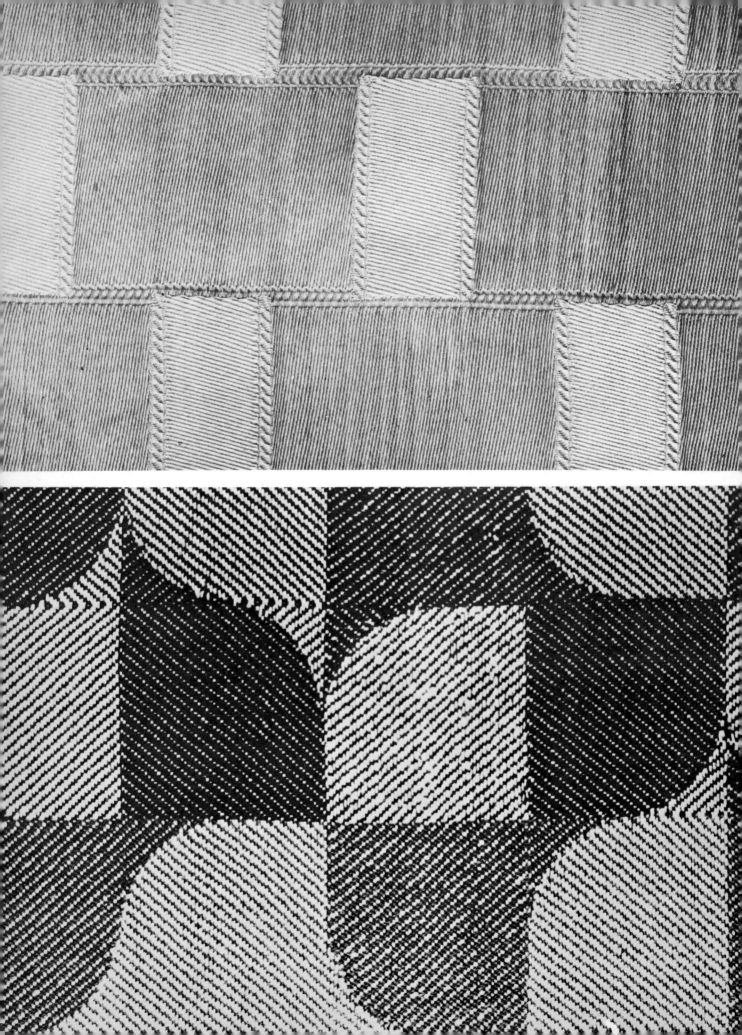

(124) Silk, satin, and sateen fabric, Linda Gardener, Royal College of Art. With spray-dyed warp. Photo Royal College of Art, School of Photography

(125) Jacquard furnishing fabric *Round Tower* Jack Lenor Larsen Inc, New York. Made using right- and left-hand twills

the number of hooks determines the number of warp ends which can be separately controlled. Looms are described by the number of hooks they have: therefore, a 200ˢ Jacquard means that 200 warp ends can each work independently; a 400ˢ Jacquard that 400 ends can work independently, and so on. A decision has to be made before the harness can be constructed about the weight of the cloth the loom is going to produce because, obviously, 200 fine yarns could occupy as little as 3in. in width and 200 coarse yarns could occupy as much as 20in. The harness is then made accordingly (16 [7]): on a 200ˢ Jacquard, if a sett of fifty ends per inch has been decided, then in a 40-in. cloth the harness will be made to manipulate ten 4-in. repeats, i.e. each hook will control ten threads across the cloth at 4-in. intervals. The harness is held out to proper width by the comber board, below which the heddles and lingoes (weights) hang; the warp is entered through the heddles generally in a straight draft, and an appropriate reed is dented. All this is now fixed and is only capable of minor re-arrangement.

In the workroom one requires as many Jacquard looms as there are different weights of cloth to be woven at the same time, although, of course, a harness can be taken down and stored and replaced by another one to produce a different cloth weight and design repeat size. Hook selection is determined by punched cards passing over a cylinder block, each card corresponding to a weft pick. Notation changes because no draft is needed, since the draft is almost always straight or pointed. The weave plan is painted in red on blue design paper which is squared off to correspond to the warp/weft relationship (e.g. if there are fifty warp ends and twenty-five weft picks per inch then an 8×4 design paper is required). The cards are cut by reference to each horizontal line of the repeat in turn. Cards are cut on a piano-like mechanism with a keyboard. The Jacquard loom available to the hand weaver is activated, like dobbies, with a foot pedal. Obviously, there is a distinct limit to the size of Jacquard that a weaver can physically operate without the aid of power.

It is certainly not necessary to work on a Jacquard loom in order to design for it. The designer's essential technical information is the number of ends per repeat, the width of the repeat and the number of picks per inch. The weaves which make up the areas of the design can be determined by working them out either on a dobby loom or the like, or on paper. The designer has now achieved total freedom, but it is very important for the weaver, when designing for Jacquards, to allow his artistic and graphic sensitivities to take full control. Quite often print-designers make a better job of handling Jacquard designs because they are accustomed to graphic freedom. Their design will be transposed into weave terms by a weave technician, and, knowing little about the mechanics of the technique, print designers are neither intimidated nor over-intrigued. Nevertheless, it is the weaver, with his knowledge of raw materials, yarns and weave construction, who should be adept in this field.

Further study

Gale, Elizabeth *From Fibres to Fabrics* Allman, London 1968
*Kirby, Mary *Designing on the Loom* Studio Publications, London, New York, Toronto 1955
*Watson, William *Advanced Textile Design* Longmans, London, New York, Toronto 1912
*Watson, William *Textile Design and Colour* Longmans, London, New York, Toronto 1912

Suppliers

Jacquard mechanisms and loom harnesses
Wadsworth & Devoge Ltd, Manor Road, Droylsden, Manchester, Lancashire, UK

Looms for foot-power Jacquards
J. Stansfield & Co, Almondbury, Yorkshire, UK

Design paper
William Allen & Co, Lower Parliament Street, Nottingham, UK

17 Twisted fabrics: sprang and twining

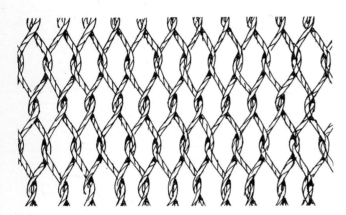

(126) Twisting

The technique of twisting or combining two or more elements by winding them together is widely used in textile construction to produce open yet stable structures (Chapter 18, hand and machine lace). The twist imparted can either be a single or compound twist, or a mixture of both. It can also be used as a firm method of entrapping another element, and this, strictly speaking, is called twining.

Sprang, or Egyptian plaiting, is the name given to an ancient but sophisticated hand method of twisting which results in a net-like open stretchy fabric. Its characteristics, by which it is immediately recognizable (diagram 120 [7]), are the net-like twisted open structure; the absence of any weft; the mirror repeat effect, i.e. whatever happens in the top half of the piece of work, including mistakes, happens invertedly in the bottom half; the necessity to secure the last and final twist firmly by some means in order to prevent the entire structure coming untwisted; its tendency to collapse width-wise unless held; and finally, the result of the interaction of all the threads upon each other, so that the final effect is not achieved all over the piece until the last twist is in place and the work has settled down.

A sheet of vertical threads, held firmly at the top and bottom, have a twist construction imparted to them two by two by finger manipulation, and a stick is inserted in order to hold the twists right across the width. There is no weft. The effect of the manipulation, held on the stick, i.e. the twist, is then imparted to both the top and the bottom of the work simultaneously, a most satisfying procedure! Impart further rows of twist, each one to both the top and the bottom, until the entire sheet of threads has been twisted and the twisting meets in the middle, then insert a holding element – this can be a bar or a cord, or the threads can be looped around one another and secured. One of the characteristics of sprang mentioned above is that left to itself it will collapse inwards in the horizontal. This tendency must be counteracted either by not having the piece too long; by the stretching action of a holding bar in the middle (the sprang would have to be attached to both ends); by stretching the whole thing on a frame; or by

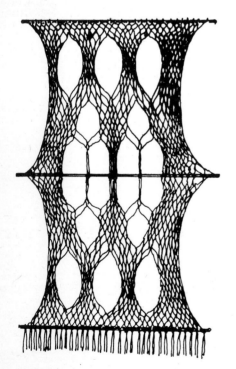

(127) Sprang

exploiting the collapsing quality (128).

As a technique sprang is capable of considerable creative development. It needs little equipment or preparation (either a frame or two bars) and its size is limited to whatever one can hang up and reach (if one is prepared to put in some pretty strenuous stretching and bending one could achieve a piece about seven feet long). Its obvious use is for wall hangings and room dividers, but it can also be adapted to light fittings: although it is a flat technique it can be urged into three-dimensional forms. The designer can exploit the following factors (129): natural curves which the sides of the work can take on; the curves and holes created by splitting the twisted structure; the mirror repeat characteristic and the fact that the holding bar and focal point of the whole thing can be decorative (129). An absolute mirror repeat is not a 'must'; the twists can meet off-centre if so desired and the piece of work (128) has deliberately avoided the effect of a mirror-repeat, although it *is* there in terms of twists. There are several variations of twist: a 1/1 twist; a double or treble 1/1 twist; 2/2 twist; 3/3 twist and still other variations, such as taking several threads and treating them as one. Only a 1/1 twist is explained here, since it is the basis of the others.

Practical working: (129) (approach a project of moderate size, say, 1ft wide by 3ft long). Acquire two pieces of wooden dowelling, both a little longer than the work's eventual width. Fix these, firmly, at two points, a little further away from each other than the work's eventual length. Decide upon a sett and wind a good, round, non-stretchy yarn between the two rods until the rods are full except for an inch or so at the ends. The yarn should be evenly wound, at whatever number of ends per inch you wish; even spacing in between the ends can be ensured by winding the yarn once or twice right round the rod itself before proceeding to the other rod (129 [1]). When the ends are secured you should now have something resembling a warp; this should then be hung up at a convenient working height and the bottom rod weighted. (In photo 128 and in diagram 127 the threads have been knotted onto a stainless steel rod.)

For working four sticks are needed, each wider than

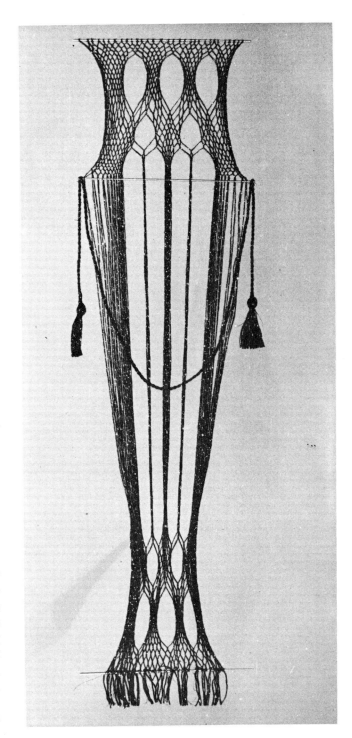

the work:

1 Thread a stick through the threads at the top, starting at the right, over and under the threads (129 [2]).

2 Thread a second *double* stick (two sticks held together in the hand), just under the first one also from the right, in the following manner: with the fingers put the first thread under the second, over the third, and under the fourth, and slip it over the end of the double stick; put the third thread under the fourth, over the fifth, under the sixth, and slip it onto the end of the double stick; continue right across the row in this manner (129 [3 and 4]).

3 Remove the first stick.

4 Separate the double stick and push one up to the top of the threads and secure it (with clothes pegs?) and push the other down to the bottom. This movement is the core of the matter (129 [5]).

5 With another double stick (the first one which has been removed plus another) execute another movement like stage 2, but the beginning is different, i.e. put the first thread over two and under three and slip over the double stick; put the second thread under three, over four and under five, and so on (129 [6]).

6 Separate the double stick, and push one up to the top of the threads, secure it, and push the other down to the bottom of the threads, as before, removing the original sticks.

Continue in this manner (steps 2, 4, 5, 6) until the twists meet in the middle of the work. Insert a third piece of dowelling which has had a channel cut into either end in which the two end warps will sit, thus holding the work out in the middle.

This procedure will produce a hanging of a 'double cotton-reel' shape, composed entirely of twisted yarn. It is, of course, only the beginning, but quite enough to set the mind working creatively. One very simple variation is to create splits in the twisted fabric which open out into curved holes. This is done by not twisting two threads which normally would be crossed

and put on a stick, leaving the same two untwisted for as many rows (an even number) as the split is desired. While the split is being made, the areas on either side are treated as separate areas of sprang. To close the split, the two untouched threads are twisted as before. The whole thing can acquire a rectangular shape by being secured to a frame all the way round; it can become cylindrical by having the top and bottom on wires which are, after working, coaxed into curves and soldered at the join. One can experiment by joining two or three separate pieces together to make long lengths; or by leaving the twists at the top slacker than the twists at the bottom, so that they will meet off-centre; or by not twisting the centre area at all, leaving two pieces of the 'double stick' (parted) in and securing them. This would leave the remaining warp to hang straight or to be manipulated in some other way – the possibilities are endless.

Twining

Twining, it was stated earlier in the chapter, is twisting when the twists enclose another element. The technique is believed to have preceded that of weaving. Basketry is an easily recognisable form of twining as the double cane which is worked around the circumference of a basket encircles, one by one, the cane uprights. Basketry is weft twining, i.e. the twining is horizontal. In order to achieve weft twining one must have the 'warp' or uprights held in some way, so obviously it is a technique which can be used on a hand loom.

Warp or vertical twining (88 [18]) can be achieved either rather like working sprang (the work meets in the middle, as every twist would produce its counterpart, assuming that the warps are held by something at either end and in the middle): or by hanging a sheet of threads, loose at the bottom (with each thread rolled into a ball like the procedure for macramé), and then inserting stiff wefts such as bark, cane or perspex rod, from below. Twining does not lend itself to mechanization, but with thought it certainly lends itself to the production of fine-art textile objects.

(129) Sprang. The Sprang sequence as in (128), if it had been treated in a more conventional manner. (These threads were knotted on, not wound)

Procedure one

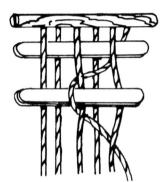

Procedure two

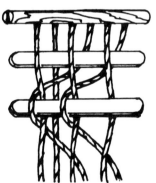

Procedure two (cont)

right
Threads wound onto dowelling ready for working

far right
Procedures three and four

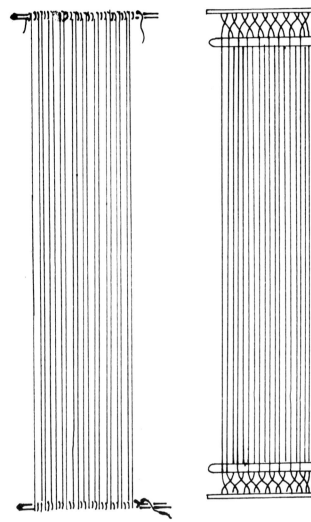

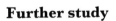

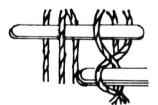

Procedure five

Further study

*Collingwood, Peter *Sprang, Revival of an Ancient Technique* Handweaver and Craftsman Magazine, vol 15, no. 2
*Emery, Irene *The Primary Structure of Fabrics* Textile Museum, Washington DC, USA 1966

18 Twisted fabrics: hand and machine lace

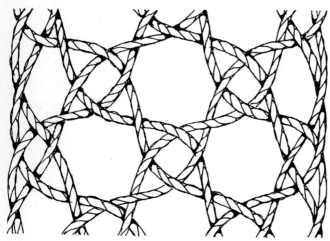

(130) Pillow lace, Dieppe net ground

The manner in which lace is constructed allows the creation of free graphic forms, generally in comparatively opaque construction, against an airy, delicate, transparent ground (131). Lace can be light or heavy weight, fine or coarse, dependent upon the weight of the yarns used and the constructions chosen. Yarns used most often are linen, cotton, silk or man-mades, i.e. those with a fine, clean, smooth outline. Lace is airy and delicate yet incredibly stable and hardwearing partly because of the method of construction which incorporates so many techniques already dealt with, twisting, looping, plaiting, weaving, knotting, etc. It can be produced in wide yardage, yardage with ornamented edges, edgings, frillings and in any desired shape, flat or three-dimensional, however complex.

The study of the history of lace is an evocative one, the very word 'lacy' is used so often as a description for all sorts of agreeable things, but it is also a very salutary one as it would seem that as a much-prized textile associated with riches, beauty, privilege and splendour, it has most often been produced in conditions of the most appalling poverty, and quite regularly being the sole occupation of one human being practically from the cradle to the grave. Hand-made lace is a rewarding area for the textile constructor, as it uses a multiplicity of techniques, put together in ingenious ways. Lace machines are complex, clever and versatile and can give the designer great freedom. There is, I think, a distinct tendency of 'think traditional' among the manufacturers of lace and there is here a vast and rewarding field of contemporary graphic imagery and texture as yet unexplored.

Hand-made lace

There are two main ways of producing lace by hand: needle-made lace (needle point) and pillow or bobbin lace. Both methods subdivide into numerous variations with special characteristics generally known by geographical location: Honiton, Brussels, Valenciennes, etc.

Needlepoint lace is made with a needle and thread and

consists of embroidery stitches mainly based on buttonhole and knot stitch. The stitches sometimes form the fabric itself and are sometimes worked over laid threads. Because of its kinship with embroidery, needlepoint will not be elaborated upon here.

Bobbin or pillow lace is a hand method which was finally mechanized. The hand production of bobbin lace needs several pieces of specialized equipment for which there can be little substitution: bobbins, one for each thread; a hard-stuffed pillow or pad (these vary greatly in shape); card on which to draw and then prick the design; a pricker; pins and a bobbin winder (131). The pillow is held either on the lap, on a table, or on a special stool called a 'horse'. The design is created on paper, then drawn on to the card, and the card pricked at the points where thread directions will change. Then the card is fixed firmly to the pillow. The lace is worked on the card with multiple yarns, each yarn being first wound on to its own bobbin. Bobbins are always used in pairs and there are never less than two pairs. The paired threads are pinned to the pillow at the beginning of the design, the threads then hang down, and the bobbins fan out on the pillow, each in its own appointed place. The bobbins are manipulated by the fingers to form the various different constructions according to the different areas of the design, pins being used to anchor the threads at each stage of the work. The movements are rather like playing the piano: one looks at the design, not the bobbins.

The basic open ground stitches include lattice stitch, torchon net, dieppe net (diagram 130), tulle net, brussels net, rose net and plaiting. The solid motifs are almost invariably worked in cloth stitch which looks like plain weave. A basic two-part stitch must be learned which consists of twisting and crossing four threads twice (131 [line 2]), the entire stitch being called a passée double.

See (131) for the passée double, cloth stitch, and one ground stitch, i.e. lattice. Instructions for the two latter are as follows:

Lattice ground (131 [line 3]). Hang one pair of bobbins on to the pattern at each of the points marked 1, 2, 3, 4, 5. Twist the first and second pairs once (131 [line 2]), cross * (131 [line 2]), twist the second and third pairs once, cross, twist the third and fourth pairs once, cross, twist the fourth and fifth pairs once, cross, insert a pin at point 1. Twist the fourth pair once, twist the fifth pair twice, cross, twist the third and fourth pairs once, cross, twist the second and third pairs once, cross, twist the first and second pairs once, cross, insert pin at point 2. Twist the first pair twice, twist the second pair once, cross, repeat from *.

Cloth stitch (131 [line 3]). Hang two pairs of bobbins on each of the points 1, 2, 3, on the pattern. Twist and cross the first and second pairs (131 [line 2]), do one passée (131 [line 2]), * cross the second and third pairs, one passée, cross the third and fourth pairs, one passée, cross the fourth and fifth pairs, one passée, cross the fifth and sixth pairs, one passée, insert pin at point 1. Do not twist the fifth pair, twist the sixth pair once, cross the fifth and sixth pairs, one passée, cross the fourth and fifth pairs, one passée, cross the third and fourth pairs, one passée, cross the second and third pairs, one passée, cross the first and second pairs, one passée, insert pin at point 2. Twist the first pair once, do not twist the second pair, cross first and second pairs, one passée; repeat from *. Photograph 132 is an example of bobbin lace, in metal thread, used for contemporary curtain fabric by Jack Larsen of New York.

Machine-made lace

Lace, as we know it, was an invention of the early Middle Ages and it is interesting that when demand outstripped supply in the seventeenth and eighteenth centuries, the knitters were the ones who tried to speed up production by making a 'lacy' knitting on their frames, using stitch transfer techniques. Efforts to produce a fabric closer to the original bobbin lace resulted in the knitting of a warp of threads on a hand frame in 1775. This was the beginning of the warp-

Hand-made Lace

Hitch

Wound thread

Handle

Beads for weight

1.

1 Bobbin of ivory, bone or wood (wound)

2 Top view of one sort of pillow. A wood framing covered with cloth, with aperture for hard-stuffed roller around which pattern is pinned. And plenty of flat area on which to lay bobbins in place

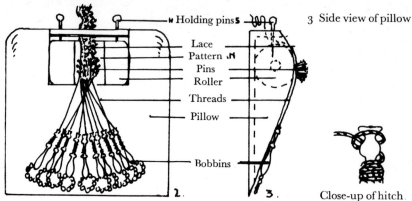

Holding pins

Lace
Pattern
Pins
Roller
Threads

Pillow

Bobbins

2.

3 Side view of pillow

3.

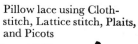

Close-up of hitch

 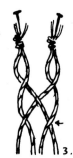 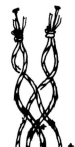 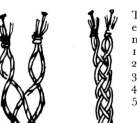

1. 1 2. 3. 4. 5.

Two pairs of bobbins executing the four movements

1 Twisting } demi-
2 Crossing } passée } passée
3 Twisting } passée } double
4 Crossing }
5 Plait

Pillow lace using Cloth-stitch, Lattice stitch, Plaits, and Picots

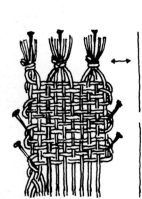

Cloth-stitch and pricking

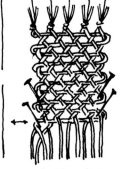

Lattice stitch and pricking

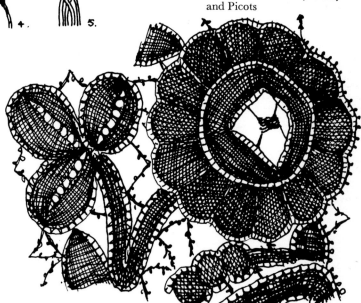

Machine-made lace constructions

Roller-locker

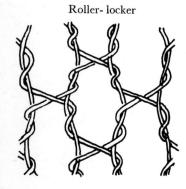

Furnishing lace

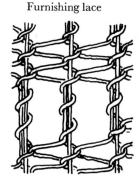

Leavers lace

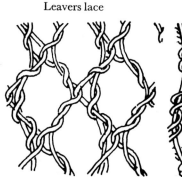

Barmen lace

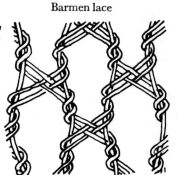

(132) Bobbin lace curtain
fabric in gold thread, Jack
Lenor Larsen Inc, New York.
Photo Alan Hill

knitting industry which now, of course, among other
things produces Raschel 'lace'. Heathcoat's lace
machine of 1809 made further progress, the principle
being a vertical sheet of warp threads, through which
were passed incredibly thin bobbins (like a sewing
machine round bobbin, squashed flat). Each bobbin
fits into its own carriage (shuttle) inside which it un-
winds; the carriages containing the bobbin and the
thread (which unwinds upwards) swing collectively
through a sheet of warp threads from front to back
and vice versa. Between each swing the warp threads
are given a lateral movement so that the bobbin
threads can twist around them. On Heathcoat's
machine the bobbins also moved their positions
laterally so that each bobbin thread diagonally tra-
versed the width of the net.

Present day twist lace is produced on five types of
machinery, three based on the Heathcoat principle,
and two quite different. In order of complexity they
are as follows.

The Roller Locker machine, which is virtually
Heathcoat's, produces plain nets, which can, of course,
be decorated by other means afterwards (131).

The next is the vast Lace Furnishings Machine
which sometimes produces fabric as wide as 200in.
This is basically like Heathcoat's but with an
important third element: yarn on spools. The warp
yarns are the undeviating vertical element, the bobbin
yarns twist around the warp, as before, but bind in the
spool yarns which traverse between two or more warp
threads. The resulting lace has a 'square'-looking con-
struction but the design complexity and size is
enormous (131).

The third machine, the Leavers Lace Machine, is
miraculously versatile; most of the traditional 'pillow
lace' constructions are possible on it, plus many others,
sometimes some with no hand-made equivalent. It
has the warp threads and bobbins as before plus forty
to several hundred extra thread beams, on which are
wound sparse warps corresponding to whatever extra
threads are required in the design. Each beam has a
perforated bar in front of it through which the
threads are guided, and these bars are moved laterally
and independently of each other by a 'Jacquard'

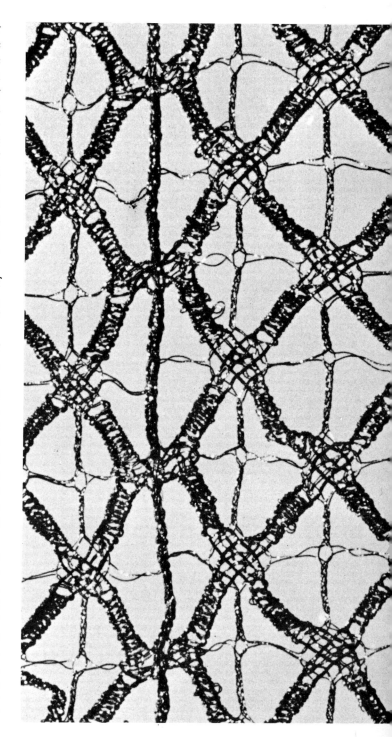

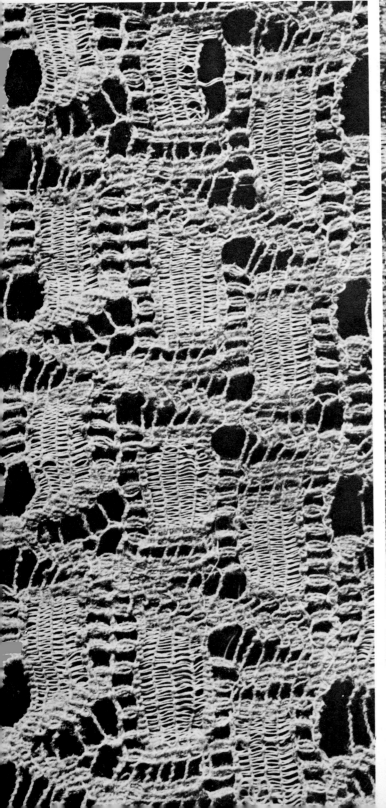

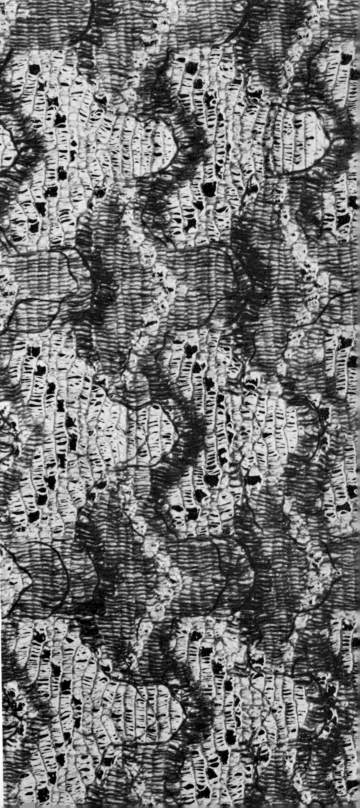

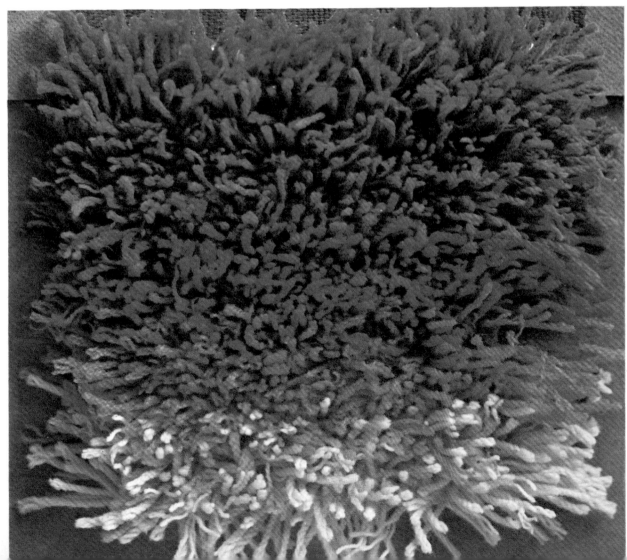

mechanism, between each movement of the bobbins. The warp threads and bobbins are therefore producing basic net fabric while the numerous extra beams are providing the third element of threads for figuring (131, 133, 134). The versatility and design scope of this machine are enormous.

The other two machine methods referred to are firstly the Barmen Machine, the actual action of which is nearest of all the machines to the action of pillow lace. Action takes place around a centre point and bobbins travelling in a prescribed track in a flat bed gyrate in a maypole-like path. Braid machines operate in a like manner (131).

The second, the Schiffli Machine, is bordering upon embroidery. It is like a multi-needle lateral sewing machine, producing an all-over lock-stitch design on an existing woven fabric, which is held out at tension. The woven cloth can eventually be dissolved to leave the embroidery forming a lace-like end product.

Further study

Channer, C. C. *Lace Making* Dryad Press, Leicester, UK 1959
Close, Eunice *Lace Making* Gifford, London 1970
De Dillmont, Thérèse *Encyclopaedia of Needlework* Editions Thérèse De Dillmont, Mulhouse, France 1930
Felkin, William *History of the Machine-Wrought Hosiery and Lace Manufacturers* David & Charles, London 1967
Freeman, Charles *Pillow Lace in the East Midlands* Luton Museum, UK 1958
Gubser, E. *Bobbin Lace* Museum Books, New York
Harding, Keith *Lace Furnishing Manufacture* Macmillan, London 1952
May, Florence Lewis *Hispanic Lace and Lacemaking* Hispanic Society of America, New York 1939
Pond, Gabrielle *Introduction to Lace* Garnstone Press, London 1968
Tod, O. G. *The Belgian Way of Making Bobbin Lace* Museum Books, New York
Tod, O. G. *Bobbin Lace Stitches, Step by Step* Museum Books, New York

Suppliers

Tools for hand-made lace
Dryad, Northgates, Leicester, UK

Old bobbins, winders, etc
Antique shops

Information on suppliers of lace-making machinery
Nottingham Lace Manufacturers Association, 395 Mansfield Road, Nottingham, UK

19 Laminated fabrics

In recent years, laminating, or bonding, has made more difference to the textile constructor's job than has anything else, and will continue to do so in the future.

The technique is to adhere one textile to another textile, or to a foam substrate, or to both (diagram 137). Whereas formerly textiles constructed by traditional methods had to be a compromise between aesthetic quality and performance, one can now, by laminating, design a fabric almost purely from the aesthetic point of view, the necessary performance factors being built into the substrates to which the fabric is bonded. This might also be a disadvantage, since limitations often serve the purpose of spurring on a designer's creativity and craftsmanship. On balance, however, this is outweighed by the advantages of being able to bring into use textile techniques which hitherto were useless, being too unstable.

The economy achieved by looser textile construction allows the greater use of fancy yarns and the greater visual appreciation of those yarns, as close-packing is no longer essential. We can now have double faced fabrics achieved by a different method other than woven double cloths; padded fabrics of varying thicknesses; loosely woven fabrics stabilized; stretchy and lacy knits stabilized (138); woven upholstery fabrics less solidly packed; fabrics deliberately distorted (135); curtain and fashion fabrics already lined and insulated (this altering radically soft furnishing and tailoring methods and time); and coloured backing fabrics giving new colour and dimensional qualities to open weaves and knits. A great field of exploration certainly lies in the field of decorative sheers.

Laminating, like many other inventions, had an unfortunate start in that the first fabrics, the old 'foambacks', were nasty to handle, uninteresting to look at, and unstable when cleaned and it has taken many years to kill this image. The change has come about by the tremendous improvement in the adhesives, the methods of adhesion, and stricter quality control.

The bond is achieved either by the use of an adhesive (either water-based acrylics or solvent-based methanes) or by heat fusion of foam. The walls of a polyurethane foam are melted and the molten foam

(137) Woven face fabric with foam padding and knit substrate

(138) Laminated fabric, Brenda Lewis, Birmingham College of Art and Design. Knit laminated to net. Photo Alan Hill

(139) Chemstitched fabrics by Lintafoam, High Wycombe. Photo Alan Hill

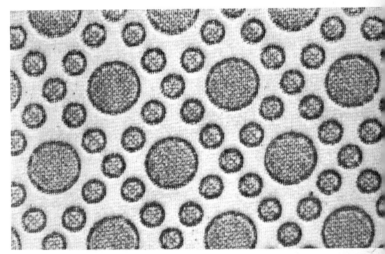

itself is used as the adhesive between the face fabric and the backing fabric. The machinery used for this is basically rollers and drying areas, through which the fabrics are passed to be bonded in a relaxed state. The fabric to be laminated needs either spare fabric at either end or sewn-on scrim, on which the machinery can bite.

There is a bonding sampling machine but this only coats the surfaces of the fabrics with adhesive and one can do this quite well manually. Bonding can be simulated in small sample form by the use of tailoring material obtainable from shops catering for the home-dressmaker. This is a fibrous sheet of material, which is placed between the two fabrics to be bonded, and, when subjected to heat and pressure, dissolves into glue (138).

Chemstitching is a patented process by which a quilted effect is imparted to fabrics by means of bonding. The design is transferred to engraved rollers, which deposit adhesive on the backing foam. When the foam is brought into contact with the face fabric and heat is applied, the point of contact, which is the design, forms the bond. This process gives great graphic freedom, plus fabric depth and light and shade (139).

Suppliers

Textile bonding
Paper by A. J. Chapman, available from Textile Bonding Ltd, Higham Ferrers, Northampton-shire, UK, on the receipt of a stamped addressed envelope

Bonding undertaken by the same firm (heat fusion of foam, acrylic and urethane adhesives)

Chemstitching
By Lintafoam Ltd, Loudwater, High Wycombe, Buckinghamshire, UK

20 Finishing and presentation

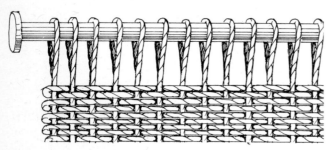

(140) Heading for woven wall hanging

Finishing is a most important part of the textile process, whether one is dealing with a sample design, cloth yardage, a rug, a hanging, a garment, or whatever. Used in its widest sense, it gives to the object a practical and appropriate final processing which was not possible during production. It is rare that a textile requires absolutely no form of finishing, although sometimes it is minimal; at the other end of the scale some finishes impart a quite new character to the product.

The presentation of work, in its widest sense, is the giving of due consideration, and further craftsmanship to the proper method and manner of showing an object and also of ensuring its life-span.

Neither of these can be underestimated or ignored and both are measures of a designer's professionalism.

Finishing

Woven fabrics are called 'loomstate' when they are cut from the loom and they may emerge clean or they may contain foreign matter, like dust and dirt, or warp size, or, in some cases, colouring which has been used for some form of yarn identification. If the fabric is clean, a simple finishing process may still be necessary in order to make the yarns swell and settle into place and 'set', and in order to effect whatever shrinkage is going to take place. Hand-produced wovens should be washed gently (squeezed not rubbed); very well rinsed, if possible in deep double sinks; hand-wrung; then either dried under firm tension by careful stretching on finishing rollers (a form of stentering) or hung (very straight) to dry; and then steam pressed.

Finishing rollers are wooden rollers, longer than the cloth is wide and about 12in. in diameter, composed of slats to allow air to circulate freely (15 [25]). Three people are required for stretching the cloth, one at either end of, and one in front of the roller, which is placed along the end of a table. Secure one end of the cloth to the roller by means of a stick pushed down between the slats and then stretch the cloth as tightly as possible round and round the roller, taking great care to ensure that the warp and weft are kept absolutely at 90 degrees to one another, using the

consecutive layers of selvedge as a constant width guide and taking great care not to overstretch the selvedge (look along the weft picks and line them up with the slats). Secure the end of the cloth with a stick placed along it and tie it with cords around the roller at the extreme ends. Stand the roller on end for natural drying (which can take some days) or hang it on sturdy rods in a drying cabinet (chapter 3). When the outside of the cloth is dry, the process can be speeded by re-rolling, beginning with the other end.

If the fabric is hung to dry, and then steam pressed, you will need a large steam press, like those used by dry-cleaners and tailors, who may well allow you to use their equipment. The press consists of a big padded table and a hinged head the same size, both of which have steam pumped through them and then drawn away by vacuum suction. Used without the head this equipment raises fabrics most satisfactorily, and the head is used only for flattening and smoothing fabrics. If a fabric is very three-dimensional, or if it contains very fancy or tightly-twisted yarns, it may well curl up like a caterpillar as the steam is pumped through. To prevent this it should be lightly pinned to the table of the press. It is important to remember that while fabric is wet, either with water or steam, it is very malleable and the shape in which it is dried is the shape it will retain.

Knitting yardage, if handled with care, can be treated in the same manner as wovens, bearing in mind that wovens are firm and stable and can be treated with some gusto, whereas knitteds are exceedingly stretchy and pliable and can be very easily distorted.

Some of the finishing processes applied to cloth, many of which change its character, are scouring (washing to remove dirt and grease); milling (making a fibrous cloth more close and firm by working it in hot soapy water – the ultimate of this is, of course, the making of felt by the beating of woollen fibre or cloth in hot water and soap); raising and shearing (or creating a pile and then tidying it). The latter is best done industrially although small areas can be attempted by hand. It is interesting that with all modern techniques, the teasel still produces the best result; carders can be used, but only with very great care. Other finishing processes, mostly industrial, are bleaching; mercerizing (the imparting of lustre); beetling (flattening with an action like that of a hammer); moth-, rot- and water-proofing; and the imparting of crease and flame resistance.

Fabric shapes, like crochet or hand- and machine-knitted garment pieces and also design samples, can be very satisfactorily finished by being washed and then carefully pinned out to the accurate shape and left to dry naturally (use *lots* of pins). The work must be bone-dry before being removed: this is called 'blocking'. If time is at a premium, shaped pieces can be finished on the steam press (lots of pinning) – with or without the head. A hand iron should always be used with caution, since the natural action of hand ironing can tend to distort and push out of shape, rather than set fabric in shape.

For some reason, students in particular have an aversion to finishing cloth, perhaps fearing that harm might be done to the result of weeks of work. But it is absolutely necessary to remove loom dirt, and to take account of shrinkage and other factors, and beyond that, the difference in aesthetic quality between a finished and an unfinished cloth is immeasurable.

Presentation

The mounting and presentation of sample designs is most important. As with the complexity of the workroom, good presentation won't make good work out of bad, but it does give good work its due. Presentation should be simple and workmanlike, with no embellishment but with all the necessary technical information. First, sample fabrics must be correctly 'finished' (one must stress again the care given to the accurate 90 degree angle of warp to weft). After finishing, the edges of samples should be latexed and then cut accurately and squarely with very sharp scissors. The designs should then be mounted in such a way that they can be seen and felt easily (never glue fabric down all over). There are several ways of mounting samples: they can be held together in swatches (141 [4]); held singly in a headed card; mounted on a flat card (141 [3]); glued behind a window mount (141

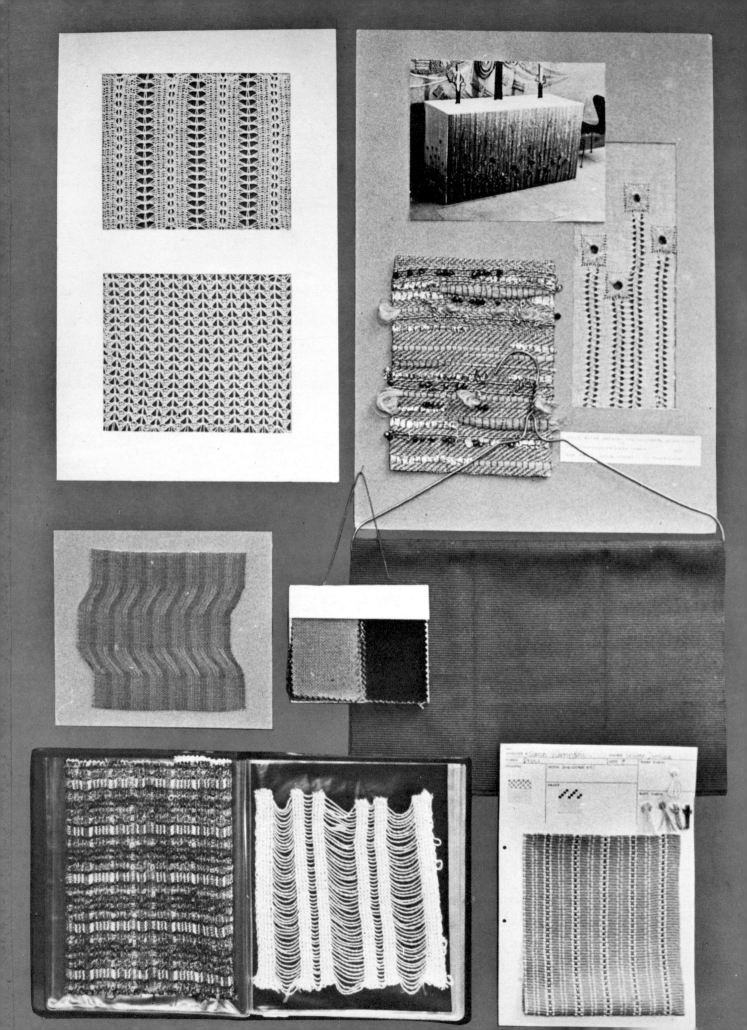

(141) Methods of presentation
and of recording designs
(from left to right)
1 Window mounts
2 Mount with samples of
woven and of embroidered
fabrics and photograph of final
objects in place
3 Card mount

4 Swatch
5 Coat hanger
6 Nyrex folder
7 Specially printed sample-
design card
Photo Alan Hill

[1]); mounted on a specially designed sample card (141 [7]); held on a hooked heading (or coathanger) (141 [5]); or put in Nyrex folders (141 [6]). The method chosen depends upon the dictates of the fabric, the designer's needs and storage facilities.

To the designer of 'one-offs', a good photographer is an invaluable ally. Textiles are very hard to photograph well and need good lighting, a good camera, and a sensitive eye. A most useful method of recording work for one's own, or for exhibition purposes, is a mount containing a photograph and samples of the materials, with letraset information (141 [2]).

The framing and hanging of panels or objects always needs a high degree of professionalism. For those which 'hang' satisfactorily with no need of extraneous support or tensioning, a stainless steel or chrome rod (92), wood dowelling (8 and 94), a hollow or solid perspex tube or curtain pole (obtainable from furnishing stores), are suitable for the top edge (140). If, on the other hand, you wish to obscure the top edge instead of displaying it then have a dowelling sliced in two and staple the work in like filling in a sandwich, then nail or glue the dowelling together again. The bottom edge can be treated in the same way; or fringed; or knotted; or hemmed to enclose a metal bar or its equivalent for weight.

For work which requires tensioning, well-made frames should be used. A good picture-framer or carpenter who will design and make framing exactly to specification is essential. A frame has to be a co-operative job between designer and carpenter as some work demands that, though it needs a frame, possibly to hold it rigid, the frame *must* be part of the whole design conception (10 and 27). Work often needs no visible frame but, rather, very careful stretching over a backing frame: in this case follow the warp and weft threads extremely carefully when securing with staples. Stainless steel angle makes superb framing, especially for fine tapestries. Many plastic edgings, both angle and U-shape, are available but they are very pliable and must be manipulated very firmly.

For work which is a free-standing or hanging form a metal armature, as used by sculptors, can be used (93).

Whenever decorative hangings and panels are created we have a very special problem: dirt and ageing. Textiles, I am told, are a museum-keeper's nightmare. One always hopes that the work will go into a controlled atmosphere but this is rare, especially in England. Sometimes it is possible to wash a hanging, but if not, one can impart spray finishes which give protection. A solution of starch, or thinned lacquer, or liquid acrylic will stiffen and hold the hanging and it will be possible to vacuum it. A satisfactory liquid acrylic finish is the artist's medium PVA (Hyplar in the USA) diluted with water. The effect of this treatment varies: cottons, linens, jutes, wools, etc. are not altered at all, rayons and silks may be darkened and de-lustred, so spray a trial piece first. One has to decide whether one can sacrifice the 'feel', or whether a hanging is essentially a visual experience. A 'Scotchgard' finish, available for some years in the USA, and now in Britain, gives protection against spills and splashes and air-, oil- and water-borne soiling. It is invisible on most materials but again, do a trial piece first. Starches, lacquers or liquid acrylic are also useful for 'setting' airy thread-like works (94).

The final statement of a piece of work is composed of its originality, its aesthetic validity, its craftsmanship and quality of execution, its 'fitness for purpose', both aesthetic and practical, its economic viability and its reasonable life-span. One should keep in mind from the beginning that every element reacts upon every other.

Further study

Gale, Elizabeth *From Fibres to Fabrics* Allman, London, UK 1968
Nelson, Norbert *Photographing your Product* Reinhold, New York 1971
Nuttall, Prudence *Picture Framing for Beginners* Studio Vista, London 1971

Suppliers

Fabric Finishing by T. M. Hunter, Brora, Scotland
'Scotchgard' from most hardware stores
PVA and Hyplar from artists' suppliers

Bibliography

Knowledge is not a matter of cramming it all in, but of knowing where to look for your information when you need it.

Listed in the bibliography are all the reference books which have been mentioned already at the end of each relevant chapter. Grouped together at the top of the list are books which I have been glad to find and would not be without – but it is quite an arbitrary personal choice.

Albers, Anni *On Weaving* Wesleyan University Press, Middleton, Connecticut, USA 1963; Studio Vista, London 1966
The book I would least like to be without. The manner in which she philosophizes about textiles goes far beyond the confines of the subject.

Feininger, Andreas *Form in Nature and Life* Thames & Hudson, London 1966
Visually very stimulating.

Keble-Martin, W. *The Concise British Flora* Ebury Press, London 1965
A strange 'outsider' to include but I find the layout of the pages quite irresistible as pieces of design.

Kirby, Mary *Designing on the Loom* Studio Publications, London, New York 1955
This book is now, sadly, out of print and only second-hand copies can be obtained. Even though visually dated, it is an impeccable and readable source of information on weaves and weaving (looms and setting-up are not included).

De Dillmont, Thérèse *Encyclopaedia of Needlework* Editions Thérèse De Dillmont, Mulhouse, France 1930
Truly an 'encyclopaedia' and, as such, invaluable.

Harvey, Virginia *Macramé, the Art of Creative Knotting* Van Nostrand Reinhold, New York, Toronto, London 1968
Beautiful drawings, very clear. The book which started the recent macramé revival.

Fannin, Allen *Handspinning Art and Technique* Reinhold, New York 1971
A most beautiful and complete book on hand-spinning, as a craft and as an art in its own right.

Beutlich, Tadek *The Technique of Woven Tapestry* Batsford, London: Watson-Guptill, New York 1967

Nordness, Lee *Objects U.S.A.* Viking Press, New York; Macmillan, Canada 1971
Full of information about objects and their designers. The introduction is an excellent comment on the present 'art-object' situation.

Meilach, Dona *Macramé* Crown, New York; General Publishing Co, Canada 1971

There are many excellent books on macramé, but in this one there are, in addition to loads of information, illustrations of some superb work by outstanding contemporary designers.

Hartung, Rolf *Creative Textile Craft* Batsford, London; Reinhold, New York 1964

Emery, Irene *The Primary Structure of Fabrics* Washington Textile Museum, 1965
A textile structure bible, written from an archaeologist's point of view.

Groves, Sylvia *The History of Needlework Tools* Country Life Books, Hamlyn Publishing Group, Middlesex, UK 1966

Albeck, Pat *Printed Textiles* Oxford University Press, London, New York, Toronto 1969
Really outside the scope of this book but most useful as a mine of practical information from a busy practising designer.

Walker-Phillips, Mary *Creative Knitting, a New Art Form* Reinhold, New York 1971
The first book of its kind.

Designing and designers

Albeck, Pat *Printed Textiles* Oxford University Press, London, New York, Toronto 1969

Albers, Anni *On Weaving* Wesleyan University Press, Connecticut, USA 1963; Studio Vista, London 1966

Albers, Anni *On Designing* Pellango Press, Connecticut, USA 1959

Beutlich, Tadek *The Technique of Woven Tapestry* Batsford, London; Watson-Guptill, New York 1967

Brodatz, Phil *Textures* Dover Publications, New York 1966

Feininger, Andreas *Form in Nature and Life* Thames & Hudson, London 1966

Humbert, Claude *Ornamental Design* Thames & Hudson, London 1961

Justema, William *The Pleasures of Pattern* Reinhold, New York 1968

Kaufman, Ruth *The New American Tapestry* Reinhold, New York 1968

Keble-Martin, W. *The Concise British Flora* Ebury Press, London 1965

Kirby, Mary *Designing on the Loom* Studio Publications, London, New York, Toronto 1955

Meilach, Dona *Macramé* Crown, New York; General Publishing Co, Canada 1971

Nordness, Lee *Objects U.S.A.* Viking Press, New York; Macmillan, Canada 1971

Seyd, Mary *Designing with String* Batsford, London 1967

Strache, Wolfe *Forms and Pattern in Nature* Peter Owen, London 1959

Walker-Phillips, Mary *Creative Knitting: a New Art Form* Reinhold, New York 1971

Spinning

Davenport, Elsie *Your Handspinning* Sylvan Press, London 1953

Fannin, Allen *Handspinning, Art and Technique* Reinhold, New York 1971

Hooper, Luther *Handloom Weaving* Pitman, New York, London 1920

Kluger, Marilyn *The Joy of Spinning* Simon & Schuster, New York 1971

Morton W. E. and Wray G. R., *An Introduction to the Study of Spinning* Longman, London 1962

Spinning Wool Dryad Press, Leicester, UK

Thompson, G. B. *Spinning Wheels* Ulster Folk Museum, Belfast, Ireland 1966

Dyeing

Davenport, Elsie *Your Yarn Dyeing* Sylvan Press, London 1955

Lesch, Alma *Vegetable Dyeing* Watson-Guptill, New York 1970

Mairet, Ethel *A Book of Vegetable Dyes* Faber & Faber, London 1916

Thurston, Violetta *The Use of Vegetable Dyes* Dryad Press, Leicester, UK

Worst, Edward *Dyes and Dyeing* Craft and Hobby Book Service, Pacific Grove, California 1970

Macramé and knotting

Allen-Williams, E. *Girl Guide Knot Book* Girl Guide Association, London 1969

Andés, Eugene *Practical Macramé* Studio Vista, London 1971

Ashley, Clifford *The Ashley Book of Knots* Doubleday, New York 1944

Burgess & Nicholson *Help Yourself to Knotting and Lanyard Making* Girl Guide Association, London 1961

Graumont, Raoul and Hensel, John *Encyclopaedia of Knots and Fancy Ropework* Cornell Maritime Press, USA 1958

Graumont, Raoul and Newstrom, Elmer *Square Knot Handicraft Guide* Cornell Maritime Press, USA 1949

Harvey, Virginia *Macramé, the Art of Creative Knotting* Reinhold, New York, Toronto, London 1967

Meilach, Dona Z. *Macramé* Crown, New York; General Publishing Co, Canada 1971

Short, Eirian *Introducing Macramé* Batsford, London; Watson-Guptill, New York 1970

Smith, Harvey G. *The Marlinspike Sailor* John De Graff Inc, Tuckahoe, New York 1969

Netting and tatting

Ashdown, E. A. *Tatting* Craft Notebook Series, USA 1961

Attenborough, B. *The Craft of Tatting* Bell, London 1972

Collard, B. St G. *A Textbook of Netting* Dryad Press, Leicester, UK

Cumming, Primrose *Netting* Dryad Press, Leicester, UK

Learn Tatting J. and P. Coates Sewing Group (UK) Book No. 1088 1969

Nicholls, Elgiva *New Look in Tatting* Tiranti, London 1959

Nicholls, Elgiva *Tatting* Studio Vista, London 1962

Knitting

Aytes, B. *Knitting Made Easy* Doubleday, New York 1970

Aytes, B. *Adventures in Knitting* Doubleday, New York 1968

Chamberlain, John *Knitting Mathematics and Mechanisms* Textile Trades Advisory Committee, Leicester College of Technology, UK 1923

Chamberlain, John *Principles of Machine Knitting* Textile Institute, Manchester, UK 1951

Dubied Knitting Manual Dubied Machinery Co. Ltd, Northampton Street, Leicester, UK

Johnson, Thomas H. *Tricot Fabric Design* McGraw-Hill, New York 1946

Mayfield, A. (ed.) *Odhams Encyclopaedia of Knitting* Hamlyn Publishing Group, Middlesex 1970

Mills, R. W. *Fully Fashioned Garment Manufacture* Cassell, London 1965

Mon Tricot *800 Stitch Patterns* 41 Boulevard des Capucines, Paris, France

Mon Tricot, editors *Knitting Dictionary* Crown, New York 1971

Non-Wovens 71 Manchester University Conference, Manchester Trade Press, UK 1971

Paling, Dennis *Warp Knitting Technology* Columbine Press, UK 1965

Prusa, Ernst *Bindungslehre der Strickerei* Melliand Textil-brichte, Heidelburg 1958

Stitch-Bonded Fabrics Shirley Institute, Pamphlet 100, Manchester, UK

Thomas, Mary *Mary Thomas's Book of Knitting Patterns* Hodder & Stoughton, London 1957

Thomas, Mary *Mary Thomas's Knitting Book* Hodder & Stoughton, London 1938

Thompson, G. *Patterns for Jerseys, Guernseys and Arrans* Batsford, London 1969

Walker, Barbara *The Craft of Cable-Stitch Knitting* Scribner, New York 1971

Walker, Barbara *The Craft of Lace Knitting* Scribner, New York 1971

Walker, Barbara *Treasury of Knitting Patterns* Pitman, London 1968

Walker-Phillips, Mary *Creative Knitting, a New Art Form* Reinhold, New York 1971

Walker-Phillips, Mary *Step by Step Knitting* Golden Press, New York 1967

World Knitting Machinery Index Hosiery Trade Journal, Millstone Lane, Leicester, UK 1967

Crochet

Ashe, R. *Crocheting for the New Look* Bantam, New York

Ashley, R. *Crocheting, the New Look* Grosset & Dunlap Inc, New York

Blackwell, Liz *A Treasury of Crochet Patterns* Scribner, New York 1971

Book of Instant Crochet H. G. Twilley, London 1969

Crochet D.M.C. Library, Comptoir Alsacienne de Broderie, Mulhouse, France

Hairpin Lace and Broomstick Crochet G.Y.S. Books, PO Box 513, Fremont, California, USA

Kinmond, J. *Crochet Patterns* Batsford, London 1969

Koster, J. and Murray, M. *New Crochet and Hairpin Work* Calder, New York 1955

Learn to Crochet Book No. 1065, J. & P. Coates, Glasgow, UK 1967

The Vogue Sewing Book Butterick Press, London 1970

Weaving

Allen-Williams, E. *Girl Guide Knot Book* Girl Guide Association, London

Albers, Anni *On Weaving* Wesleyan University Press, Middleton, Connecticut, USA 1963; Studio Vista, London 1966

American Fabrics, editors *American Fabrics' Encyclopaedia of Textiles* Prentice-Hall, New York 1960

Atwater, Mary *The Shuttlecraft Book of American Handweaving* Collier-Macmillan, New York 1951

Atwater, Mary *Byways in Handweaving* Collier-Macmillan, New York 1968

Beutlich, Tadek *The Technique of Woven Tapestry* Batsford, London; Watson-Guptill, New York 1967

Birrell, Verla *The Textile Arts* Harper, New York 1959

Black, Mary *New Key to Weaving* Bruce Publishing Co, Milwaukee, USA 1957

Blumenau, Lili *The Art and Craft of Handweaving* Crown, New York 1955

Blumenau, Lili *Creative Design in Wallhangings* Allen and Unwin, London 1963

Chetwynd, Hilary *Simple Weaving* Studio Vista, London; Watson-Guptill, New York 1969

Collingwood, Peter *Sprang, Revival of an Ancient Technique* in Handweaver and Craftsman Magazine, vol 15, no. 2

Collingwood, Peter *The Technique of Rug Weaving* Faber & Faber, London; Watson-Guptill, New York 1967

Cyrus, U. *Manual of Swedish Handweaving* Charles T. Branford Co., Boston, USA 1956

Dryad Footpower Looms Dryad Press, Leicester, UK

Grierson, Ronald *Woven Rugs* Dryad Press, Leicester, UK 1950

Hartung, Rolf *Creative Textile Craft* Batsford, London; Reinhold, New York 1964

Hooper, Luther *Handloom Weaving* Pitman, New York, London, 1920

Kauffman, Ruth *The New American Tapestry* Reinhold, New York 1968

Kirby, Mary *Designing on the Loom* Studio Publications, London, New York, Toronto 1955

Mairet, Ethel *Handweaving Today* Faber & Faber, London 1939

Rainey, Sarita *Weaving Without a Loom* Davis Publications, Worcester, Massachusetts, USA 1966

Rainey, Sarita *Wallhangings, Designing with Fabric and Thread* Davis Publications, Worcester, Massachusetts, USA 1966

Regensteiner, Elsa *The Art of Weaving* Studio Vista, London 1970

Seagroatt, Margaret *Rug Weaving for Beginners* Studio Vista, London 1971

Simpson & Weir *The Weaver's Craft* Dryad Press, Leicester, UK 1963

Spinning Wool Dryad Press, Leicester, UK

Tablet Weaving Dryad Press, Leicester, UK

Tattersall, C. *Carpet Knotting and Weaving* Victoria and Albert Museum, London 1920

Thorpe, Azalea and Larson, Jack *Elements of Weaving* Doubleday, New York 1967

Tidball, H. *Build or Buy a Loom* Craft & Hobby Book Service, Pacific Grove, California, USA

Tovey, John *The Technique of Weaving* Batsford, London; Reinhold, New York 1965

Tovey, John *Weaves and Pattern Drafting* Batsford,
 London; Reinhold, New York 1969
Watson, William *Textile Design and Colour* Longmans,
 London, New York, Toronto 1912
Watson, William *Advanced Textile Design* Longmans,
 London, New York, Toronto 1912
Weaving for Two-Way Table Looms Dryad Press,
 Leicester, UK
Weaving on Four-Way Table Looms Dryad Press,
 Leicester, UK
Weeks, Jeanne *Rugs and Carpets of Europe and the
 Western World* Chilton Book Co., New York 1970
Wilson, Jean *Weaving for Anyone* Studio Vista, London;
 Reinhold, New York 1967
Znamierowski, Nell *Step by Step Weaving* Golden Press,
 New York 1967

Lace

Channer, C. C. *Lace Making* Dryad Press, Leicester, UK
 1959
Close, Eunice *Lace Making* Gifford, London 1970
Felkin, William *History of the Machine-Wrought Hosiery
 and Lace Manufactures* David & Charles, London
 1967
Freeman, Charles *Pillow Lace in the East Midlands*
 Luton Museum, UK 1958
Gubser, E. *Bobbin Lace* Museum Books, New York
Harding, Keith *Lace Furnishing Manufacture* Macmillan,
 London 1952
May, Florence Lewis *Hispanic Lace and Lacemaking*
 Hispanic Society of America, New York 1939
Pond, Gabrielle *Introduction to Lace* Garnstone Press,
 London 1968
Tod, O. G. *The Belgian Way of Making Bobbin Lace*
 Museum Books, New York
Tod, O. G. *Bobbin Lace Stitches, Step by Step* Museum
 Books, New York

General

Channing, Marion *The Textile Tools of Colonial Homes*
 35 Main Street, Marion, Massachusetts, USA 1969

Emery, Irene *The Primary Structure of Fabrics* Textile
 Museum, Washington DC, USA 1966
Gale, Elizabeth *From Fibres to Fabrics* Allman, London
 1968
Goslett, Dorothy *Professional Practice for Designers*
 Batsford, London 1961
Groves, Sylvia *The History of Needlework Tools* Hamlyn
 Publishing Group, Middlesex, UK 1966
Hartung, Roy *Creative Textile Craft* Batsford, London;
 Reinhold, New York 1964
Krcma, Dr Radok *Manual of Nonwovens* Manchester
 Trade Press, UK 1971
Miller, Edward *Textile Properties and Behaviour*
 Batsford, London 1968
Nelson, Norbert *Photographing Your Product* Reinhold,
 New York 1971
Nonwovens 71 Manchester University Conference,
 Manchester Trade Press, UK 1971
Nuttall, Prudence *Picture Framing for Beginners* Studio
 Vista, London 1971
Stitch Bonded Fabrics Shirley Institute Pamphlet 100,
 Manchester, UK

Magazines

Craft Horizons Journal of the American Craftsman's
 Council, 44 West 53rd Street, New York
Design Journal of the Council of Industrial Design,
 Haymarket, London SW1
Handweaver and Craftsman 220 5th Avenue, New York
*Quarterly Journal of the Guilds of Weavers, Spinners and
 Dyers* 1 Harrington Road, Brighton, UK
Webe Mit 705 Waiblingen bei Stuttgart, Postfach 65,
 Germany
Threads in Action Box 468, Freeland, Washington, USA

Book lists and suppliers lists
are obtainable from
The American Craftsman's Council, 44 West 53rd
 Street, New York

Book lists
obtainable from Museum Books & Drummond
 (opposite)

Courses of study

Book shops

I find helpful are:

Museum Books, Inc., 48 East 43rd Street, New York

K. Drummond, 30 Hart Grove, Ealing Common, London W5 (appointments only)

Craft & Hobby Book Service, Box 626, Pacific Grove, California

Foyles Bookshop, Charing Cross Road, London WC2

When ordering books, equipment or material supplies from another country the transaction can be dealt with for you by your bank. Should you have no bank account any bank will look after the matter for you. In Britain it can also be dealt with at the Post Office by means of an International Money Order.

Great Britain

Information on those Colleges of Art and Polytechnics awarding the 'Diplomas in Art and Design' in weaving, some of which include knitting, and post-graduate Dip AD courses, is available from the National Council for Diplomas in Art and Design, 16 Park Crescent, London WIN 4DN.

A two-year post-graduate course in weaving tapestry and knitting is given by The Royal College of Art, Kensington Gore, London SW7. There is a close liaison with the textile industry, both in the UK and abroad. Applications and testimonies of study for the entrance examination must be submitted in January.

Undergraduate and post-graduate courses in various categories of textiles are available at the University of Leeds and the University of Manchester. Research and study on some forms of stitch bonding can be undertaken by arrangement with the University of Manchester.

Courses of varying duration, including post-graduate, on all aspects of machine knitting and lace are available at Trent Polytechnic, Burton Street, Nottingham.

Day visits and courses of varying duration on industrial carpet production are available at The School of Art, Kidderminster College, Hoo Road, Kidderminster.

Day visits and courses of varying duration on all aspects of the woollen industry, including spinning and power weaving, are available at West Wiltshire and Trowbridge College of Further Education, Trowbridge, Wiltshire.

United States of America

The American Craftsman's Council Directory of Craft Courses – published by the ACC gives information on universities, colleges, workshops, and courses in general, and is available from 44 West 53rd Street, New York.

Index

Page numbers in italics refer to illustrations